Art
in Primitive
Societies

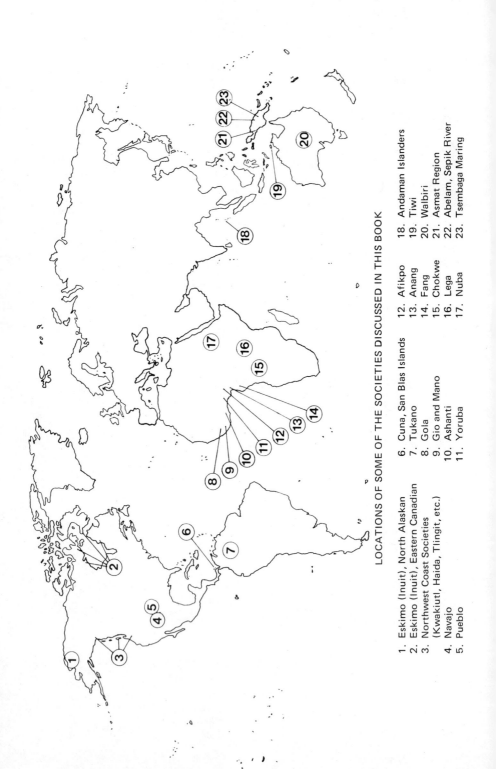

LOCATIONS OF SOME OF THE SOCIETIES DISCUSSED IN THIS BOOK

1. Eskimo (Inuit), North Alaskan
2. Eskimo (Inuit), Eastern Canadian
3. Northwest Coast Societies (Kwakiutl, Haida, Tlingit, etc.)
4. Navajo
5. Pueblo
6. Cuna, San Blas Islands
7. Tukano
8. Gola
9. Gio and Mano
10. Ashanti
11. Yoruba
12. Afikpo
13. Anang
14. Fang
15. Chokwe
16. Lega
17. Nuba
18. Andaman Islanders
19. Tiwi
20. Walbiri
21. Asmat Region
22. Abelam, Sepik River
23. Tsembaga Maring

Art
in Primitive
Societies

Richard L. Anderson

Kansas City Art Institute

Prentice-Hall, Inc., *Englewood Cliffs, New Jersey 07632*

Library of Congress Cataloging in Publication Data

ANDERSON, RICHARD L
 Art in primitive societies.

 Bibliography:
 Includes index.
 1. Art, Primitive. I. Title.
N5311.A52 709'.01'1 78-15512
ISBN 0-13-048108-4

Prentice-Hall Series in Anthropology
David M. Schneider, Editor

©1979 by Prentice-Hall, Inc., Englewood Cliffs, N.J. 07632

Printed in the United States of America

10 9 8 7 6 5 4 3 2 1

Editorial/production supervision and interior design by Penny Linskey
Cover design by Pasternak, Kiser & Associates
Manufacturing buyer: John Hall

PRENTICE-HALL INTERNATIONAL, INC., *London*
PPRENTICE-HALL OF AUSTRALIA PTY. LIMITED, *Sydney*
PRENTICE-HALL OF CANADA, LTD., *Toronto*
PRENTICE-HALL OF INDIA PRIVATE LIMITED, *New Delhi*
PRENTICE-HALL OF JAPAN, INC., *Tokyo*
PRENTICE-HALL OF SOUTHEAST ASIA PTE. LTD., *Singapore*
WHITEHALL BOOKS LIMITED, *Wellington, New Zealand*

To Elizabeth
and to my parents,
Donald L. and Mary Alyce Anderson

Contents

5 Where Does it All Come From: The Psychology of Art 111

Illustrations

Preface

A book on art in primitive societies may adopt any one of several approaches, each valid for its own purposes. There are, first, the "picture books"—books with little text but many photographs or drawings of art works from primitive societies. These books, and the museum exhibits that often prompt their creation, are valuable in familiarizing large numbers of people with the appearance of art from primitive societies. Similar to such books are those, usually written by art historians, that give extensive verbal descriptions of regional art styles. These too serve a worthwhile informational service.

But the question, "What does it look like?" is only one of several interesting issues regarding art from primitive societies. Other important questions are: For what reasons were these art works created; who were their makers; and what do they mean? Questions such as these are typically of interest to cultural anthropologists; and anthropologists have, since the time of Franz Boas,

intermittently turned their attention to them. But with the notable exception of Boas's own *Primitive Art*, first published in 1927, there has been·no attempt to bring together in a single book the many insights that have resulted from the systematic study of art from primitive societies. The present book is an attempt to begin such a synthesis.

Specifically I have tried to present the principal issues that are relevant to the study of art as a cultural phenomenon and have illustrated the topics with data derived from in-depth ethnographic field studies. (The interested reader will want to supplement these case studies by going directly to the primary ethnographic sources and by viewing—in museums and books—the art in question.)

Underlying this approach is my own conviction that *art is only partially mysterious*, a belief that deserves some comment here. Some aspects of art *are* "mysterious" in that even the most sanguine of social scientists do not claim to have a fundamental understanding of many aspects of art. For example, we know that looking at art can give the viewer a distinctive thrill of pleasure; and we know that this response reflects an important feature of art. But beyond those obvious observations there is little that can be said with certainty regarding the affective response to art.

But to admit that there are gaping holes in our understanding of art is not to deny or belittle the amount of insight we have into the phenomenon: Art is *only partially* mysterious, and the major portion of this book deals with those topics that are less refractory to systematic study.

Chapter 1 takes up the problem of definition: What is meant by "primitive" and what by "art"? Neither of these terms is easy to define satisfactorily, and the first chapter discusses some of the difficulties involved. Chapter 2 deals with the functions of art in primitive societies. The question, "What does this piece of art do?" is seldom adequately met by a single answer. What, for example, did Chartres Cathedral do in thirteenth-century France? It provided a safe, dry location for church ceremonies; it acted as a useful symbol of the unified religious beliefs of the people of the surrounding countryside; it gave additional symbolic legitimacy to the socio-political elite of France; its porches provided shelter for markets; its construction and maintenance gave employment to untold numbers of craftsmen—all this in addition to the aesthetic pleasure that the cathedral provided to all who saw it. While they are typically more modest in scale than Chartres Cathedral, many pieces of art from primitive societies can be shown to serve economic, social, symbolic, and political functions for the people who create them.

Chapter Three deals with symbolism: How prevalent is it in the

art of primitive societies? How important is it? Are there universal symbols? The fourth chapter discusses the artist in primitive societies. By looking at the training, lives, and works of individual artists in several different societies, some general characteristics will emerge, showing them to be skillful, if non-professional, artisans who are well integrated into the cultures of which they are a part.

Chapter Five discusses various psychological topics related to art, such as the sources of the artist's ideas for art works and the creative process itself. Chapter Six deals with the topic of change, both in traditional settings as well as in response to contact with the Western world. The final chapter summarizes the cross-cultural patterns in art that have been noted in various contexts throughout the book; it also points out some of the similarities and differences between art in primitive societies and art in the contemporary Western world, pointing out the more significant (but not necessarily more obvious) ways in which our art and that of primitive societies are both similar and different.

What benefits can we ourselves derive from the study of art in primitive societies? For one thing, the subject is intrinsically fascinating, capturing our attention and stimulating our curiosity in the same way as does anything from a far-away and exotic-seeming place. Beyond this, however, I hope that the cross-cultural study of art will deepen the reader's understanding of art and the human species in general. Robert Redfield had this goal in mind two decades ago when he wrote, "Whether we come to see the artifact as a creative mastery of form, or see it as a sign or symbol of a traditional way of life, we are discovering, for ourselves, new territory of our common humanity. We are enlarging the range of our recognition of human sameness as it appears in human difference" (1971 [orig. 1959] :64).

Thanks are due to the Kansas City Art Institute and to the Center for Professional Development of the Kansas City Regional Council for Higher Education for funding some parts of the library research upon which this book is based. I also bear a great debt of gratitude to William J. Crowley, Warren L. d'Azevedo, and Paul D. Schaefer, all of whom read the manuscript with care and whose numerous and thoughtful suggestions were all greatly appreciated—if not always followed to the letter. Sincere thanks also go to Katherine Arredondo, Janis Cram, Kenneth Cram, Susan McGreevey, John McGuire, Gayle Nelson, Hal E. Wert, and numerous students at the Kansas City Art Institute, who read and commented on part or all of the manuscript; to Penelope Linskey and Stan Wakefield, of Prentice-Hall, Inc., for their editorial assistance; to David Gray for preparing

the line drawings, to Kurt Eckhard for doing part of the photographic work, and to Pasternak, Kizer, and Associates for designing the cover; to Rosann Rahn and Anne Devaney for their intelligent and competent typing of a large portion of the manuscript; and, finally, to Georgeann Marsh, for her support of the project when it was a twinkle in the author's eye. My greatest debt however is to Elizabeth Scholer Anderson, whose constructive criticism influenced every page of the manuscript, whose best ideas I shamelessly confiscated for my own use, and whose warm support and encouragement through all phases of the project made its completion possible.

Grateful acknowlegement is also made to the following for permission to quote from copyrighted material:

George W. Harley, *Masks as Agents of Social Control in Northeast Liberia*, portions reprinted by permission of the President and Fellows of Harvard College.

Mary Jane Schneider, "But Is it Art? A Critical Look at Anthropolotical Studies of Non-European Art," 1976, portions reprinted by permission of the author.

From *The Traditional Artist in African Societies*, Warren L. d'Azevedo, Editor, copyright (c) 1973 by Indiana University Press. Portions reprinted by permission of the publisher.

Nelson H. H. Graburn, editor, *Ethnic and Tourist Arts of the Fourth World*, copyright 1977 by The Regents of the University of California; reprinted by permission of the University of California Press.

Simon Ottenberg, *Masked Rituals of the Afikpo: The Context of an African Art*, copyright (c) 1976 by the University of Washington Press, portions reprinted by permission of the publisher.

Photographs of two Liberian masks, Peabody Museum, Harvard University, copyright (c) by the President and fellows of Harvard College, 1977. Used by permission.

R.L.A.

Art
in Primitive
Societies

Art
in Primitive
Societies

Chapter 1

The Meanings of "Primitive" and "Art"

When the American folk song "Rock Island Line" is sung, it's often accompanied by the following story: At a certain time in the history of the Rock Island Railroad there were state-operated toll booths along the line, and only trains carrying agricultural products such as livestock were allowed to pass through the gates without paying a sizable toll. The engineer on one train outsmarted the system by telling the toll collector:

> I've got pigs,
> I've got pigs.

When he was given permission to pass through the toll gate without paying any toll, the engineer gave his machine full throttle and as the train accelerated he shouted back to the toll collector:

I've got pig iron,
I've got pig iron,
I've got all pig iron,
I've got all pig iron!

The moral of the story is clear: If two people are to communicate in any depth about a particular subject they must come to some minimal agreement about the meanings of crucial words. Or, if they cannot *agree* about definitions, each person must at least know what definition the other person is using. If this basic requirement is not met, the individuals are at best frustrated and at worst (as in the above story) deceived. If this is the case in discussions about tangible items like pig iron, it's an even greater hindrance to exchanges concerning abstract ideas.

This book is about art in primitive societies, and the meaning of this phrase obviously depends on the meanings of "primitive" and of "art." These are certainly not obscure words—all of us use them in our everyday conversations. But they do stand for fairly abstract ideas, and a trip to the dictionary confirms our worst fears: The *Oxford English Dictionary* lists 18 meanings for "primitive," and none of them corresponds perfectly with the way in which most anthropologists use the word in such phrases as "primitive society," "primitive economics," and so on. Seventeen separate meanings are listed for "art," and it is by no means easy to determine which (if any) of them can be used with reference to all the diverse items found in collections of art from primitive societies.

Because their importance is matched only by their elusiveness of meaning, the words "primitive" and "art" are the foci of this chapter. The goal is not to expound perfect or final definitions of the terms, but rather to discuss the problems of defining the terms and then present tentative definitions that will allow us to reach the minimal agreement necessary for communication. It is, for the moment at least, less a philosophical problem and more a practical one.

The Meanings of "Primitive"

When cultural anthropologists use the phrase "primitive society," they usually have in mind a population that, by comparison to other societies, has the following traits:

1. The necessities of life are obtained by means of a relatively simple technology, based only on hunting and gathering or, at most, on plowless agriculture.
2. The population is relatively small in numbers and low in density.

3. The group has a relatively limited amount of social, economic, and political specialization. Thus, for example, while one member of the group may be acknowledged as the best curer among them, he or she does not totally specialize in the role of medical practitioner but practices hunting, farming, or whatever, along with the other adult members of his or her sex.

When these criteria are applied to actual societies, of course, we'll find that rather than simply using two clear-cut categories, primitive and nonprimitive, we must instead think in terms of a continuum ranging from the more primitive societies to the less primitive ones. Further, placement of a given society along the continuum can only be approximate for two reasons: A society's overall technological complexity is difficult to assess in purely quantitative terms;[1] and the three above-mentioned criteria of primitiveness may vary independently to a certain extent.

Despite these problems, however, there clearly *are* wide differences between the societies of the world in regard to size, technological complexity, and sociocultural homogeneity. And, equally clearly, the art items that interest us here are products of the smaller, less technologically complex, more homogeneous societies. But the question remains: May these societies, or the art they produce, be labeled *primitive*? A brief look at the ways in which anthropologists have gone about studying primitive societies will shed some light on the issue.

Since around the turn of this century, cultural anthropologists have had as their goals the description and (insofar as possible) the analysis of nonwestern societies. Prolonged, in-depth fieldwork has been the most common approach: By picking a single society, learning the language of its members, living in it for a year or more, and establishing some feeling of rapport with the society's members and sharing their day-to-day experiences, the anthropologist tries to see the society in its own terms, rather than solely in the terms of his own western society.

The result of this type of research has consistently revealed that primitive societies, although much different from the anthropologist's own in many ways, are nonetheless based upon highly complex and sophisticated designs for living: Every society has its own "culture" that specifies the proper relationship between the individual and others, between the individual and the supernatural, and between the individual and the physical environment. And these cultural norms are by no means simple—as will be attested by

[1]A first step toward the quantification of technological complexity has been attempted by Oswalt (1973) and Lustig-Arecco (1975).

anyone who has tried to understand, say, the traditional kinship systems of the native societies of Australia.

Bearing in mind these observations, let's return to the questions asked above: Can we justifiably call these societies primitive? And, more to the point, can their art be called primitive art? Several writers have answered these questions in the negative (cf. Gerbrands 1957:9-16; Haselberger 1961:441-44; B. Fagg 1961:364). The debate concerning the use of primitive is not just an academic matter. Rather, it has serious political implications that will affect the way we think and talk about other members of the human race.

Criticism of the use of primitive falls into two categories. The first concerns the denotative meanings of primitive; the second, its connotations. I will deal with each of these arguments in turn.

Denotations: "Primitive" Art Versus "Earliest" Art. Gerbrands (1957:10) has claimed that "the basic meaning of *primitive* is original, earliest, first, in other words it indicates a stage of commencement." This being the case (so the argument goes), the term cannot properly be applied to any contemporary society or its art since each one has its own long history. Societies that lack writing systems do not have written records of their past, of course; but the archeological record provides undisputed evidence that all contemporary societies are the descendants of other, different, previously existing societies. Thus, although primitive might justifiably be used to describe cave paintings made 20,000 years ago, it is both inaccurate and misleading to apply the word to most of the items found in collections of non-western art, since many of them are chronologically younger than, say, impressionist paintings!

This argument is linguistically naive. One denotative meaning of primitive *is* "of or relating to the earliest age or period." But one word often has several different meanings. (The word "radical," for example, is used by political scientists, mathematicians, and chemists; for each it has an explicitly different meaning.) Primitive, in addition to meaning earliest, can have a second meaning—referring to things that are relatively less complex than others. This clearly is the intended denotation when applied to a contemporary primitive society. If a person, expert or layman, refers to an African mask carved in the nineteenth or twentieth century as primitive, he clearly does not mean that the piece is the earliest work of art ever to have existed, but rather that it comes from a society that is relatively less complex than that of the industrialized west.

The Connotations of "Primitive." The second objection to the use of the word primitive derives from the fact that whichever denotative

meaning is attached to it, the word often carries with it certain pejorative connotations. To call something primitive may suggest that it is unsophisticatedly "simple, unfinished, and undeveloped" (Gerbrands 1957). This, I believe, is a very real problem in that the layman who calls an African mask primitive may very well be using the word with these connotations in mind.

This argument is much more difficult to evaluate than the first. For one thing, in terms of the technology involved, some of these connotations are not inaccurate: The art that is currently being produced in the industrialized nations *is* more complex technologically than that from nonindustrialized societies. Synthetic pigments and fibers, pottery kilns heated by natural gas and electricity, highly specialized metal alloys, and the power tools used to work with metal and wood—all of these are normally unavailable to artists in nonindustrialized societies.

But technology aside, what can be said about the form, the content, or the aesthetic response evoked by a work of art from a technologically primitive society? Is it accurate to imply that they are unsophisticatedly "simple, unfinished, and undeveloped"? The answer must be a resounding *no*! Although no quantitative methods exist for measuring these qualities, even a superficial familiarity with art from primitive societies makes one seriously doubt that it is systematically more "simple" than western art. The adjective "undeveloped" is inapplicable to art from any source; and the suggestion that primitive art is "unfinished" is simply erroneous. Indeed, a major goal of this book is to show that the art of nonliterate peoples is anything but simple, undeveloped, or unfinished.

These possible connotations of primitive are not only mistaken; they are also highly value-laden, suggesting that the people or things to which they are applied are crude, clumsy, or in some other sense systematically inferior to people or things in present-day, industrialized Europe and America. Such a suggestion, of course, is repugnant to most anthropologists and to many other westerners and nonwesterners. This line of criticism of primitive has hit a very sensitive nerve in charging that by continuing to use the word primitive we are aiding and abetting those who would like, for whatever reason, to portray Third and Fourth World peoples as backward savages inferior to ourselves.

Abandon "Primitive"? One solution to this problem, of course, would be to abandon altogether the distinction between primitive and nonprimitive societies. With reference to individual regions or art traditions, such a solution is highly desirable: we *can* speak unambiguously of Samoan art, native Australian art, or Yoruba art.

But to abandon primitive as a term to refer generically to such societies around the world would be, I believe, unjustified. Any person who has lived in a small-scale, technologically simple society can attest to there being important social-structural differences between that type of society and our own. Modern industrialized nations produce a material surplus, and this surplus is controlled by sociopolitical systems that are qualitatively different from those found in small-scale societies. Large-scale states are characterized by such traits as complicated systems of taxation and conscription, a class system, full-time political and religious practitioners whose subsistence is provided by the society at large, and so on. These, and the other traits that are so characteristic of nonprimitive societies, are of tremendous social importance, and they are inevitably reflected in art itself: Societies at the extreme *non*primitive end of the continuum typically have art that is based on a highly complex and diversified technology. Art training in such societies is often institutionalized in schools rather than being transmitted solely by oral tradition. Artists tend to be full-time specialists who buy food and shelter with money rather than hunting, gathering, or farming for themselves and building and maintaining their own houses. Typically there is a great diversity of artistic styles, including at any given time one (or more) "fine" art traditions as well as numerous varieties of popular arts. And, finally, art styles commonly change more rapidly with the passage of time in such societies than is the case in primitive societies. Thus, although there are commonalities between primitive and nonprimitive societies and the art they produce, the differences between the two are of fundamental importance. Clearly we do need some term to distinguish between these two polar types of societies.[2]

A second alternative is to retain the distinction between primitive and nonprimitive, but to refer to it by use of a different word. The problem would be solved if we could find a word that traditionally has referred to the societies that meet the three criteria of primitiveness outlined above but that has none of the misleading and derogatory connotations that can accompany primitive. Unfortunately, such a word does not exist—at least not in the English language as it is spoken today.

Of the many terms that have been suggested by various anthropologists and art historians as replacements for primitive, every one has been shown to have serious shortcomings. "Preliterate,"

[2] See Stanley Diamond's *In Search of the Primitive: A Critique of Civilization* (1974, esp. pp. 116-75) for a defense of the continued use of the word primitive coming from the political left.

"preindustrial," "traditional," "native," and "indigenous" all have many of the same pejorative associations that primitive has acquired. "Ethnological" and "nonwestern," on the other hand, are too broad, since they would include the art of China, India, the Middle East, and pre-Columbian Mesoamerica and Peru, areas that are far from meeting the criteria of primitiveness that define the area of study. "Traditional" is unsatisfactory cross-culturally because, inasmuch as all art everywhere derives from one tradition or another, all art is traditional in a sense. "Tribal," the word that seems to be the most widely preferred alternative to primitive, is unsatisfactory both because of its own demeaning flavor and because it is too narrow a term, excluding as it does those societies that are organized into groups that are smaller than tribes (e.g., Eskimo "bands") and, more importantly, the larger "chiefdoms" (e.g., the Tahitians and the Trobriand Islanders). Recent rethinking of the word tribe indicates that it may be an even more ambiguous term than primitive (cf. MacNeish 1968; Fried 1975).

It is beyond the scope of this book to deal at length with the lack of a suitable substitute for the word primitive. It is noteworthy, however, that in several different contexts, sociolinguists (e.g., Brown and Gilman 1960; Gumperz 1971) have shown that differences in political and economic power are often reflected in language, particularly in terms of address. It is then perhaps inevitable that as long as there is a wide economic and military gap between the industrialized nations and the societies of the Third and Fourth World, *any* term that is adopted by the former for reference to the latter will take on highly value-laden connotations and will, as William Fagg (1961:365) has suggested, quickly become distasteful to large numbers of people.

"Primitive:" A Working Definition. Reluctantly, then, I have chosen to use the term primitive throughout this book, on the grounds that (1) the distinction between primitive and nonprimitive societies is conceptually useful for a cross-cultural study of art, and (2) no alternatives currently exist that are preferable to the traditionally-used primitive. When the term is used hereafter the reader should bear in mind the following provisos:

1. A society is to be considered primitive if (a) its subsistence is provided by a relatively simply technology; (b) it has a relatively small and sparce population; and (c) it has a relatively limited degree of social, economic, and political specialization.
2. No strict dichotomy can be made between primitive and nonprimitive societies, but rather there is a continuum along which societies can be placed in some very approximate order.

3. To refer to a society as primitive does not mean that it is identical to those that existed in the distant past nor that its members, institutions, or cultural appurtenances (including art) are simpler, less sophisticated, or less valuable than those of nonprimitive societies.

One implication of this definition should be made explicit, namely, that primitive is not synonymous with nonwestern. With few exceptions I will not discuss the art of the world's other major nonprimitive traditions—China and its congeners; the civilizations that developed in the Indus, the Tigris-Euphrates, and the Nile valleys; and the pre-Columbian civilizations of Meso-America and the Andes. Also, since our goal is to view art in its social and cultural context, little will be said about art produced in societies that disappeared long before the arrival of notebook-toting cultural anthropologists. Sculptures and cave paintings from the distant past are fascinating, but our knowledge of the cultures that produced such art is superficial and, to a large extent, conjectural. Finally, I have consistently used the phrase "the art of primitive societies" rather than "primitive art," since the above-listed criteria of primitive apply not to art but to societies.

Naively, one might have assumed that primitive is an easy word to define—but then the fabled toll collector on the Rock Island Line probably thought the same thing about "pig" until he learned otherwise. In fact, a definition of primitive raises issues that are intellectually and politically important. The word has been dealt with at length in hopes of both making clear the potential problems of its definition and of making explicit the meaning it is intended to convey throughout this book.

The Meanings of "Art"

The definition of art has been a disputed issue for literally ages, dating in the west from at least Plato's time right down to the present. Our goal here is not to find a *final* definition of art, but rather to develop a tentative working definition that will be useful cross-culturally, and to discuss some of the difficulties that are involved in arriving at such a definition.

The query "What is art?" has historically masked two distinctly different questions. First, it may mean, "How can art be distinguished from non-art?" Alternatively it may mean, "Among those things that are classified as art, what distinguishes great art from mediocre art?" For our purposes, it is helpful to discuss these two issues separately.

Art versus Non-Art. In the western world, art has traditionally referred to "skill in performance, acquired by experience, study or observation" (*Webster's New Collegiate Dictionary*, 1959:50), or to the results produced by such skill. There is a historical precedent for using this definition cross-culturally, with Boas saying as early as 1916 that "all art implies technical skill" (1940-[orig. 1916]:535). This succinct and down-to-earth definition will serve us better than any other, but a number of additional comments should also be made.

First it should be noted that art is the product of *human* activity. A sunset may evoke feelings in some people that are similar or identical to their response to art, but the sunset is not art (cf. Boas 1955:349).

What about the products of nonhuman animals—do apes and monkeys, for instance, make art? Ethological studies have shown that maturing animals do indeed acquire certain skills, and that these are gained through experience and observation. Intuitively most of us feel that human skills must be qualitatively different from those of nonhuman animals, and it is tempting to build these assumptions into a theory of art. Such notions, however, are not based on empirical knowledge of animal behavior, although future studies may shed some light on the subject. Until that time we should bear in mind that man has a monopoly on artistic production only because we have arbitrarily defined art that way. (The use—skillful or otherwise—of visual media by nonhuman primates is discussed in Schiller 1971; Morris 1962; and D. Smith 1973.)

The word "skill" in the definition deserves some further comment also. It implies an ability that is not acquired automatically and equally by all people (as are, for example, breathing and walking) but rather an ability that must be developed by the individual. Inevitably, some people are more skillful than others, since one person's interests, opportunities, and so on, may predispose him or her to acquire a greater amount of skill than another person for a particular activity. This is a distinction that seems to be recognized in all societies, and for this reason it is crucial to a cross-culturally useful distinction between art and non-art. Edmund Leach, a British anthropologist, has commented thus on the differential acquisition of skills:

> At the age when a European infant starts to play with a pencil, a Borneo Dyak boy starts to play with a knife. By the time the European can express himself reasonably well by writing conventional symbols on paper, the Borneo Dyak can do the same by carving conventional shapes out of wood. In such societies nearly every adult male can carve after a fashion. *Master carvers, of course, are just as rare as are master calligraphers in our own society* (1961:29; emphasis added).

Since our definition of art relies so heavily on the concept of skill, the question might well arise, "But how are we to recognize skill when we see it?" In answering this question we should first note that it is always a *relative* degree of skill that is involved—one person's level of ability in comparison to another person's. Obviously, skill is not an all-or-nothing quality, but rather there is in every medium a continuum of skill (and, hence, of art) ranging from those who display consummate skillfulness to those who possess little. (Thus, to return to Leach's example, skill in handwriting varies in the west from that of the "rare" calligrapher, through the careful longhand of, perhaps, the majority, to the reckless scrawl of those whose skills are minimal.)

But having noted that skill is always a matter of relative degree, there are two ways we might proceed. On the one hand we could use ourselves as a standard of comparison for measuring relative skill. I, for example, have virtually no experience at wood carving. Doubtless, if I tried I could carve *something*, but I could not do it as skillfully as could a man who, having grown up in Borneo Dyak society, has acquired a relatively greater degree of skill—skill which, to use the dictionary definition cited above, has been "acquired by experience, study or observation." (Note that the relationship between the skillful Dyak carver and me is not reciprocal: He can duplicate my amateurish efforts more easily than I can copy his skillful work.)

When confronted with artifacts from other societies it is often an outsider-based (or "etic") definition such as this that is used to distinguish art from non-art. Thus, objects from other societies become candidates for art museum collections when they reflect a level of skill in their production that far exceeds our own level of skill. Using this definition, carvings made by *any* mature Dyak man can be thought of as being art. (Or, to cite a real rather than a hypothetical case, after extensive fieldwork among the Bangwa of west central Africa, Brain and Pollack concluded that many of the Bangwa figures in western collections are "no more distinguished than rough-hewn carvings made by youths to pass away a few minutes" [1971:60].)

Often our state of relative ethnographic ignorance leaves us with no alternative to such an approach, but it is not, I feel, the best way to proceed. Instead of using ourselves as the standard of comparison for measurement of relative skill, we should, when possible, use the same criteria that are used in the society in question: How much skill does this particular object display, in comparison to other objects from the same society and as judged according to the stand-

ards of the members of that society? Such an insider-based (or "emic") definition of skill is preferable for two reasons.

First, the skill involved in a particular process may be very difficult to estimate by an outsider who has no practical experience with the medium. Thus, for example, a person who has never worked extensively with clay probably has little basis of judgment for determining which of a number of ceramic pots from another society required the greatest skill to create.

A second, and more important, reason for preferring an insider-based definition of skill is that the criteria of judgment of skill differ from one society to another. The aesthetic values that have traditionally been held by the Yoruba of West Africa will be discussed later in this chapter; for the moment suffice it to say that in judging Yoruba sculpture, native art critics do not always focus upon the same elements of craftsmanship to which we ourselves attach importance. Given these factors, it is preferable, when possible, to measure skill by comparison to other works from the same society, using native values for the determination.

Our earlier definition of art places no restrictions upon the *type* of activity that is done skillfully. Thus it includes not only the arts of sculpture, painting, and ceramics, but also the art of dance, the art of warfare, the art of cooking, and so on. The contemporary distinction between the fine arts and others arts is quite recent, dating only from about the time of the Industrial Revolution (Williams 1958:xiii-xiv). It was not made by the ancient Greeks, nor is it made in most primitive societies. Confining our attention here to the visual arts is justified, then, only by convenience and is yet one more arbitrary aspect of the definition of art that is being used. Of course, in nonwestern societies we must be prepared for the fact that the visual arts will include not only those media, such as woodcarving, ceramics, and two-dimensional painting, that we are accustomed to think of as art, but also media that have had little or no development in the fine art tradition of the west: decoration of the human body, feather and quill work, two-dimensional work in sand, and so on—in short, *any* tangible medium that may be altered through human manipulation to produce an object that one may see.

Having made these comments and qualifications we can now present the working definition of art that is used throughout this book: *Those things are considered to be art which are made by humans in any visual medium and whose production requires a relatively high degree of skill on the part of their maker, skill being measured, when possible, according to the standards traditionally used in the maker's society.* By

extension, an artist is one who, independently or in cooperation with others, uses his or her superior skill to produce such objects; and the artistic process is the sequence of manual and psychological events directly involved in their production.[3]

The above definition of art makes no reference to either the possible nonutility of art items or the psychological response that art can evoke in the viewer. Since both of these factors are frequently claimed to be definitive traits of art, their omission here should be commented upon.

The Inutility of Art. Often the claim is made that art, by its very nature, is nonutilitarian. Thus, for example, all that is needed for a headrest is a block of wood. To make the piece weigh less, the inner portion may be carved out, leaving a platform with legs. All this has been done in the interest of utility. But if the carver goes on to make a special design on the headrest, perhaps even ornamenting its legs to the extent of weakening them, then this part of the headrest's form may be considered its artistic component (cf. Jones 1974:266), and the handsome headrests of the Tikopia of Polynesia have been described as examples of their artistic abilities (Firth 1974:32-47).

The idea that a definitive trait of art is its uselessness may seem reasonable to us westerners, accustomed as we often are to equating "art" with "fine art" displayed in galleries and museums, ostensibly doing nothing. (Even with regard to western fine art, however, we are in error: Clearly such art not only provides a basis for an aesthetic response in some viewers, but also plays a role in the realm of economics, legitimizes current tastes and values, and so on.)

The issue is still more complicated when the art of nonwestern societies is taken into account. For example, an attractive amulet made by an Eskimo carver may seem nonutilitarian to us, but its maker would surely disagree, telling us (if we asked) that the amulet

[3]The application of this definition to the material culture of the west will be discussed in chapter 7. Here we need only note that it would include all fine art. Styles such as "found art" would fit easily into the definition since the "finder" of such objects presumably has more highly refined perceptual and imaginative skills than do non-artists. (Thus, for example, a rusty bicycle seat and handlebars that I conjoin and display as *Bull's Head* would not receive the same acclaim from art critics as would Picasso's similarly dubbed work.) "Craft" items produced by individuals having special skills would be included also, as would such "popular" arts as award-winning graphic design and masterpieces of the cinema. "Folk" or "naive" art would be included if skillfully made, but that which reflects only the maker's eccentricity would not be, unless his or her unique sensibilities are skillfully realized.

serves a very important and specific purpose—perhaps this one will help the hunter who owns it to find more caribou in the summer months (Balikci 1970:202). Of course we could maintain that we, with all our so-called scientific knowledge, know that the amulet does not really help the hunter find caribou in the summer. But before we make this claim we should remember that our understanding of the psychology of autosuggestion is rudimentary at best, and that the amulet might very well help the hunter find additional caribou—not by giving him magical aid but by providing the extra measure of self-confidence that is necessary for successful hunting.[4]

Chapter 2 is devoted to a discussion of the functions of art in primitive societies, showing that in very many (if not all) cases art serves a variety of important uses in addition to the obvious aesthetic pleasure that it gives. It may be true that the functions of a particular piece of art may not be obvious to us or to its maker and that its functions are often far removed from mundane matters such as subsistence activities. Nevertheless, art inevitably "does" something. Limiting the definition of art to items or features that seem to be nonutilitarian is, I think, a move that would hamper, more than help, our understanding of art.

The Affective Response to Art. The creation or viewing of art objects can evoke a strong response in the mind of the artist or the viewer. A ceramic pot, for example, may be used for storing water, but its decorations and overall appearance make it very pleasing to the eye. A wooden mask is made for use in a religious ceremony, but its form and execution give it an impact of a special kind.

[4]Two additional examples of our relative naivete regarding the functional aspects of art are of interest:

1. The West African Yoruba, as will be discussed later in this chapter, strongly prefer statuettes whose smooth finishes give them a shiny luminosity. One might assume that this preference arises not from practical considerations but rather from purely aesthetic considerations. Native art critics feel otherwise, however: A Yoruba critic, when given several statuettes for evaluation, "praised one statuette and damned another on the score of luminosity: 'One image is not beautiful and can quickly spoil. Its maker did not smooth the wood. Another image was carved so smoothly that one hundred years from now it will still be shining—if they take proper care of it—while the unpleasing image will rot regardless' " (R. Thompson 1971:378).

2. Maquet (1971:8), to illustrate the distinction between instrumental and non-instrumental features, states that the rounded edge of a wooden bowl is instrumental because it makes cleaning easier, but that the perfect circularity of the rim is non-instrumental because it is difficult to achieve by use of only hand tools, and that the roundness serves no purpose. However, as Bunzel (1971:3) noted with regard to coiled pottery, a medium in which perfect roundness is at least as difficult to attain as in wooden bowls, roundness is highly desirable because it maximizes the strength and capacity of a vessel while minimizing its weight.

This affective response that art may elicit has served many western thinkers as the basis of a definition of art. Aristotle, for example, attached great importance to art's—and especially to drama's—ability to stir the emotions of those exposed to it; and modern philosophers and sociologists such as Cassirer, Dewey, Wittgenstein, Simmel, and Munro have discussed various aspects of the affective response to art. Although the working definition of art used in this book does not include a reference to the affective response to art, it is nonetheless an issue that should be given sympathetic consideration, both because of its popularity with other writers as well as its fundamental importance for the study of art. In the following paragraphs I will outline the position that is most commonly taken and then note the difficulties that follow from defining art chiefly in terms of the affective response that it may elicit. Later, in chapter 2, the issue will arise again when we consider "Art as Gratification."

The seminal papers by anthropologists that offer definitions based on the affective response to art are Warren L. d'Azevedo's "A Structural Approach to Esthetics: Toward a Definition of Art in Anthropology" (1958), and George Mills' "Art: An Introduction to Qualitative Anthropology" (1971 [orig. 1957]). The positions of d'Azevedo and Mills are similar enough that they may be considered together. Unlike most sociologists and philosophers, both d'Azevedo and Mills have done art-oriented ethnographic fieldwork (d'Azevedo with the Gola of Liberia and Mills with the Navajo), and both have published extensively on their respective researches.

In their definitions of art both d'Azevedo and Mills take special note of the way that art can bring about certain feelings in the creator or viewer. There is always, d'Azevedo points out, "a feature of enhancement and present enjoyment of experience" inherent in those things that have an aesthetic component (1958:707). When viewing or making a work of art one has a sense of "the especially meaningful, the new insight, the conscious unity of feeling, or the shock of recognition" (p. 708).

For Mills, art is "the creation, by manipulating a medium, of public objects or events that serve as deliberately organized sets of conditions for experience in the qualitative mode" (1971:95). The crucial phrase in Mills' definition is "qualitative mode." This, Mills says, "refers to the immediacy of art—its presence, impact, sensuousness" (p. 84). "The effect of a work of art," Mills suggests, "radiates outward in all directions; each suggestion arouses novel emotions, desires, and ideas, the mind moving as rapidly over these

as a train climbs its horizontal ladder" (p. 86). Finally, "Art is like the vision of Saul: there is a voice, a presence, an impact" (p. 82).

Both d'Azevedo and Mills elaborate on this fundamental aspect of their definition of art. Both note, for example, that the affective response that they describe occurs in artists themselves as they bring an art work into creation, and also in the mind of the viewer who is attuned to the work of art, with Mills noting that "the experience of the art lover is similar to that of the artist" (1971:81). Following Boas, d'Azevedo and Mills also point out that a similar (or identical) affective response is prompted by some things other than art itself—things from nature, such as a bird's song, or from one's own world of personal experience, such as a scene with which one associates particularly poignant memories. What sets the art experience apart from these other aesthetic experiences are the facts that art occurs in certain media, that it results from a special sort of ability or intent on the part of the maker, and (for Mills) that it is produced for a real or imagined public.

In their respective papers d'Azevedo and Mills make a number of additional valuable observations and important qualifications. All mentalistic definitions have a tendency to become totally transcendent abstractions, ideal forms that have no actual existence in the world of tangible things and human actions. The d'Azevedo-Mills definition of art comes, at times, perilously close to doing this, with d'Azevedo, for example, commenting that the object or event that inspires the aesthetic response is "no more the locus of art than edifices are the locus of architecture, or a formula the locus of mathematics" (1958:712). But d'Azevedo, at least, is at pains to keep the definition pinned down to actual people, actions, and things, going to some length to distinguish the artistic object, the artistic process, and the psychocultural contexts that connect one with the other.

D'Azevedo and Mills also note that although the affective response to art is its most characteristic trait, art often has additional important features, serving in various situations as a medium of communication, as a handmaiden to politics, religion, or economics, and so on. Finally, Mills notes that, as with any proposed definition of art, "we may be sure in advance that we shall encounter fuzzy edges, and that some activities may or may not be considered art depending upon the expansiveness of one's sympathy" (1971:78).

Should the Affective Response to Art be Considered Definitive? There can be no question that d'Azevedo and Mills, along with the other thinkers in the same tradition, are discussing an issue of

absolutely vital importance. The feeling that one can get when making, viewing, or otherwise experiencing a work of art may indeed be overwhelming, and an understanding of the aesthetic reaction surely is one of the most important goals of the systematic study of art, whether among ourselves or in other societies. But, for the moment, the question isn't whether or not the issue deserves serious consideration (it obviously does), but rather whether or not this particular trait should be included in our working definition of art. A few words about the functions of definitions will clarify matters considerably.

A definition may be intended to serve one of a number of purposes. First, it can be merely a sorting device, a basis for distinguishing one category of things (or events or ideas) from another category. This type of definition, which I have been referring to as a "working definition," is what we are now seeking for art: we simply want to find the most effective way to distinguish art from non-art. (Or, more realistically, we want to define a dimension such that art is at one extreme, non-art at the other, and arrayed appropriately between the two extremes are those things that are "sort-of-art" and "sort-of-not-art.") The test of a working definition is its effectiveness as measured by two criteria: (1) Can it be readily used in actual situations to sort Xs from Ys and (2) can it make no errors (or an acceptably small number of errors) in doing so?

A second type of definition, and one that should be kept conceptually distinct from a working definition, is what we might call an "essential definition," i.e., one that focuses on the essence or most important qualities of the thing being defined. In theory these two types of definition are not reciprocal in function: A satisfactory essential definition should have a high sorting capability whereas a working definition does not necessarily reflect the essential qualities of the entity being defined. Clearly, sorting abilities being equal, an essential definition is more desirable than a working definition.

With this distinction in mind we can return to the definition proposed by d'Azevedo and by Mills, as discussed in the preceding section. Their suggested definition, I feel, is an essential one, postulating that the *most fundamental* feature of art is the affective response it can create in the maker or viewer. If it is satisfactory, this definition would be more powerful than the working definition (based solely on skill), that I proposed earlier. But although the d'Azevedo-Mills definition is very appealing, there are, I feel, two compelling reasons for not adopting it—at least, not at the present time.

First, it seems imprudent to assert that we currently know just what the essence of art is. This is because the number of meth-

odologically sound accounts of art from other societies remains quite small, perhaps no more than a few hundred. And, to my knowledge, none of these has systematically gathered information on the affective response to art. When the corpus of reliable data has grown substantially the suggestion by d'Azevedo, Mills, and others, that a particular type of affective response always and everywhere characterizes art, may be shown to be true. On the other hand, as evidence accumulates, we may discover that in other societies the affective response to art is substantially different in nature or is virtually absent. Societies in which a high value is placed upon maintaining affective equilibrium and constant control of the psyche will be the acid test. They will reveal whether the aesthetic response that we ourselves often experience is universal or if, on the other hand, the vivid sensing of "a voice, a presence, an impact," to use Mills' phrase, occurs in some but not all societies. In any case, at the present time the issue should be left open as an area for much needed future research and study, but should not be used as the foundation of an essential definition of art.

Even if the d'Azevedo-Mills approach is currently unsupportable as an essential definition, what about tentatively adopting it as a working definition, one that fulfills our two needs of (1) being readily applicable in actual situations for distinguishing art from non-art, and (2) having no, or an acceptably low number of, errors? Unfortunately an affect-based definition falls short of meeting either of these requirements.

With respect to applicability, the difficulties are obvious: Individuals' subjective states are notoriously difficult to ascertain, especially if the states tend to be fleeting and personal in nature, as is the case with the affective response to art. There is seldom an adequate vocabulary available for inquiry into the subject. (Try, for example, to explicitly describe your own emotional reaction to a work of art that you yourself like, and the difficulties involved in a cross-cultural study of such feelings will be readily apparent. Even Mills resorts to the use of similies—qualitativeness is "like the vision of Saul," the mind moving as rapidly "as a train climbs its horizontal ladder.") In every society that lacks a subtly sensitive vocabulary for reference to transient subjective states of mind, and in every one in which the individual's inner state is not freely disclosed to another—in all of these places the anthropologist would face great, perhaps insurmountable, difficulties in determining the native distinction between art and non-art.

Further, as d'Azevedo and Mills confirm, the affective response to art is not by itself a sufficient criterion to distinguish art from non-art. It is, in fact, liable to errors both of mistaken inclusion and

exclusion: Even objects that are unquestionably art may leave some observers nonplussed; and elitism is inevitable in a definition that looks for an affective reaction *only* in the minds of "art lovers." Conversely, the epiphany of feelings that may be prompted by art can also be caused by things and situations other than art, such as the sating of a bodily appetite, exposure to a remarkable natural phenomenon, and so on.

This last difficulty can be remedied only by adding to the affect-based definition suggested by d'Azevedo and Mills the skill-based definition that I proposed earlier, arbitrarily excluding everything but the results of highly developed human skill in certain specified meia. Once this is done, the affect-based portion of the definition becomes only an encumbrance, causing more methodological difficulties than the analytic clarity it might provide.

We have, then, returned to the point from which we began. A definition of art based on the skill of the maker is the most serviceable one we can use. The affective response that art production or appreciation can generate is a topic of crucial importance to the understanding of art in general. As noted, this issue will be dealt with later in chapter 2. But for purposes of definition, art, as the term is used in this book, is not assumed necessarily and inevitably to create a particular type of affective response in the maker or viewer—at least, nothing beyond the admiration that may be prompted by consummate skill on the part of the artist.

Good Art versus Bad: A Yoruba Example. As previously noted, the question, "What is art?" often really means "What is good art as opposed to not-so-good art?" This question is unavoidable in certain situations. For example, many museums own more artifacts from primitive societies than their available space permits them to display. Decisions must therefore be made as to which of the items are "better" than others and thus are to be displayed in preference to the inferior items that will remain in storage.

Although practical considerations such as these may force one to make his or her own value judgments, the careful and sympathetic study of art from primitive societies is often hindered by such an approach. The reason for this is that to understand the art of a given society it must be taken on its own terms—or, more exactly, on the terms of the people who produced it. Studies of the aesthetic systems of primitive societies, although they are relatively few in number, convincingly show that *their* terms are often dissimilar to *our* terms. The aesthetic values of the Yoruba of West Africa illustrate this point.

About six million Yoruba individuals live in West Africa, mostly in Nigeria, but also in Dahomey and Togo.[5] Organized into over 50 kingdoms, they share a common language, dress, and (to a certain extent) culture. By comparison to the other societies of the world, the Yoruba have a relatively complex technology in that subsistence is derived from hoe-cultivated agriculture; weaving and iron working are also practiced. Their populations are highly nucleated (towns with 20,000 to 50,000 people probably existed before major European contact), and their economic and political systems are highly specialized. Thus on a continuum between primitive and nonprimitive, Yoruba society is clearly far from the primitive extreme. (For more ethnographic information on traditional Yoruba society see Bascom 1969; Forde 1951; and Lloyd 1966.)

Yoruba art deserves consideration here because of the unique thoroughness with which Robert Farris Thompson has studied Yoruba aesthetic values (1971, 1973). Thompson collected information by visiting a number of Yoruba villages, taking with him various pieces of Yoruba sculpture that he owned. In each village he began by collecting background information about local carvers, the age of individual carvings, and so on. Thompson describes the rest of his technique:

> This art historical research served as a kind of lure. Potential [art] critics moved in the curious crowds of bystanders which always formed around the writer, his wife, and assistant. The crowd was then asked, while pieces of sculpture brought out for study were still in the sunlight, was someone willing to rank the carvings for a minimal fee and explain why he liked one piece over another? Owners sometimes immediately made clear that they did not want to participate—"put it to another person," a twin image owner protested once. Almost without fail someone would step forward and immediately begin to criticize the sculpture. The rare delays did not stem from lack of verbal skill. Rather some informants were simply afraid that their efforts would not really be compensated. Others wished to study the works with care in the light, turning them around and testing their profile and mass (1973:26).

In all, 88 native Yoruba art critics gave Thompson their opinions— ranking items and, more importantly, telling him the basis for their preferences.

[5]Unless otherwise indicated, cross-cultural examples are described in the "ethnographic present," i.e., *as if* they continue to exist today unchanged from their state as described by an anthropologist at some time in the past. Also, I have used those ethnographic examples that I feel to be the best documented and most relevant to the issue in question. Additional examples are cited in the "Guide to Additional Reading" sections appearing at the end of each chapter.

From this mass of data, Thompson isolated over a dozen generalized aesthetic principles that are commonly used by Yoruba individuals in judging a given piece of sculpture. (Figure 1-1 shows a sculpture that Yoruba critics feel to be a successful realization of these aesthetic principles.) Some of these have parallels in our own aesthetic value system. For example, for a statuette to be considered beautiful by Yoruba standards it must possess *ifarahòn,* which Thompson translates as "visibility" and which requires that the major masses of the work be clearly visible and that all decorations (incised knifework, etc.) be clearly seen.

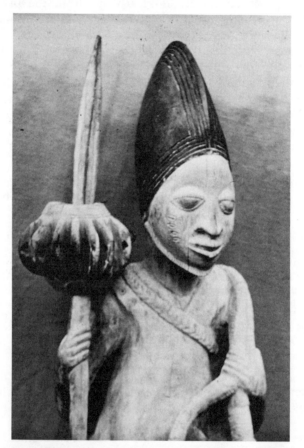

Figure 1-1 Yoruba wood carving, *The Image of the Thundergod as Crowned Lord of the Yoruba.* Made before 1837, 36 inches high. *Nigerian Museum, Lagos. (Photo courtesy Robert Farris Thompson.)*

Other Yoruba aesthetic values are alien to us. Thompson claims that perhaps the single most important Yoruba criterion of aesthetic

excellence is ephebism, or the depiction of people in their prime. When one informant was asked why he preferred one statue over three others, he answered with his own question:

> "Between a beautiful young woman and an old woman which would you prefer for a wife?" The expected reply was given. The informant was amused for he had led his interrogator into corroborating his argument. "I like one image best," he then stated, "because it is carved as a young girl while the other three are like old women" (1973:57).

The acuity of Yoruba critics for judging ephebism is considerable. One female image was rejected because it had "breasts which sagged, with the right breast longer than the left, a not infrequent phenomenon among Yoruba mothers whose children have favored one nipple over the other while nursing. . . . The most elegant [female statuettes] possessed breasts of the same length and consequently resembled a young woman" (R. Thompson 1973:57).

What conclusions can be drawn from this brief survey of Yoruba aesthetic values? First, it is clearly apparent that the Yoruba have a highly developed set of ideas about art: There are clear-cut native standards for judging art; these standards are widely shared among art cognoscenti among the Yoruba; and Yoruba art criticism is articulated by means of a specialized vocabulary. The notion that only westerners are aesthetically sensitive is clearly a product of our own ethnocentrism.[6]

The second conclusion to be drawn from Thompson's study is that the Yoruba system of aesthetics is markedly different from our own, both in specifics (e.g., they abhor carved figures with open mouths because a fly, one of the traditional messengers of evil, might enter) and in some general principles: Luminosity, symmetry, and roundness *may* be praiseworthy attributes in western art, but their absence from a particular work would not necessarily decrease its merit.

The situation is parallel to a tale told by the Bété (also of West Africa), the "Story of the Chimpanzee and the Antelope":

> In a village party, two of the men's captives lament on their misfortunes, then get into an argument. The antelope, a male, sighs at the thought of his mistresses back in the forest crying in his absence. Then, in his turn, the chimpanzee, nostalgic, longs for his own sweethearts, and what sweethearts they are!

[6]Westerners are not the only ones whose views reflect such an ethnocentric bias. Thomson notes that one difficulty in obtaining information on aesthetic values from some traditional Yoruba individuals is that they "seem to assume a White man's ability to perceive aesthetic import in art as weak or underdeveloped" (1973:30)!

"What?" says the antelope, "you mean you have lovers who adore you enough to miss you?"

"And why not?" asks the chimpanzee, puzzled.

"Why, your reputation of . . ."

"Of ugliness?" hints the chimpanzee.

"Yes. Ugliness is so proverbial in the memory of animals that your story sounds like a joke or a lie," the antelope concludes.

"Yes, I understand," says the chimpanzee. "But remember simply that there is no absolute ugliness of chimpanzees except in the village and in the minds of antelopes and other animals" (Memel-Fotê 1968:49).

We can learn a lesson from the proverbial chimpanzee of the Bété story: If the goal is to try to make sense of art from primitive societies, we will gain more understanding by keeping our own inevitable aesthetic judgments to a minimum and by trying, insofar as possible, to take art from other societies on its own terms.

Conclusion

Discussions of definitions of fundamental terms can be very frustrating; and when the discussions are only disguised arguments about the *ultimate* meaning of a word, they are little more than ends in themselves. If, however, polemic can be avoided, a discussion of definitions can provide two benefits: It can serve as a basis for meaningful communication between people by providing an agreed-upon set of meanings for terms, and it points to possible problem areas that we should be careful about during the course of our discussion. I hope that the preceding account of "primitive" and "art" has provided these two benefits.

Primitive, it was noted, can be a dangerous term, carrying along with it such undesirable connotations as crude and backward. But in the absence of an alternative that is both accurate and un-tainted by equally derogatory connotations, the decision was made to use primitive in this book, but with a strictly circumscribed meaning—namely to refer to societies that, by comparison to others, are based on simple technologies, have small, sparse populations, and are relatively homogeneous as regards economic, political, and social differentiation. Real societies are scattered along a continuum ranging from primitive to nonprimitive, but to call some societies primitive does not mean that they, their members, or their art are any less valuable or legitimate than their counterparts in nonprimitive societies.

The definition of art presents an even stickier problem. The first job is to distinguish between art as a set of one's own personal preferences versus art as a label that anthropologists and art historians have traditionally used for reference to certain types of artifacts. We all make our own private aesthetic judgments based on personal preferences, but little progress can come from arguing over differences in tastes. This is particularly true cross-culturally, where one society's tastes may be distinctly different from another's.

Instead of a definition based on a specific set of aesthetic value judgments concerning art objects, this book will use one that focuses on the activity involved in making the objects. Specifically, those things will be considered to be art whose creation requires an extraordinary amount of skill on the part of the maker. Only tangible, human-made objects will be considered; things made by nonhuman animals and the results of such human skill as music and dance will both be arbitrarily excluded. The aesthetic components of art objects may not be closely linked to subsistence activities, but they are seldom completely without function in the society that produces them. Also, although they often evoke a distinctive psychological response in the viewer, too little is known about this response and its cross-cultural variations to incorporate it into the definition of art.

Many people will find these solutions to the problems of defining primitive and art unsatisfying. The definition of art proposed above hardly provides a litmus paper test for distinguishing art from non-art. (Of course, in reality there *are* lots of borderline cases.) Likewise, my solution to the problems of defining primitive leaves much to be desired. Undoubtedly some readers will continue to attach meanings to it that I have explicitly disavowed.

But for all their faults, the definitions given in this chapter are serviceable; and, for the present, that's all that is needed. To sweep persistent definitional problems under the carpet is seldom productive, if for no other reason than that such an approach creates a false and dangerous impression of the perfection and finality of our current state of knowledge.

GUIDE TO ADDITIONAL READINGS

General Reference Works. Those interested in locating more detailed ethnographic or art-related information on a particular society can profitably begin by consulting the Human Relations Area Files (HRAF), available on microfiche in many academic libraries. Also, the fifteen volumes of the *Encyclopedia of World Art* contain many

articles by specialists describing the art of numerous nonwestern societies. Finally, Ehresmann (1975) lists bibliographies of published literature on art in most of the world's culture areas.

Definitions of "Primitive" and "Art." The philosopher W. T. Jones has written a very insightful article (1974) discussing the ways in which anthropologists tacitly define the field of "primitive art." Gerbrands (1957:9-23) gives an extended discussion of the difficulties involved in using the term "primitive," while Diamond (1974) has made a strong defense of continued use of the same term. Any good general work on aesthetics, such as the one edited by Osborne (1972), may serve as a starting point for one wishing to survey the range of western philosophers' speculations on the ultimate nature of art.

The Nonvisual Arts. By comparison to the visual arts the performing arts have received considerably less study. The field of ethnomusicology has been surveyed by Nettl (1956), Merriam (1964), and N. McLeod (1974), while a variety of case studies have been collected in McAllester (1971). Also, some of the contributions to *The Traditional Artist in African Societies,* edited by d'Azevedo (1973a), deal with music in its cultural context.

Dance has received less attention still, although the Committee on Research in Dance (CORD) has begun an active program of supporting and publishing cross-cultural studies (e.g., Kaeppler et al. 1977). Older treatments of dance are Sachs (1937) and Kurath (1960); these have recently been augmented by a general survey of the anthropology of dance by Royce (1977).

The dividing line between drama and ritual is illusive. Ottenberg's Afikpo work (1975) is relevant while Gregory Bateson's *Naven* (1958 [orig. 1936]) is a classic effort at discerning a society's—in this case, the New Guinea Iatmul's—fundamental features by studying one of its public ceremonies.

Ethnoesthetics. Systematic studies of nonwestern aesthetic systems are very few in number: Thompson's Yoruba work (1971, 1973) is unique for its completeness. The aesthetic values of the East African Pakot have been described by H. Schneider (1956); Warren and Andrews (1977) discuss in some detail the bases of aesthetic criticism among the West African Akan. Many works on the art of individual societies discuss, as an aside, traditional standards of aesthetic judgment. Bunzel's *Pueblo Potter* (1971) is an example of such a work.

Chapter 2

The Functions of Art in Primitive Societies

To understand something is often a matter of grasping just what that something does. If you understand your car's carburetor, then you have (among other things) some knowledge of the job it performs in your car—that is, you comprehend its mechanical function. If you thoroughly understand Banquo's ghost in *Macbeth*, then you are aware (among other things) of the role's contribution to making the play work—you grasp its dramatic function. Certainly functional knowledge by itself is incomplete: If you understand your car's carburetor, in addition to knowing its function you also know what it looks like and where it is located; and undoubtedly the chill that goes down your spine when Banquo's ghost appears on stage is a far different thing from the dispassionate analysis of the ghost's role in the plot of *Macbeth*.

But even though functionalist knowledge is not everything,

social scientists have long recognized its great value. Functionalism emerged as a useful analytic approach to society and culture early in the twentieth century. Before that time scholars had been chiefly concerned with descriptive historical studies: Two major topics of interest were (1) the reconstruction of the evolution of sociocultural systems, from their earliest into their present forms, and (2) the investigation of past diffusion of cultural traits from one region to another.

These efforts, intrinsically interesting though they are, were impeded by two difficulties. First, little sound ethnographic data existed: Explorers' tales of the exotic places they visited, and missionaries' letters telling of the "savages" they were trying to convert, made perhaps for intriguing reading, but they were not always accurate in detail. Boas, Malinowski, and other early twentieth-century anthropologists set out to remedy this problem, demonstrating by example the great fruitfulness of rigorous, in-depth fieldwork. (Boas' enormously influential *Primitive Art,* first published in 1927 but extant in the form of lecture notes from 1903, was a major turning point away from speculative evolutionary studies and toward fieldwork-based ethnological description and analysis of art in primitive societies.)

The second difficulty encountered by nineteenth-century writers was theoretical in nature. They generally had assumed that technologically simple contemporary societies, such as the native groups of Australia, accurately reflected in all respects the way in which all societies existed in the distant past. Such may be the case with regard to technology, but it cannot safely be *assumed* to apply to other aspects of life such as religion and kinship systems. Instead, such an evolutionary pattern must itself be proven to exist—not an easy task in that such things as religion and kinship patterns of prehistoric societies leave little tangible evidence for archeologists to recover and interpret.

The Functionalist Approach

Functionalism, as developed chiefly by the French sociologist Emile Durkheim, provided a way out of this theoretical *cul de sac.* Instead of using ethnographic data as a basis for historical conjecture, functionalism attempts to explain the beliefs, institutions, and practices of individual societies by searching for the contribution they make toward the maintenance of human life and the cultural stability of the society in which they occur. When confronted with

customs that initially seem strange and inexplicable, if one attempts to discover their function, the customs begin to make sense to us. Often that which had seemed purposeless, or even counterproductive, becomes thoroughly reasonable, perhaps ingenious.

The functionalism of Durkheim and his French colleagues was brought into the anthropological theory of the English-speaking world by Bronislaw Malinowski and A. R. Radcliffe-Brown. For his part Malinowski emphasized the individual and psychological functions of culture; when we discuss "Art as Gratification" in the following pages, we will be walking in Malinowski's shadow.

The brand of functionalism that evolved from Radcliffe-Brown's writings has been even more fruitful with regard to art. Radcliffe-Brown, like Durkheim himself, conceived social systems to be composed of more than just the individuals who make them up: They may be thought of as being organic entities, with existences and needs of their own. The social patterns that exist in a given society can be conceptualized as effective ways of meeting these needs. Thus, Radcliffe-Brown emphatically states, "The function of any recurrent activity is the part it plays in the social life as a whole and therefore the contribution it makes to the maintenance of the social continuity" (1935:396). (Durkheim himself had been equally emphatic when he wrote, *"The function of a social fact must always be sought in the relationship the fact sustains with some social end"* [1938, emphasis in original].)

Much of the present chapter will view art and society in the organic perspective developed by Durkheim, Radcliffe-Brown, and others. This approach is very fruitful; however, three qualifications should be made explicit:

First, there is seldom a neat, one-to-one correspondence between practice and function. A particular phenomenon in a particular society may fulfill numerous psychological, social, or cultural needs. Moreover, the same practice may serve quite different purposes in another society. As the examples in this chapter show, art is just such a multifunctional phenomenon.

Second, although in some cases the functions of art will be fairly obvious, in other instances art will serve more covert functions, ones that might not be immediately apparent to the reader or to the artists themselves.

This leads to the third point: Sometimes it will be difficult, if not impossible, to conclusively prove that art serves a particular function. All scientists generate theories to help them account for the things they find in the world around them, but unlike the physical scientists with their controlled experiments, social scientists usually

can only support their theories with whatever cross-cultural data has been collected—that plus a strong dose of good judgment.

One might argue that for an aesthetic appreciation of a work of art it is irrelevant to know its function within the society it came from, just as knowledge of meteorology is unnecessary for the enjoyment of a beautiful sunset. Such information, so the argument could go, adds nothing to the viewer's experience and may even be an undesirable distraction.

Such an argument cannot be refuted on logical grounds. If an individual's only goal is the immediate, sensuous response to a physical stimulus, then *any* reasoned discussion about the stimulus is pointless. But as the aphorism of the 1960s had it, there are "different strokes for different folks," and undoubtedly there are many people (I am one myself) who not only enjoy an immediate, sensuous response to an object but who derive additional pleasure from having extra background information about it. For people in this category, some of the most useful information about art in primitive societies will be derived from an examination of art's functions in these societies.

Art as Gratification

If you, as a native of western culture, were asked, "Why does your society produce art; what purpose does art fulfill?" your first reply would probably refer to the individual psychological gratification that is often connected with the creation of, or exposure to, works of art. The affective response to art is a subject that arose in chapter 1 with respect to the definition of art. The conclusion then was that this particular feature of art should not, for numerous reasons, be used as the basis of our working definition of art. It is, however, an issue of vital importance for the cross-cultural study of art—if for no other reason than that the affective response is more intrinsically related to the work itself than any of the other functions that art fulfills (d'Azevedo, personal communication).

The affective response to art—or, in fact, to any thing or event that has an aesthetic component—is manifest in a number of forms. "Delight" is perhaps the best word to describe the feeling of positive enjoyment that works of art prompt in westerners. Alternately, making or viewing art can bring feelings of agitation or tranquility; our response can be intellective or visceral; the reaction can be immediate and fleeting or it may slowly develop into prolonged appreciation.

The Difficulties of Studying "Art for Art's Sake." There has been little systematic, empirical study of the affective response to art. Two reasons for this are apparent: First, as the remainder of this chapter shows, art typically fulfills several social and cultural functions in primitive societies. Therefore it is not necessary to justify art's existence by simply saying, "They produce art because it gives them pleasure." An analogy with subsistence activities makes the argument more clear. In a hunting and gathering society, the adult men who do the hunting may claim that they enjoy hunting. But only the most naive outsider would believe that the enjoyment derived from hunting is its sole, or even its primary, reason for existence. Obviously the nutritional value of the food collected by the hunters is important enough to justify the hunting, whether the hunters claim to enjoy the acivity or not.

A second factor involves the meaning of "pleasure." We westerners often distinguish between two different motives for doing something: We do it because we want to, or we do it because we have to. But in traditional societies, where culture change usually occurs much less rapidly than it now does in our society, people do not always make this distinction. One may do something—hunt, get married, or produce art—simply because that s what one does, and one typically derives satisfaction from doing that which is traditionally considered right and appropriate. From the native viewpoint, the activity is proper; it follows the age-old precedent for behavior in the culture, and the culture probably provides guidelines for the way in which the activity should be performed.

These two factors, the typical multifunctionality of art and the difficulty of ascertaining the extent to which nonwestern art production is motivated by the desire for aesthetic pleasure, coupled with the relatively sketchy nature of our own understanding of the aesthetic response, lead to a single conclusion: Any claim that nonwesterners produce art *solely* for their own aesthetic enjoyment should be viewed with extreme caution. Too often such a claim derives not from first-hand ethnographic fieldwork but rather from the preconceptions of people who like to think of members of primitive societies as simple-minded children of nature.

The Basis of the Affective Response to Art. What is it about an art work that prompts an affective reaction in individuals? David B. Stout has tentatively suggested that artists in any society may use four major methods to produce emotion and evoke aesthetic responses. They may:

(1) employ symbols that have established emotional association; (2) depict emotion-arousing events, persons, or supernatural entities; (3)

enlist the spectator's vicarious participation in the artist's solution of his problems of design and technical execution; (4) employ particular combinations of line, mass, color, etc., that seem capable of arousing emotions in themselves. Usually, these procedures are employed in some combination (1971:32).

Given the skill-based definition of art we are employing, Stout's third factor seems particularly important. The satisfaction that comes from mastery of technique, and the awe that such mastery inspires in people who are aware of the technical difficulties the artist has overcome—these are coextensive with art itself.

Stout's theory sheds some interesting light on the cross-cultural appreciation of art, that is, the extent to which members of one society can genuinely feel an aesthetic response to art from another cultural tradition. The first three factors Stout mentions are all clearly culture-specific. For example, an oil painting of George Washington crossing an icy Delaware River would stir little enthusiasm in a native of the Kalihari Desert who knows nothing of either Washington, dangerous river crossings (and their symbolic parallel to Washington's military venture), or the particular challenges of the oil medium—unless, of course, the desert dweller shares our own delight in the foreign and exotic. Thus, only Stout's fourth factor—the use of line, mass, color, etc.—has the potential for being universal in effect, providing a possible basis for cross-cultural art appreciation. (Chapter 7 discusses at greater length the question of the possible universality of formal artistic qualities.)

Virtually all of the writing by anthropologists, sociologists, and philosophers on the affective response to art has derived from introspection, with writers on aesthetics basing their theories on their own response to art objects—that, plus an admixture of commonly-held western assumptions about the way one "should," in an ideal world, react to the making or viewing of a work of art. Useful hypotheses can, of course, emerge from such an approach, but until they are empirically tested, they remain in the domain of folk belief rather than science.

A few psychologists—notably Berlyn (1971) and Nunnally and his associates (Faw and Nunnally 1967; Nunnally, Faw, and Bashford 1969; Nunnally 1977)—have attempted to experimentally study the relationship between the affective response to art and such variables as the pleasantness of, or incongruity in, a given two-dimensional figure. To date such studies have been largely limited to western individuals and subject matter, and the results have been at best only suggestive. For example, Nunnally (1977) reports that there appears to be no orderly relationship between the visual pleasant-

ness of a figure's appearance and the amount of attention given the figure by individuals viewing it under controlled conditions. These shortcomings aside, the techniques of the behavioral psychologists do provide an empirical antidote to a field that tends toward unbridled speculation.

In Praise of Folly. The question asked in the present chapter is, "What does art do?" The answer being pursued in this section is, "Art is a source of gratification for the maker and the beholder." But this reply prompts us to ask a second question: "If the history of the human race is an epic of self-preservation under adverse circumstances, of securing enough food to sustain our (and our children's) bodies, and of defending an area of land to live in, then how is it that all societies have been able to afford this luxury that is art?" The following sections of this chapter discuss a number of practical benefits that art provides in various societies—its value as an adjunct to economics, its contribution to maintenance of social equilibrium, and so on. But what about the sheer enjoyment that art can provide? *Is* art simply a luxury, or is there more to the story than that?

Certainly the enjoyment derived from art *does* fill a need shared by all peoples. As a source of gratification, largely free from the demands of the workaday world, the aesthetic element of art provides a welcome respite from practical concerns. As such, it makes a contribution to mental well-being that cannot be underestimated. The maxim, "A happy person is a healthy person," has been repeatedly confirmed by medical science, and as the growing field of art therapy indicates, an active involvement with art lessens the anxieties that are annoying at least and debilitating at worst.

There is another way in which art (*as* art, rather than as handmaiden to other cultural phenomena) justifies its own existence: It provides a psychic and ecological cushion between the situation of life as it usually is and the unexpected situation that might occur in the future. In an ecological perspective every population usually has not only the ability to exist under normal circumstances, but also the latent ability to withstand the severe transient conditions that *might* occur in the environment. If a society were barely capable of coping with normal conditions, it probably could not survive the rare situation that is abnormally demanding and that is as unpredictable as it is inevitable—the climatic disaster such as drought, flood, or typhoon; the change in the larger ecosystem such as an unexpected alteration in plant or animal populations; or the shift in the human environment beyond the society's boundaries, resulting, perhaps, in

unprecedented warfare. It may be fruitful to think of the energies and pleasures that pass through aesthetic channels during nonstress times as providing a wellspring that may be tapped in times of stress. Speaking (in a different context) of traditional African sculpture, Roy Sieber has remarked that the governing aesthetic concept is not "art for art's sake," but rather "art for life's sake" (1962:8). The same may be literally true of art in *all* media and on all continents.

Warren L. d'Azevedo has rightly remarked that "one of the problems in the study of the arts of other cultures is that anthropologists have consistently directed their interests to the 'other functions' of art, rather than to the central issue of aesthetic, symbolic and affective aspects of artistic activity" (personal communication). In addition to the fundamental issue of studying the nature of the affective response itself, there are numerous questions that should be dealt with: interpersonal variation in the aesthetic response; differences among artists, and between artists and nonartists; cross-cultural differences; and the contribution to the affective response made by the various factors involved—skillful use of the media, formal aspects of the art work, and suggestive use of subject matter, whether symbolic or representational.

Although inquiry into questions such as these is certainly necessary, it is equally certain that the entire area will be extremely difficult to deal with without indulging in either unfounded speculation or carrying out empirical studies that are so removed from actual experience as to be devoid of relevance. Nonetheless a start must be made; we have little to lose but our ignorance.

Art and the Economic Realm

Economics, in the broadest sense of the word, is the study of those goods and services that are deemed valuable in a particular society, and of the exchanges between people of those goods and services. Since art is inevitably the result of personal skill, and since such skills are necessarily limited in supply and valued by many people, art often has an economic aspect, despite the fact that we ourselves sometimes think of art and economics as being in complete contrast with each other. If it seems philistine to place beautiful art objects in the workaday arena of economics, a thorough consideration of the functions of art in primitive societies requires that this be done, at least for the moment.

Trade and Social Relations. When goods or services are exchanged between people, often more happens than meets the eye.

The obvious transfer of tangible goods has certainly taken place, with individual A giving something to individual B, while B either gives something in return or promises to reciprocate at some later date. But in addition to this overt, material exchange there is also typically a *social* exchange, with A and B passing the time of day with each other, exchanging bits of local gossip, discussing past and future trades between themselves and others, and so on. Such conviviality between trading partners, far from being an unnecessary luxury, is often quite valuable in itself in that it furthers mutual trust between the traders, an important prerequisite for future trading between the two, and it may be the basis for other sorts of alliances. Trading partners, for example, may support each other during wars, or they may acquire spouses from each other's group.

In addition to these practical benefits of the trading situation, there may be important intangible benefits as well. The exchange of items between trading partners may serve as the basis of positive emotional ties between the individuals involved. If the society is small in scale and relatively homogeneous culturally, then the "good faith" necessary for the trading situation reaffirms ties of affiliation that already exist. In a larger, more diverse society, trade legitimizes affective bonds between diverse sectors of the population. In any event, exchange both requires and is the basis of feelings of good will and mutuality, conditions that would seem to be functional prerequisities for any viable society. This conception of exchange comes directly from the Durkheimian tradition, being developed most extensively in *The Gift* (1967 [orig. 1925]), by Marcel Mauss, Durkheim's nephew and most influential successor.

These fringe benefits of the trading relationship may be valuable enough in themselves to justify such a relationship even when there are no goods of practical value to be exchanged between the partners. In such a situation an arbitrary value may be attached to some otherwise nonutilitarian objects, and these may be used as a basis for the trading partnership.[1] At this point, art may enter the picture, since art works are typically arbitrarily valued objects whose material contribution to subsistence is covert at best. An ethnographic example will serve to illustrate how such a mechanism can work.

Tsembaga Ornamentation and Trade. The Tsembaga, a Maring-speaking group numbering only about 200 people, live on the south wall of the Simbai Valley in the east-central New Guinea highlands

[1] Malinowski's classic description (1922) of the Kula exchange in the Trobriand Islands, and the vast literature of economic anthropology that has grown up around his account, provide numerous examples of such trading.

(Rappaport 1968). As slash-and-burn horticulturalists, they must have stone axes to clear land for garden plots in the dense secondary forest. Unfortunately for the Tsembaga, however, varieties of stone suitable for making ax heads occur only in a few scattered localities in the highlands, and the Tsembaga are separated by several other tribes' territories from the stone quarries closest to them. Thus axes come into the hands of the Tsembaga only after having been traded from one man to another through several different groups. For-, tunately, the Tsembaga produce salt, a vital commodity that the ax-producing groups can obtain only through trade.

One might expect that the trading arrangements would be relatively straightforward, with the two kinds of goods that are necessary for subsistence, axes and salt, being traded back and forth between their respective producers. But in fact, there are serious drawbacks to such a system, as has been noted by Roy Rappaport, who studied Tsembaga subsistence and ritual in considerable detail:

> It may be questioned whether a direct exchange apparatus that moves only two or three items critical to subsistence would be viable. If native salt and working axes were the only items moving along a trade route, or were the only items freely exchangeable for each other, sufficient supplies of both might be jeopardized merely by inequalities in production. . . . If all that the Simbai people [including the Tsembaga] could obtain for their salt were working axes they would be likely to suspend the manufacture of salt if they had a large supply of axes on hand, regardless of the state of the salt supply in the Jimi Valley. The converse might be the case if the ax manufacturers had large stockpiles of salt (1968:106).

Since salt producers are typically separated from stone ax producers by at least two intervening peoples, and in the absence of any supratribal authority, no direct pressures can be brought to relieve possible inequities in the system: If "a man must put pressure on a trading partner to put pressure on a second, who will in turn put it on a third, who will attempt to get an ax from the manufacturer, success is less likely" (Rappaport 1968:107).

How do the Tsembaga and their neighbors overcome this problem? Their solution is to trade, in addition to the utilitarian goods of salt and working axes, several kinds of nonutilitarian items, including bird of paradise plumes, fur headbands, and shell ornaments. All of these things are used by Tsembaga men for decorating their bodies and their shields, thus providing the principal means of aesthetic expression. For all these items there is a constant, unlimited demand by all groups. Therefore the producers of salt and working axes always have an incentive to produce these utilitarian

goods and, by trading them for the primarily art-related goods, they provide their entire region with a steady supply of salt and axes.

In essence, then, Rappaport's argument goes thus: For a group to survive in the New Guinea highlands it must obtain stone axes and salt. However, given the scattered distribution of the sources of these goods and the lack of communication between nonneighboring groups, a trading system based only on the exchange of these two items alone is probably not feasible. In practice, however, there is also an exchange of bird of paradise plumes and the like—items that are valued for aesthetic rather than subsistence reasons and for which there is an unlimited demand. Trade in these items insures the steady production and even distribution of the necessities of salt and stone axes.[2]

The Tsembaga case illustrates the unexpected ways in which the fields of art and economics can overlap. This example is typical in that the relationship between art and economics is neither simple nor obvious. Indeed, from the Tsembaga point of view, they trade their salt for art-related items, not in order to make the trading system operate smoothly, but rather because "they consider fine plumes and shells, gold-lip or green sea snail, to be among the most beautiful of objects and men enjoy possessing them for their own sakes" (Rappaport 1968:106). Also the decorations make a man more attractive to women when he dances; and the shells can be used, along with other items, in payments to the bride's family after marriage.

Probably there are few traditional situations in which art is manufactured or valued solely for economic reasons. (In the Tsembaga case, body decoration serves to communicate social standing, marital status, etc., and, presumably, it brings a greater measure of enjoyment into the lives of the wearers and those who see them.) However, the economic functions of art, if they are sought out, often shed valuable light on the cultural context of art in primitive societies. And undoubtedly the subject's importance will increase in proportion to the exposure of traditional societies to international cash economies. There is a growing market in the west for art from the Third and Fourth Worlds, and there is no lack of entrepreneurs who are eager to promote such sales. Thus, the relations between economics and art from primitive societies are becoming more overtly important.

[2]Michael Harner's account of the Jívaro of eastern Equador provides another instance in which the trade of art-related items facilitates trade in goods that are directly necessary for survival (cf. Harner 1972:129).

Art and Cultural Homeostasis

Primitive societies, as a rule, change much more slowly than western societies have during the last two centuries. Primitive societies are not actually "changeless," as some of the more romantic writers on the subject have implied; it is nevertheless the case that in most primitive societies the amount of change that occurs during an individual's lifetime is relatively small. Further, those changes that do occur, such as shifts in the locations of hunting territories or the succession of one political leader by another, are usually superficial. The *structural* aspects of the society—e.g., the very fact that the group has a hunting territory or that it has a particular sort of political system—seem to change only slowly.

With the passage of time all systems, social or otherwise, tend toward chaos unless there is an input of energy directed toward maintaining the system. How is it then that societies generally remain structurally stable for long periods of time? What is it that allows societies, especially those which have no written laws or constitutions, to remain so conservative?

The functionalism of Durkheim, Radcliffe-Brown, Talcott Parsons, and others offers an answer to these questions. These writers suggest that social solidarity is maintained chiefly in two ways. First, social life inevitably entails a modicum of uniformity of belief and action within the population: Through various institutionalized means, individuals in a particular society come to accept, to a greater or lesser degree, the goals, value systems, and styles of living that are in harmony with those of others in the society. Second, insofar as differences do exist in a particular society, they tend to be complementary in nature: Specialization and independence creates sectors of the population that are dependent upon each other's continued existence. (Inasmuch as change does indeed occur and as revolutions sometimes drastically alter individual societies, the effectiveness of these two centripetal forces is clearly limited.) These solidarity-maintaining forces operate through the established social institutions and cultural patterns of a society—its educational, political, and economic systems, its language, religion, and laws, and (as the following sections illustrate) through its art.

The notion that art may help maintain the status quo is a conclusion that goes contrary to many of our own preconceptions about art. For most of us in the twentieth-century western world, artists are first and foremost innovators—bohemians and visionaries who would rather ignore or renovate their social milieu than produce

works that support the *status quo*. But such a characterization of our own art community may be in error; and, more importantly, ours is only one of the thousands of societies that inhabit the earth.[3] Because *our* art often seems anti-establishmentarian we cannot safely assume that art is thus everywhere. The following examples illustrate several ways in which art can aid the stability of societies. They are case studies in the cultural homeostatic functions of art.

Art and Social Control. George W. Harley lived in northeast Liberia for 23 years working as a missionary, primarily with the Mano and Gio tribes. During that period he acquired a large collection of ceremonial masks and accumulated a wealth of ethnographic information concerning their use, which he recorded in *Masks as Agents of Social Control in Northeast Liberia* (1950). As the title suggests, Harley's thesis was that among the Mano and Gio, besides whatever "higher" needs their art might satisfy, it was also a major aid to the maintenance of law and order.

During Harley's stay, political authority in these tribes was vested principally in a group of chiefs and a council of elders. The authority of these individuals was public and known to all in matters of everyday management of towns and the enforcement of common laws. However their control over more important matters, such as the handling of crises and emergencies of life, depended upon their being leading members of the Poro (1950:viii). This was a secret fraternity that all young men joined when they came of age. Poro leadership was in the hands of a hierarchy of individuals: the more important the issue, the smaller and more secretive was the circle of chiefs and elders who held ultimate authority:

> Chiefs had the custom of calling in the elders to help decide matters of complicated or obscure nature. They might sit in the town council and express their opinions openly and informally, but as a matter increased in importance, the meetings of the elders became more and more secret until they reached the final high council. This met at night in a secret part of the sacred Bush, presided over by a high priest with a simple but highly effective ritual (p.viii).

Within the Poro there was a small, elite group, the *Ki La mi*, for which "there was a stiff initiation fee, and a limitation of member-

[3]It is possible, of course, that art in the contemporary western world *does* aid cultural homeostasis, but that we are as oblivious to this function of our art as the Tsembaga are of the economic functions that Rappaport has attributed to their art. Tom Wolfe's controversial *The Painted Word* (1975) discusses some of the possible establishmentarian functions of art in the United States.

ship to individuals of outstanding intelligence or high hereditary standing" (p. viii). Within the *Ki La mi*,

> there was a still higher group called *Ki Gbuo La mi,* against whom personal insults or violence was considered no less than treason. When one of these men died it sometimes happened that his death was not only kept secret but was, in fact, minimized by making a death mask before his burial. This was carved in wood, as a rude portrait or characterization, and in it his spirit was supposed to find an abode at least reminiscent of its former fleshly habitation (p. ix).

Thus the death masks came to be worshiped in and of themselves, representing as they did individuals who were of the very highest importance during their lives and who, after their deaths, were believed to be free spirits capable of interceding between earthly men and the town of the dead.

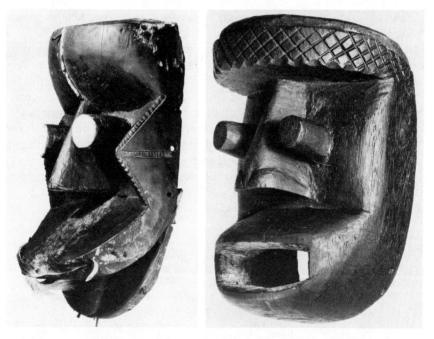

Figure 2-1 Two black wooden masks. Liberia. *Peabody Museum, Harvard University. Photographs by Hillel Burger.*

These masks, and others owned by elite members of the Poro, were thus endowed with supernatural power and as such they were important tools for the administration of justice. For example, court cases involving issues of life and death were presided over by a judge "whose identity was hidden under a great mask, representing

. . . the great forest demon" (p. x). The case would be decided according to traditional native principles of right and wrong, as applied by the masked judge. As everywhere, however, disputes seldom ended without some ill feelings; and the judge's anonymity, protected by his wearing a mask and head-to-foot costume and speaking in a falsetto voice, insured that he could make an impartial judgment without fear of retribution by a condemned person's surviving relatives.

Harley recounts another instance in which masks were used in the political process (1950:16): Zawolo was the chief of a territory that included some seven or eight towns. The office—and the mask that accompanied it—had been handed down from father to son for four generations. When an important issue arose Zawolo would call a meeting of the lesser chiefs and elders in his territory. Meeting at night in the forest, with guards placed on incoming roads to insure secrecy, the council would discuss the issue at length. Then,

> after the old men had talked the case through and reached their decision Zawolo would uncover the mask, call it by name, and review the case, telling the mask:
>
> "We have decided so and so. We want to know if you agree with our decision. If you agree let the cowrie shells fall up. If you disagree let them fall down."
>
> Then he would take the [four] shells and throw them like dice on the mat in front of the mask. The decision was supposed to be the decision of the ancestral spirits and was final. . . .
>
> I have never known a man more dignified and gentle [than Zawolo] and I was a little surprised to learn that in the old days he literally had the power of life and death over his people, for, as keeper of the great mask, he was a judge from whose decisions there was no appeal. The casting of lots before the masks was something of a formality. [Chiefs like Zawolo] were too sincere to decide everything by throw of dice upon pure chance. Old Zawolo knew how to throw them to get the answer he wanted. If he got an answer that did not suit him he could always invent an excuse for reopening the question and giving the cowries another throw (p. 16).

Note exactly how a decision was reached: A council of (presumably) the wisest men in the territory, led by the region's most influential individual, reviewed the matter and reached a tentative decision, based on the traditional values of the culture. This decision was then ratified and given supernatural warrant through approval by the mask. The decision became, in effect, the choice not of mortals but of the revered ancestors. If the decision was not purely traditional but involved a case for which no precedent existed, the

decree would be announced by a town crier and become law (p. 11)
Thus law was interpreted and created in northeast Liberia; and,
significantly, works of art—masks—were the agents through which
this was accomplished.

Harley remarks in summary that masks representing spirits
(gɛ's),

> exercised all the functions necessary for control of society on the reli-
> gious, the executive, and the judicial levels, reinforcing their authority
> by oracular responses. The human manipulation of these inanimate
> objects was so regulated by custom that abuse of power was kept at a
> minimum. The "owner" or high priest-judge could send gɛ's as his
> messengers, police, magistrates, extortioners, or entertainers; but he
> himself was subject to the will of the people through the council of
> elders.

> If the wearer of a mask died, his place was taken by another and
> the mask continued to function without interruption. Thus the equilib-
> rium of the community suffered a minimum disturbance, being that
> occasioned by the loss of an individual not especially important as
> such, rather than the loss of an important official whose individual
> character could not be replaced, whose successor might be activated by
> policies divergent from those already established. The mask thus pro-
> vided continuity of authority, regardless of the personal attributes of
> the current wearer (p. 42).

Art served additional functions in the societies described by
Harley, and the political system had several other dimensions in
addition to the uses of masks described above. (Indeed, a serious
shortcoming of Harley's work is that he tells us so little of other
aspects of Gio and Mano art: the training and social status of artists,
native standards of aesthetic excellence, and so on.) Nevertheless,
this case does show how art works can be used as a means of social
control.[4]

Authority, Legitimacy, and Art in the Andamans. As intellectual
heirs of the thinkers of the Enlightenment we may sincerely believe
that all people are created equal. The fact of the matter is, however,
that in every known society social inequality exists—between the
sexes, between adults and children, or between the politically influ-
ential and those with little influence. When one individual claims
control (partial or total) over another, the claim may ultimately be
based on the individual's having greater physical power at his com-

[4]Additional examples of art being used as a means of social control in West
Africa can be found in Sieber 1962; Messenger 1962; and Cole 1972. In the west, too,
masks are sometimes used to conceal the identity of individuals responsible for
punishing aberrant behavior. Thus, for example, in some localities masked Hal-
loweeners reek havoc with the property of people who are considered inordinately
cranky, stingy, or malicious.

mand. But obviously all of a people's time cannot be spent in fighting to establish and maintain dominance patterns, and in fact such internecine fighting is usually the exception rather than the rule. Instead, dominance may be maintained on a day-to-day basis through cultural precedent: Everyone, including the "have-nots," knows that the "haves" possess relatively greater power, that this power differential has been in existence for some time, and, perhaps, that it is traditionally considered right and proper that such a differential exists.

If those with relatively less power are reluctant to accept the rightness of their position, those with power can—and often do—use various techniques to *symbolically* display their power. Both the powerful and the powerless benefit from the fact that the display is symbolic: In an actual show of force both the weaker and the stronger sides waste energy (and perhaps lose lives) that could be put to better use.

The accumulation of valuable items is often a most convincing means of displaying one's power. But what should an influential person collect? One could accumulate utilitarian items—usable stone axes, for example—but what purpose would they serve, since one's personal needs would quickly be met? Further, the society as a whole would suffer if the collection of stone axes deprived others of their use.

In some societies the problem is elegantly solved for the relatively more powerful by their collection of items that are valued, that are limited in supply, and that are not overtly utilitarian. Art works meet these criteria admirably and thus may conveniently serve as "status symbols."

Social inequality exists in every known society, but it is much more extreme in some than in others. The society of the Andaman Islanders is one in which there is relatively little inequality. The Andaman Islands lie in the Bay of Bengal, about 300 miles south of Burma, and their inhabitants were described by one of the anthropological fathers of functionalism, A. R. Radcliffe-Brown. The Islanders live in local groups of 40 to 50 people each; local groups are loosely linked in tribes, with about 10 groups per tribe (Radcliffe-Brown 1964:28). There is no organized government within the local groups, but "the affairs of the community are regulated entirely by the older men and women. The younger members of the community are brought up to pay respect to their elders and to submit to them in many ways" (p. 44). The authority of the elders is not maintained by outright force, however.

> It must not be thought . . . that the older men are tyrannical or selfish. I only once heard a young man complain of the older men getting so

much the best of everything. The respect for seniority is kept alive partly by tradition and partly by the fact that the older men have had a greater experience than the younger. It could probably not be maintained if it regularly gave rise to any tyrannical treatment of the younger by the older (p. 44).

The only sort of political power in the local groups is a generalized sort of influence that accrues to men who possess "skill in hunting and in warfare, generosity and kindness, and freedom from bad temper" (p. 45).

Alvin Wolfe (1969) has suggested that, in Africa at least, the amount of art produced by a society is roughly proportional to the extent to which the society is divided by social cleavages. The geographic generality of Wolfe's thesis is debatable (cf. Houlihan 1972, McGhee 1976, and A. Wolfe 1976), but Andaman society certainly fits the rule. The only "art" described by Radcliffe-Brown in this virtually cleavage-free society is the decoration of individuals' bodies by means of scarification, painting, and the wearing of ornaments, and the decoration of utilitarian items such as bows, canoes, and baskets (Radcliffe-Brown 1964: 315-23). Nevertheless this scant amount of art is directed largely toward the end of stabilizing the social order.

Andaman Islanders' decoration (of either individuals' bodies or of utilitarian items) is always prompted by a desire to signify increased "social value" of the person or thing decorated. For example, a young person is scarified on the occasion of a ritual that marks his or her coming of age. The Islanders justify the scarification on grounds that "it improves the personal appearance and that it makes the boy or girl grow up strong." However there can be little doubt that the scars serve also as social insignia, symbolizing to the wearer and to all others that the person is no longer a child but rather a legitimate adult, with all the authority and responsibilities that accompany adulthood.

Ashanti Art: Symbols of Power. The thesis that was presented in the preceding paragraphs—that art items may function as "status symbols" for the more powerful members of a society—is difficult to document in a relatively egalitarian culture such as that of the Andaman Islanders. By contrast, evidence is often quite ample in highly stratified societies such as the traditional African kingdoms, of which the Ashanti (Asante) of southern Ghana is an excellent example.

The Ashanti Confederacy, a political union formed in about 1701 and now encompassing over a million people, stands in sharp contrast to the small-scale, politically simple society of the Andaman

Islanders. The Confederacy maintains an elaborate political hierarchy, headed by a hereditary king called the Asantehene. The Asantehene is the keeper of a wide variety of ritual objects and regalia, symbolic of his supreme position in the Confederacy. The most important of these items is the Golden Stool.

The origin of the Stool deserves to be recounted here, illustrating as it does the Stool's importance for Ashanti unity and stability. The Confederacy was formed by the joining together of a number of previously independent city-states.

> To seal their union, Okomfo Anokye, chief priest, adviser, confidant, and paternal nephew of Osei Tutu [the first king of the Confederacy] promised the king and the nation that he would call down from the skies a super-natural stool of solid gold which would enshrine and protect the soul of the nation. As a precondition to fulfilling his promise, however, he demanded that the ancestral (blackened) stools, state shields, state swords, and other regalia of all the member states be surrendered to him. This was done, and he buried them in the bed of the Bantama River in Kumasi. The purpose of this action was two fold: to ensure that no item of regalia in the new kingdom could have a longer history than the Golden Stool and hence take precedence over it, and, by depriving the formerly independent states of the relics of their respective pasts, to pave the way toward a new and broader union (Fraser 1972a:139-40).

These conditions were met by the new member-states of the Ashanti Confederacy, and a Golden Stool did indeed appear, falling (as tradition has it) from heaven onto the lap of the king. In case the message was missed by any present, the chief's priest publicly proclaimed that the King was

> the Father and Supreme Ruler of the people. The Golden Stool, he stipulated, must be treated with the utmost respect and was to be fed at regular intervals, for if it should become hungry, it might sicken and die; with it would perish the soul of the Ashanti nation. To make certain that all the subgroups accepted the Stool, Okomfo Anokye ordered that locks of hair, nailpairings and rings belonging to the principal chiefs present be surrendered to be driven into the Golden Stool, along with such mystical objects as the skin of a viper. He also spelled out a formal constitution for the government of the Ashanti and outlined a code of moral laws to be observed throughout the country (Fraser 1972a:140).

The authority of the head of the new Ashanti Confederacy was not wholly symbolic. One of the most powerful city-states that now became subservient to the king had recently been defeated by him militarily. Nevertheless, in this elaborate ceremony the king was explicitly instated as the ultimate authority throughout the Confederacy.

The beautiful Golden Stool of the Ashanti remains today the

most important symbol of the unity of the Ashanti people and of the supreme power of their king. It is considered to be supernatural and to it are rendered honors that are, broadly speaking, "those rendered to an individual of the highest rank. The Stool must never touch the bare ground, and, when it is exhibited on state occasions, it rests on its own special throne, the silver-plated *Hwedomtea*, an elaborate chair" (Fraser 1972a:141).

In addition to the Golden Stool itself, the Ashanti king has a number of other stools. These ceremonial art items are particularly revealing for the political implications of their decorations:

> As soon as a candidate for the throne has been chosen, it is customary for him to decide on the design and ornamentation of his personal stool in order to convey a message to his people. This message may appear in the form of the column (*sekyedua*) that supports the seat of the stool, or, more commonly in Ashanti, in the ornamental patterns which, for the Asantehene, are fashioned in gold leaf. The St. Andrew's cross (*apodwa*) design selected by King Owei Bonsu, for example, expressed the idea that he would consolidate the accomplishments of his predecessors. The message of King Kwaku Dua I, a circular chain (*kontonkrowie*), meant that the ruler would make his power felt by all peoples (though in fact he was the least pugnacious of kings) (Fraser 1972a:143-44).

In addition to stools, the Ashanti king's importance is also symbolized by his owning a great number of gold state swords (what could be more impractical for use as a weapon than a sword made of such a soft metal as gold?), decorated gold containers for holding gold dust, and state umbrellas. The latter, made of richly colored materials and sometimes topped with wood carvings and sheathed in gold leaf, again often carry a political message that is quite explicit. "On one belonging to the Asantehene, there appears a representation of a certain fruit called *prekese*, which has a very strong smell. This signifies that the Asantehene is omnipresent: like the *prekese*, he is to be sensed even where he is not seen; in other words, no gossip or plotting can evade his hearing" (Fraser 1972a:145-46). The king owns twenty-three umbrellas, each reserved for a special occasion (p. 147).

The art works owned by Ashanti political leaders serve a variety of uses—aesthetic, history-recording, religious, and patriotic. But without doubt they also serve another purpose: They stand as constant, awe-inspiring proof that their owners are the most powerful people in the kingdom.[5]

[5]A number of the essays collected in *African Art and Leadership* (1972), edited by Douglas Fraser and Herbert M. Cole, give other examples of the role of art in politics.

Lega Art and Ethical Education. Ashanti art is a publicly visible expression of the proper relationship between follower and leader. In other cultural contexts, art may alternatively provide a model for proper behavior between all people in a given society. It can, for example, be used as an adjunct to moral or ethical education. The Lega of Central Africa provide an excellent example of such a didactic use of art.

The Lega number about 250,000; most adult males are members of an important voluntary association called *bwami* (Biebuyck 1968, 1972). The *bwami* is hierarchical in structure, composed of five grades (with three complementary grades for women), each grade being subdivided into a number of subgrades. All men aspire to an elevated position in the hierarchy, but advancement in the association comes only to the few who are most enterprising, who can marshal sufficient support from other members, and who can accumulate the large numbers of goods that are needed for gifts and payments. At the pinnacle of the hierarchy are those few men, always over the age of 50, who have attained the highest subgrade of the *kindi* grade. These men, whom Biebuyck calls aristocrats, "are looked upon as outstanding examples of virtue and morality. They have passed through all initiatory experiences, assimilated the teachings and values connected with them, and for that reason they are also considered the very wisest" (1972:12).

It is in the moral training of the initiates of the upper *bwami* grades that art enters the picture. Lega art includes figurines of humans and animals made of ivory, pottery, bone, wood, and wickerwork; most of it is owned by members of the highest grades of the *bwami* association. Initiation of new members into these grades of the association provides the most important occasion for use of Lega art. Each statue is associated with certain proverbs, and these proverbs provide moral training for the initiates, graphically illustrating a behavior that is either praiseworthy or, more often, reprehensible. For example, Biebuyck describes one figure as a carved stick

> whose top is slit so as to suggest an open mouth. . . . The object illustrates the saying, "He who does not put off his quarrelsomeness will quarrel with something that has the mouth widely distended." (In other rites this idea may be rendered by a crocodile figurine with widely distended jaws). The aphorism alludes to the disastrous effects of quarrelsomeness and meddlesomeness (1973:217).

Biebuyck (1973:184-226) describes a vast number of other Lega items—both natural and man-made art works—that are used in *bwami* ceremonies. Each is associated with from one to twenty or

more aphorisms. Any one aphorism considered in isolation may seem trivial; but taken as a whole, the corpus represents an over-whelming compendium of Lega ethical ideals.

Art and the Social Order. In all the examples given thus far, the relationship between art and cultural stability has been overt, obvious, and relatively amenable to description and study. But what about the deeper relationships between art and the social order? Many writers (e.g., Adams 1973; Paul 1976; L. Thompson 1945; Lévi-Strauss 1963, 1970; Fraser 1955; Hatcher 1974) have suggested that in a particular society the predominant art styles mirror the basic cultural values of the society—values so fundamental that they may not be explicitly verbalized by members of the society itself.

An example of such a subtle relationship between art and culture is given by James Fernandez in his remarks on the aesthetic values of the Fang of equatorial Africa:

> The data suggest that what are given in Fang life, what are basic, are two sets of opposition. One is spatial, right and left, northeast and southwest; the other is qualitative, male and female. Both the social structure and the aesthetic life elaborate on these basic oppositions and create vitality in so doing. . . .
>
> In both aesthetics and the social structure the aim of the Fang is not to resolve opposition and create identity but to preserve a balanced opposition. This is accomplished either through alternation as in the case of complementary filiation [i.e., kinship] or in the behavior of a full man; or it is done by skillful aesthetic composition in the same time and space as is the case with the ancestor statues of cult ritual (1971:373).

Munn's work among the Australian Walbiri, discussed at length in chapter 3, provides another example of art functioning as a "cultural gyroscope," as Bellah (1965:173) has termed similar symbolic systems.

Claims such as these are quite intriguing. If they are valid, if a society's aesthetic values mirror its nonaesthetic values, then the ethnographic payoff for studies of art would be great indeed. The difficulty lies in the fact that such claims tend to be highly speculative. What may seem patently obvious to one observer may seem sheer fantasy to another. And the deeper the relationship hypothesized between art and culture for a given society, the more difficult it is to empirically support the hypothesis.

One way out of this dilemma has been given by John L. Fischer (1971). Fischer asked, is there generally a relationship between a society's social structure and certain stylistic aspects of the society's art? To find an answer, he compared the results of two previously published cross-cultural surveys. In one of these, Berry had examined art work from 30 different nonwestern societies, ranking them

according to 18 different criteria (Berry 1957:380). For example, he ranked the societies with respect to the *symmetry* of their art, ranging from the relatively symmetrical works of the Yakut, Teton, and Omaha, to the relatively asymmetric art of Bali, Dahomey, and Alor. For statistical simplicity, Berry contrasted two groups—the 15 societies with more symmetric art versus the 15 with more asymmetric art.

In the other cross-cultural study that Fischer utilized, George Peter Murdock had previously evaluated a large number of societies with respect to numerous sociological variables. For example, he considered the *degree of social stratification* of societies, specifying such things as whether or not a society has numerous social castes or classes, whether there was a hereditary aristocracy, and so on (Murdock 1957:675).

Drawing on these two surveys Fischer was able to look for correlations between numerous sociological variables and art style variables—for example, between stratification of society and symmetry of art. By performing some relatively simple statistical manipulations, he found that these two particular variables were indeed correlated: The odds are better than twenty to one that if a society is highly stratified socially, it will produce relatively asymmetrical art, whereas a society with little social stratification will more than likely have symmetrical art. As the probabilistic aspects of this statement indicate, there can be exceptions to the rule, but the great strength of the statistical method adopted by Fischer is that these cases are shown to be just that—exceptions. (The existence of numerous exceptions does, however, lead one to a conclusion that may be arrived at from several other directions—namely, that the relationship between art and culture is seldom obvious and straightforward. Thus, the use of a society's art alone as a basis for deducing its fundamental cultural features or *Zeitgeist* is risky at best.)

Tedious as statistical studies such as Fischer's may seem, cross-cultural surveys are invaluable for our understanding of the social and cultural functions of art. If Fischer's findings are valid, one can conclude that whatever else art does, it provides "a sort of map of the society in which the artist—and his public—live" (Fischer 1971:159)[6]. The relationship between the map and the terrain it repre-

[6]Fischer's study, though seminal, has a number of serious methodological shortcomings. His conclusions should be validated and expanded by studies that (1) are based on a larger number of societies with less geographic bias; (2) use better sampling techniques for choosing the art to be considered from each society; (3) use more than one judge for the evaluation of art styles; and (4) use more sophisticated tests for correlation. Works by Robbins (1966) and Dressler and Robbins (1975) have been valuable additions to this line of inquiry.

sents may not be simple or perfectly accurate, but insofar as there *is* a correspondence, art must be seen as a conservative, rather than innovative, expression of culture. Art gives legitimacy to the traditional way of doing (or thinking about) things, providing a tangible support for the *status quo.* Or, if it does point to a currently unrealized ideal, its goal is a traditional one, not a revolutionary vision for a future that is radically different from the present.

Such a conclusion leads us to ask a further question: What features of art make it widely useful as a means for aiding cultural stability? There are, I think, several answers to this question.

First, art can be (and art in most primitive societies is) representational. Thus it has an unlimited potential for recording in a tangible and (usually) lasting form information that would otherwise be lost to the past. This history- and precedent-recording ability of art works is particularly valuable in nonliterate societies. (Viewing art in this light, it is easy to see how some writing systems evolved from pictograms, thus institutionalizing the communicative capacity of art.)

Second, art can be (and typically is) public in nature. Thus it not only communicates, but it provides a medium for communication between large numbers of people; and the message remains largely intact from place to place and from one time to another.

Third, the explicit message communicated by art can be made even more potent by the evocative, affective level of the medium. When art speaks, we listen—both with our heads and with our hearts.

Continuity and change are necessarily present in every society, but traditional societies typically exhibit more of the former than of the latter. Stability does not occur automatically, but must be constantly maintained in the face of individual needs that are contrary to traditional patterns. What is needed is a means of encoding traditional norms, disseminating them to the population at large, maintaining them for future generations and, if possible, doing all this in such a way that the population will "get the message." Art, in all the diverse ways discussed in this section, may be called upon to perform these duties, and often it does so in a highly effective way.

Art and the Supernatural

Judging from some museum collections of art from primitive societies, where item after item is labeled "fertility god," "ancestral figure," "fetish," or "altar piece," one might conclude that art in primitive societies is predominantly, if not wholly, used for religious

purposes. Such is absolutely not the case. For example, the Chokwe of central Africa produce only insignificant religious artifacts—miniature charms and shrine figures that any Chokwe adult male is capable of producing. Chokwe secular art, by contrast, is very highly developed, produced by a small number of professional artists—predominantly carvers and blacksmiths, but also potters, tailors, matmakers, and basketmakers (Crowley 1972:25). Most of their produce is totally secular in its use, providing furnishings and decorations for chiefs' houses. In addition, some Chokwe art straddles the borderline between sacred and profane—masks made for stock characters (*mikishi*) in traditional dances, for example. But even for works in this genre, while

> it would be deceptively simple to describe the *mikishi* as the deities of the Chokwe . . ., actually the Creator god, Nzambi or Kalunga, is aloof from the affairs of men and never appears in inconography. In the contemporary Congo, where half the Chokwe are Christian, the religious aspect of the *mikishi* might be compared to that of Santa Claus in an American city—figures of ancient piety now reduced to generalized symbols of festivity (Crowley 1972:25).

Art is also predominantly—or wholly—secular among the West African Tiv (Bohannon 1971), Bush Negroes of Dutch Guiana, South America (Herskovits 1959), and in the traditional cultures of Madagascar (Linton 1941), to name just a few documented cases.

Rather than conceiving art to be universally the handmaiden of religion (or vice versa), it is more profitable to note the similarities between art and religion in regard to what they each do and how they do it. Religion, like art, serves various needs, but one of its more common functions is the contribution it makes to the maintenance of social stability and cultural homeostasis through its embodiment of both an ethos and a set of ethical principles that are more or less shared by all members of the society. As shown in the preceding section, art very often performs a similar homeostatic function. Furthermore, as Marvin Harris has noted, art, religion, and magic

> satisfy similar psychological needs in human beings. They are media for expressing sentiments and emotions not easily expressed in ordinary life. They impart a sense of mastery over or communion with unpredictable events and mysterious unseen powers. They impose human meanings and values upon an indifferent world—a world that has no humanly intelligible meanings and values of its own. They seek to penetrate behind the facade of ordinary appearance into the true, cosmic significance of things (1975:583).

Moreover, art, religion, and magic attain these goals in similar ways: Arbitrary distinctions are made—for art, between the beautiful

and the ugly; for religion, between the sacred and the profane; for magic, between that which can and cannot be controlled by humans. And these distinctions become culturally encoded traditions, handed down from generation to generation by means of emotionally charged socialization of the young.

Thus the realms of art and of the supernatural may be similar in many respects. In a given society the two phenomena may intersect, performing similar functions in similar and mutually reinforcing ways. Alternatively, the two may operate independently of each other, drawing, perhaps, on related subject matter, but using it to different ends. Thus, for example, the art of the Pacific Northwest Coast, described in chapter 3, uses mythic people and animals as subject matter, but the ends are by and large secular, namely the glorification of the aristocratic families that sponsor the art (see also Forge 1961).

Future research may shed light on such questions as: What factors predispose a society to support secular, rather than sacred art? When is art distinct from religion and magic? What is the interplay between the three institutions?[7]

Conclusion

Even the most superficial acquaintance with art from primitive societies should convince the westerner that it is mostly "about" people. Walk through a gallery of art from primitive societies and most of the pieces you see will depict people or animals with human qualities. As Firth noted some time ago, "The essentially social character of primitive art is reflected in [the] forms themselves. There is almost entire absence of landscape. What depiction of landscape does exist appears as subsidiary material in hunting scenes and the like" (1951:173).

Viewed in its social and cultural context, art in primitive societies is far from a useless luxury. It does give enjoyment, to be sure (if indeed this may be considered a luxury). But it also often plays an important role in the economic and political realms, as the

[7]The notion that art evolved from religion is sheerly speculative, based on one possible interpretation of Paleolithic art, especially the extant cave paintings. Some of these paintings may indeed have been prompted by religious belief systems, although one might equally plausibly argue that in these cases art inspired religion, rather than the other way around. In any case, not all of the ancient cave art can be so simplistically explained. Ucko and Rosenfeld (1967) provide a critical survey of the various theories that have been proposed to account for Paleolithic art.

examples in this chapter have illustrated. In addition, it probably serves other functions that have as yet been little studied. It may, for example, record history for a prehistoric people; or it might serve as a testing and practice ground for developing skills that are primarily useful for subsistence activities or defense. Throughout this chapter I have tried to emphasize the fact that art can—and typically does—do many things. An understanding of the functions of art in primitive societies helps one avoid simplistic, naive misconceptions about the nature of art in general. When one becomes aware of the rich texture of the functional context of art in a particular society, he or she begins to view it in a way that approaches that of a native member of the society—that is, as a vital and necessary part of culture.

GUIDE TO ADDITIONAL READINGS

Functionalism. A vast amount of twentieth-century British and American anthropological writing reflects the functionalist approach. Classic ethnographies are Radcliffe-Brown's *The Andaman Islanders* (1964 [orig. 1922]) and Malinowski's *Argonauts of the Western Pacific* (1922). Rappaport's *Pigs for the Ancestors* (1968) is a contemporary functionalist *tour de force.* Hemple (1959) discusses the shortcomings of the functionalist approach.

Art as Gratification. One of the principal themes of Alexander Alland's *The Artistic Animal* (1977) is that the aesthetic response is not only inherent to art but derives from a genetic predisposition present in all humans. Parsons (1951, esp. pp. 384-427) is the basis of much current sociological thinking on the affective aspects of human interaction and socialization.

Art and Cultural Homeostasis. Sieber (1962) and the essays collected by Fraser and Cole in *African Art and Leadership* (1972a) provide a variety of case studies of art fulfilling political functions. Biebuyck's *Lega Culture* (1973) is an excellent study of the interaction of art, education, and ethical values. Witherspoon's *Language and Art in the Navajo Universe* (1977) is a masterful study of Navajo culture via art and language.

Chapter 3

Iconography and Symbolism

When we first look at a work of art from a primitive society we are immediately struck by its appearance—the colors that are used, its shape, the materials from which it is made, and so on. But often there is more to a piece than first meets the eye: Its appearance may have some meaning behind it; its maker may have intended to remind the viewer of certain things or people, events or ideas that transcend the piece itself. It may, in short, be symbolic or iconographic.

Symbolism is a huge topic, permeating virtually all spheres of human society and culture. Some writers have even claimed that our ability to use symbols defines our very humanness (cf., e.g., White 1959; Langer 1951). In any case symbolism is a very important component of art in some primitive societies. The present chapter discusses the most central subjects related to symbolism, using as illustrations the art of the Pacific Northwest and of the Walbiri of west-central Australia.

What Is a Symbol?

The word "symbol" has had a long and interesting career in western thought. More than 2,000 years ago the Greeks used the word *sumbolos* to refer to the rejoining of a thing that had been divided or broken in two. For example, two friends might break a token in half, each of them keeping one of the halves. The fact that the two parts—and only they—could be rejoined to form the whole was proof of the common bond of friendship between the two individuals. Already in this early usage of symbol there was a meaning that still often recurs: Some tangible item (the divided token) was being used to stand for an abstract idea (friendship).

Symbol was redefined and broadened in meaning by the early Christian writers, and since then other nuances have continued to accrue to the term so that today it has a whole range of meanings. Some indication of the breadth of this range is illustrated by the fact that while some items may be disparagingly referred to as "mere" symbols, to call other things "symbolic" is to elevate them in importance far above their mundane meaning.

The common denominator of many of the current usages of symbol derives from the work of the influential nineteenth-century writer, Charles S. Peirce. Professionally Peirce was a physicist and astronomer, working most of his life for the United States Coast and Geodetic Survey. But in addition to his activities as a scientist, Peirce was also a tough-minded philosopher who published essays in various scholarly journals and corresponded with other philosophers of his day. He developed many ideas that proved seminal to modern symbolic logic, information theory, and semiotics. (This last field was begun by Peirce himself—he called it "semeiotics"—and consists of the systematic study of signs and meanings. It has been useful in areas ranging from computer theory to animal communication.)

Peirce's work is relevant here because of his approach to the definition of symbol. He began by noting that in our everyday lives some things are commonly taken as indications of other things. Peirce called all such things *signs*, and went on to make a useful distinction between three types of signs—index, icon, and symbol. These terms are used throughout the rest of this chapter, so it is important that their exact meanings be made clear at this point.

An *index*, according to Peirce's definition, is a sign that emerges from some natural phenomenon rather than being an arbitrary convention of culture. For example, a person's pulse is an index that he is alive. It's an index rather than an icon or symbol because the relationship between pulse and being alive stems from natural fea-

tures of the human body; clearly it is not something that humans have merely agreed upon by cultural convention.

Both icons and symbols, however, derive from human convention; they are products of culture rather than of nature. The difference between icons and symbols is that icons bear some resemblance to the thing for which they are a sign; symbols, by contrast, bear no resemblance to their referents. Consider, for example, two roadsigns that might be seen along a rural highway. One has on it only a silhouette picture of a running deer, the other simply says "DEER CROSSING." In Peirce's nomenclature the first sign is an *icon* in that the thing itself (the painted metal sign) bears some resemblance to the thing it signifies (a deer running across the highway). The second roadsign with its printed message is a *symbol* because there is absolutely no visible resemblance between its appearance and the deer the sign is warning motorist of. (Thus the ancient Greek *sumbolos*—a token or coin that two friends break in half and divide between them—is still a symbol in the Peircean sense: The token is something that, by convention, stands for something else, namely, a bond of close friendship.)

Index, icon, and symbol—three types of signs. The categories are not clearly demarcated, of course. Signs that at first seem to be symbols, for example, often turn out to have some resemblance to the thing they represent. That is, they are slightly iconic. But despite this problem Peirce's approach can be accepted for what it is, namely a useful set of terms that help clarify discussions about art and other forms of human communication.

The Iconography of Northwest Coast Indian Sculpture

Cultures of the Northwest Coast. The tribes of the Pacific northwest of North America possessed some of the most interesting institutions of the aboriginal western hemisphere. They lived along the coast and on coastal islands ranging from what is now the state of Oregon in the south, to Yakutat Bay in Alaska in the north. The major groups, going from north to south, were the Tlingit, Tsimshian, Haida, Bellabella, Bella Coola, Kwakiutl, Nootka, Coast Salish, and Chinook. Thanks largely to the meticulous fieldwork of Franz Boas, many aspects of their culture as it existed at the turn of the century have been recorded in great detail.

The early ethnographers of Northwest Coast societies believed that the people lived in an environment of luxurious surplus. Although they traditionally lacked agriculture, the needs of the native inhabitants seemed to have been amply met by the rich fishing, gathering, and hunting resources of the lush Northwest Coast eco-

system. More recent historical studies suggest, however, that the surpluses that existed at the turn of the century probably were a direct result of contact with Europeans. The white aliens brought diseases that drastically reduced the size of native populations, thus decreasing population pressure on the natural environment. Also the employment of Indians in commercial fishing, fish canning, and lumber operations provided a new source of cash income, thus making the native population appear relatively affluent.

The prenineteenth-century situation was probably much different, however. Food may have been ample, but its supply was erratic, with short-term and unpredictable surpluses in one location being accompanied by shortages and possible famine in another. To partially offset this inequality of supply, an elaborate system of reallocation of material goods existed. The redistribution was effected by the complex traditional social systems composed of nobles, commoners, and slaves. Within the upper level of this hierarchy there was much competition for high social rank, with each noble trying to out-do his rivals in the amount of goods he could accumulate and then publicly distribute at ceremonies called potlatches. The result of this system of redistribution was that the population as a whole benefited through gaining some protection against the ravages of periodic famine. The nobles themselves gained some personal wealth, but their chief reward lay in the additional prestige they received. This prestige was manifest in a variety of forms, not the least of which was the art produced in Northwest Coast societies. (Houlihan 1972; Drucker 1955; Piddocke 1965; and Rohner and Rohner 1970 provide additional ethnographic information on Northwest Coast cultures.)

Northwest Coast Art. The art of the Northwest Coast rivaled that produced anywhere in the world, both in sheer amount produced and (in the eyes of some westerners) in its aesthetic quality (cf., e.g., Wingert 1962:357). Fortunately, the art of the Northwest Coast is one facet of the culture that Boas described in some detail (1897, 1955:186-299). Since Boas' time additional scholarly studies have been carried out, based on analyses of museum collections, studies of older ethnographic documents, and interviews with the last generation of native artists whose works still reflect at least some of the traditional methods and styles[1] (Holm 1965, 1972, 1975; Hawthorn 1961; Waite 1966; Siebert 1967; Wingert 1951; Gunther 1962). Except

[1]The following account is based on traditional Northwest Coast art and society as they existed at and before the early twentieth century. Recent years have seen a revival of artistic activity among many of the native peoples of the Northwest Coast. This welcome renaissance of a nearly forgotten art combines many traditional techniques, media, and subjects with a contemporary concern for ethnic identity and pride.

where noted otherwise, all of the Northwest Coast art described below was the product of male artists. Women produced handsome baskets and mats, but these, unfortunately, have received much less description and analysis.

Wood was the most common medium for male Northwest Coast artists, but they also worked in bone, stone, shell, and native copper. The most common forms were masks, free-standing figures (including the so-called totem poles), and decorated boxes, clubs, and rattles. Many objects were painted, the most commonly used colors being black, red, and blue-green (or blue or green); white and yellow were also used occasionally.

Although there are noticeable differences between the art styles of the various Northwest Coast tribes, and even distinguishable differences within individual tribes, the art of the entire area was highly distinctive. After seeing only a few works even the aesthetically naive can begin to pick out pieces of Northwest Coast art from museum collections with some accuracy. The distinctiveness lies in several factors: Humans and animals are by far the most common subjects portrayed; the head, and particularly the eyes, eyebrows, and mouths of animals or people are emphasized; a few design elements (such as the "eye" design) are repeated in a great variety of different contexts; and decorative figures are typically made up of, or enclosed by, characteristically curving lines (see Figures 3-1 through 3-6).

The fact that humans and animals are the most common subjects of Northwest Coast art reflects the social and religious beliefs of the groups. The figures portrayed were actually owned by individuals and were a mark of the social rank of their owners. Like European family crests, they were inherited or acquired through marriage, warfare, or other means. Most seem to have been associated with traditional stories or myths. Some represented a single creature; others portrayed several of the personae of a given myth. Into this last category fall many of the so-called totem poles—"so-called" because as anthropologists have come to use the word, a totem is a thing, often an animal or a plant, with which an individual (or a kin group such as a clan) has a special religious or ritualistic relationship such as mutual protection. Noble Northwest Coast families owned specific folk tales, and the characters in the stories were carved on poles to be used as burial or commemorative objects, but the families had no special supernatural relationship with the animals or people who played roles in the stories and were portrayed on the poles. Hence the figures on the poles were not "totemic" in the strict sense of the word.

Northwest Coast Iconography. Northwest Coast art is, in Peirce's terms, iconographic. That is, people and animals are depicted in a conventionalized manner, and at least in some ways the designs bear a palpable resemblance to the person or animal depicted. The interesting aspect of the art, however, is the manner and extent of the resemblance. Some pieces strike us as being quite literal, as in the case of the Northwest Coast portrait mask shown in Figure 3-1. Not only is the Native American physiognomy very accurately rendered, but the grain of the wood has been used in such a way as to suggest a furrowed brow.

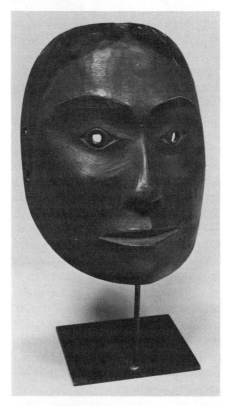

Figure 3-1 Northwest Coast portrait mask, probably Tlingit. Wood with paint, 8 inches high. *Courtesy Donald D. Jones.*

Much Northwest Coast art, however, is the result of varying degrees of stylization so that the resemblance between the work and the person or animal represented becomes increasingly tenuous, passing through several steps of conventionalization. To begin with

the artist could ignore or modify many details of a given animal, retaining only those traits that were considered definitive for the species. An example will make this technique clear. Figure 3-2 shows a Tlingit carving. Those of us unfamiliar with Northwest Coast art would probably identify it as representing an animal of some sort, or perhaps a person with abnormally large front teeth.

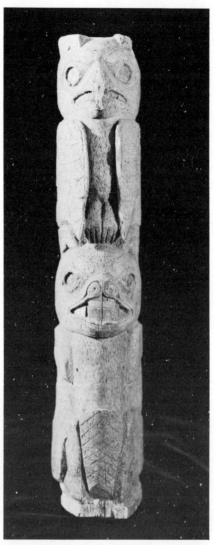

Figure 3-2 Tlingit model housepost. Collected ca. 1900. Whalebone with abalone inlay. 20 inches high. *Courtesy Kansas City Museum of History and Science.*

The maker of this piece, however, would tell us that he has depicted not just any animal; for him, it's obviously a beaver. Why? Because the position of the ears indicates it to be a nonhuman animal, and because it has two large front teeth, a scaly tail (indicated by the hatching on the roundish area at the bottom center), and its fore-paws are raised as if the animal were holding a stick—as, indeed, the beaver does in some Northwest Coast sculptures. All of these, in the shorthand of Northwest Coast iconography, are characteristics specific to the beaver. The short nose with spiral nostrils is also often found in representations of beavers, but this may be omitted or changed at the discretion of the artist. Indeed, necessity may force the artist to modify or omit any of the details except the enlarged incisors and the scaly tail; the figure will still be recognized as a beaver (Boas 1955:186). Other species were similarly stylized: The hawk always had a large curved beak whose point curved back to touch its face; the frog, always a wide, toothless mouth, a flat nose, and no tail; and so on.

Some features were semidistinctive for each species as well. For example, beavers' eyes were usually (but not always) represented by Kwakiutl artists as being shorter and higher than the eyes of eagles (see Figure 3-3).

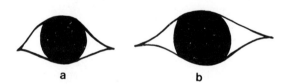

a b

Figure 3-3 Stylized representations of animal eyes, Kwakiutl. (a) Beaver. (b) Eagle. (*After Boas, 1955.*)

The next possible step in stylization that the Northwest Coast artist might take was to rearrange the component parts of a given animal so as to fill the area he wished to decorate. Often this was done by conceptually cutting the animal along a few lines and spreading out the resultant parts so as to fill the design field. An-other example will illustrate the technique: Figure 3-4 shows a Haida or Tsimshian dancing hat made of spruce roots. It is in the shape of a truncated cone; to its top would have been attached a series of rings, each ring symbolizing a step up the social ladder. In the first

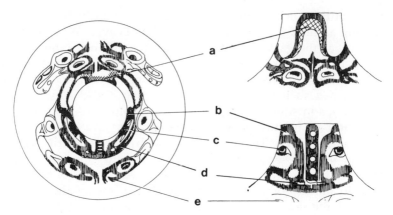

Figure 3-4 Conical hat, made of spruce roots and decorated with beaver design, Haida or Tsimshian. Left, View from above. Right, Side view of upper portion. (*After Boas, 1955.*)

drawing the hat is viewed from above so that only the decorations on the wide conical brim of the hat are seen; the second drawing gives a side view of the front and back of the hat's conical top.

The decoration of such hats presented Northwest Coast artists with a difficult problem in that the design field was basically circular with an empty space in the middle. How could the decoration—in this case the beaver figure we met in the previous example—be distributed around such an oddly shaped field? The artist ingeniously solved the problem by imagining a three-dimensional beaver complete with its distinctively large incisors, hatched tail, erect ears, and forepaws in front of his body. This he conceptually split down the middle, leaving only the face and tail intact. The two resultant profile views were unfolded and stretched out to fill the design field. The final product might initially strike us as being totally abstract, but a closer look confirms that all the crucial parts are present: the two front teeth (d), the hatched tail (a), the erect ears (b), the forepaws held in front of the body (e). (The forepaws are not holding a stick in this instance.) To fit the face into its allotted space, the usually roundish beaver eyes (c) have been elongated to very narrow forms; and in this case the hind legs are shown folded under the beaver as if he were sitting up on them.

The parts of the beaver shown in Figure 3-4, though split and unfolded, are still more or less in proper relation to each other. The manipulative process can be carried one step further, however, so that the disassembled parts are distributed around the design field with only the most tenuous resemblance between their placement on the field and their anatomical locations. Figure 3-5 illustrates this

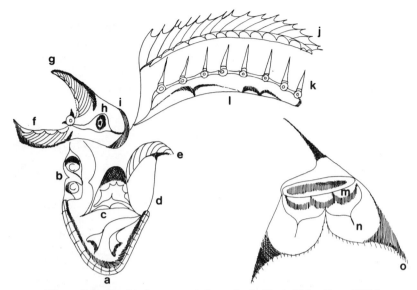

Figure 3-5 Kwakiutl representation of a halibut. (*After Boas, 1955.*)

final step in the process. Boas' interpretation of the parts of this particularly striking Kwakiutl design is as follows:

> [The figure] represents the halibut; (a) the mouth and over it the nose, (b) the eyes, (c) the bone of the top of the head and (d) the side of the head. In (e) are shown the gills; (f) and (g) represent the intestinal tract, and (h) is the part of the intestinal tract just under the neck; (i) is the collar bone, (j) the lateral fin, the bones of which are shown in (k). (l) is the clotted blood that is found in the dead halibut under the vertebral column; (m) represents the joint of the tail, (n) part of the bone in the tail, and (o) the tip of the tail (1955:205).

Carried to this extreme degree of stylization it is not surprising that Northwest Coast Indians themselves had problems interpreting their own art. There are numerous recorded instances of individuals, even highly regarded artists who, when presented with a piece they had never seen before, "explained" the meanings of parts of the figures in ways that contradicted other native interpretations of the same piece. For example, John R. Swanton (cited in Boas 1955:209), an early ethnographer of Northwest Coast culture, asked two different individuals for an explanation of the Haida housepost shown in Figure 3-6. Both agreed that the figure at the top of the post represented an eagle. But one told Swanton that the lower part related the story of a woman who was carried away by a killer-whale: Her face, he said, is shown just below the eagle's beak, and the large figure at the bottom is the whale. The face just above that of the whale stands for the whale's blowhole. Swanton was given a

very different interpretation of the housepost by the second person, who maintained that the large face at the bottom was that of a grizzly bear, perhaps meaning a sea-grizzly bear; the small figure above its back was a "sea ghost," a character that usually rides on the back of a sea-grizzly bear. This person gave no explanation whatsoever for the small upper face.

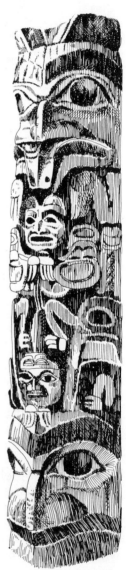

Figure 3-6 Haida housepost. (*After Boas, 1955.*)

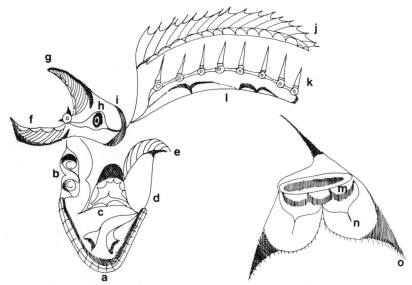

Figure 3-5 Kwakiutl representation of a halibut. (*After Boas, 1955.*)

final step in the process. Boas' interpretation of the parts of this particularly striking Kwakiutl design is as follows:

> [The figure] represents the halibut; (a) the mouth and over it the nose, (b) the eyes, (c) the bone of the top of the head and (d) the side of the head. In (e) are shown the gills; (f) and (g) represent the intestinal tract, and (h) is the part of the intestinal tract just under the neck; (i) is the collar bone, (j) the lateral fin, the bones of which are shown in (k). (l) is the clotted blood that is found in the dead halibut under the vertebral column; (m) represents the joint of the tail, (n) part of the bone in the tail, and (o) the tip of the tail (1955:205).

Carried to this extreme degree of stylization it is not surprising that Northwest Coast Indians themselves had problems interpreting their own art. There are numerous recorded instances of individuals, even highly regarded artists who, when presented with a piece they had never seen before, "explained" the meanings of parts of the figures in ways that contradicted other native interpretations of the same piece. For example, John R. Swanton (cited in Boas 1955:209), an early ethnographer of Northwest Coast culture, asked two different individuals for an explanation of the Haida housepost shown in Figure 3-6. Both agreed that the figure at the top of the post represented an eagle. But one told Swanton that the lower part related the story of a woman who was carried away by a killer-whale: Her face, he said, is shown just below the eagle's beak, and the large figure at the bottom is the whale. The face just above that of the whale stands for the whale's blowhole. Swanton was given a

very different interpretation of the housepost by the second person, who maintained that the large face at the bottom was that of a grizzly bear, perhaps meaning a sea-grizzly bear; the small figure above its back was a "sea ghost," a character that usually rides on the back of a sea-grizzly bear. This person gave no explanation whatsoever for the small upper face.

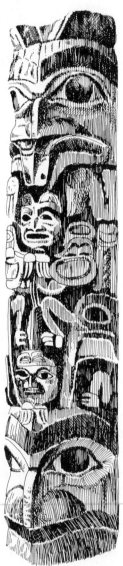

Figure 3-6 Haida housepost. (*After Boas, 1955.*)

Examples of multiple interpretations should not be over-emphasized. Northwest Coast art relies upon elaborate and widely shared techniques of stylization. There is no question that the original maker of a piece, his apprentices, the patron for whom it was constructed, and other members of the immediate community knew the exact intended meaning of an elaborate carving or blanket.

Northwest Coast Art as Traditional Status Symbol. The preceding paragraphs have described the iconographic aspects of Northwest Coast art. In this style, individual pieces are conventional representations, usually of people or animals, and the works resemble, to a greater or lesser degree, the things they are supposed to represent. Often the iconic interpretations extend far beyond the piece itself. An individual mask, for instance, may be a visual token that recalls to the native viewer an elaborate folk tale, comparable to the way a picture (or carving) of Pinnochio would remind us of the whole moral tale associated with the little boy and his distinctively long nose.

But Northwest Coast art is also in some ways symbolic in the strict sense of the word. A piece carries with it a message that bares no palpable resemblance to the image itself: It is a "status symbol." The totem poles, houseposts, and most of the masks were signs of the high social standing of their owners. Even if a native viewer did not accurately decipher the iconic message of a given art work, he undoubtedly appreciated the social significance of the piece. The quantity and elaborateness of the works of art possessed by a person were public statements of his relative position in the social hierarchy. As we know, members of Northwest Coast societies were vitally concerned with their relative social standing, so to them the symbolic messages transmitted via their art were far from trivial.

For us, these explicitly symbolic aspects of Northwest Coast art might be something of a disappointment. Some time ago Frederic Douglas and Rene D'Harnoncourt wrote, with regard to American Indian art, "The word *symbol* has always had a great appeal to buyers of Indian curios, who love to think they can purchase a mystery and a half with every souvenir" (1941:14). Although our own interest goes deeper than that of the souvenir hunter, we may share the hope that all symbols in art from primitive societies conceal a "mystery and a half." But in the case of Northwest Coast art we have found that although individual pieces do indeed carry iconic and symbolic messages, these messages are hardly mysterious. A given item probably represented a specific person or animal; this being was probably

associated with a folk tale that was largely of significance only to the family that owned it; and the only really symbolic message was its indication of the owner's social standing. It may be a puzzle for us, as nonnatives, to learn these meanings, but once discovered they hardly provide a key for an in-depth understanding of Northwest Coast culture as a whole.

But by now we are well aware of the enormous diversity that exists in art cross-culturally. If "mystery-and-a-half" symbols are not to be found in Northwest Coast art, then the symbolism of other art styles may meet our high expectations. The art of the societies of central Australia, such as the Walbiri, is a good candidate for such further study.

The Walbiri of Central Australia and Their Art

The Walbiri live in a region that we westerners might consider to be one of the least hospitable in the world, namely, the desert region of west-central Australia. In sharp contrast to the lush environment of the Northwest Coast American Indians, the Walbiri inhabit a region where water is found only in natural depressions in rocks in the ranges of outcrops and low-lying hills that run through their land, or else is collected from the bottoms of holes dug in dry creek beds into which water slowly seeps. Lacking agriculture the Walbiri traditionally derived their subsistence solely from gathering numerous kinds of vegetable foods and from hunting wild game. They resided in small, semi-nomadic bands that traveled from water hole to water hole, living at each for as long as local supplies of water, food, and game lasted. Eventually their travels would bring them back to their starting place, and the cycle would begin again. This pattern of constant circling from place to place is a recurrent theme in both the mythology and art of the Walbiri.

Between 1956 and 1958 Nancy Munn spent 11 months living near a group of about 375 Walbiri who resided in the vicinity of a government settlement at Yuendumu. Munn concentrated her study on Walbiri art and religion, and the rich data she collected have appeared in numerous publications (Munn 1962, 1964, 1970, 1971, 1973, 1974).

Much of Walbiri art is concerned with the people's religious beliefs, a complex subject in itself. Munn's summary of Walbiri religion will suffice here. The Walbiri, she states,

> have a typical central Australian totemic ideology involving belief in innumerable ancestral beings whose travels created the topography of

the country. Many of these are personified aspects of the environment such as rain or honey ant; but others are wholly human or non-human.

The ancestors and the times in which they travelled are called *djugurba*, a term that also means "dream." Walbiri men say that the ancestors, sleeping in their camps at different sites, dreamed their songs, graphic designs, and ceremonial paraphernalia. These phenomena record their travels, and the gist of Walbiri views on this matter seems to be that they also dreamed the world they created in their travels; as one man suggested, they dreamed their track (*yiriyi*) (1974:195).

A final feature of Walbiri society of relevance here is the "lodge," a ceremonial group composed of all initiated males in one locality who are related to each other through male lines of kinship. Each lodge has associated with it certain totemic ancestors. The relationship is a reciprocal one, with the lodge members feeling that they both influence, and are influenced by, the ancestors to whom they are related. In practice, an ancestor oversees the ritual ceremonies performed by members of its associated lodge, and the lodge members are responsible for caring for the symbolic paraphernalia used in the ceremonies.

Walbiri Art. The Walbiri provide convincing evidence of the pan-human importance of art. Despite the barrenness of their physical environment, the simplicity of their technology, and the sparseness of their population, they produce art—indeed, art of considerable variety and abundance.[2] Walbiri work in the following media: sand drawing, body decoration (using grease, pigments, and the fluff of certain plants and animals), wood, and stone. The latter two media, used only by men, are incised with designs and often rubbed with colored pigments. Elaborate headdresses are also made.

Art occurs in a wide variety of cultural contexts in Walbiri society, ranging from the mundane to the sacred. At one extreme are

[2]If Walbiri culture has an artistic deficit, it lies in the low level of art specialization that exists in Walbiri society. Apparently all adult Walbiri can (and do) create graphic designs, and Munn makes no references to native standards for judging the relative virtuosity of the makers of designs. Mountford (1961:7), in discussing Australian native art generally, remarks that "all aborigines are natural artists; I have yet to meet one who would not or did not want to paint." But then Mountford goes on to say, "Naturally, some are more skilled than others and take more care" (1961:7). Munn, however, says with respect to Walbiri sand story designs, "There were few married women at Yuendumu who did not have at their command a number of such stories and who could not recount them with fluency, expressiveness, and skilled use of sand graphics and gesture signs" (1973:63).

the informal drawings made in the sand by individuals as they sit on the ground talking or gossiping with each other. Munn (1973) remarks that the Walbiri "regard sand drawing as part of [their] valued mode of life, and as a characteristic aspect of their style of expression and communication. To accompany one's speech with explanatory sand markings is to 'talk' in the Walbiri manner" (p. 58).

More formalized are the "sand stories," told primarily by women, recounting traditional tales of the activities of the ancestors. In addition, both men and women use specific designs for body decoration. Accompanied by the appropriate songs and ceremonies, these will attract members of the opposite sex, or will increase the likelihood of a fertile union. As one man explained, a young married woman "might be painted on the breasts at a *yawalyu* ceremony to 'make her breasts large' and to 'make the milk come,' i.e., to encourage pregnancy" (Munn 1973:43).

The final Walbiri use of art is in the ceremonies performed by men for such important activities as initiating boys into adult manhood, insuring the procreative powers of the society as a whole, and so on. All of these events require decorated paraphernalia, some pieces of which are created especially for the occasion on which they are used, others being stored by the men in secret locations for use in subsequent ceremonies.

Walbiri Representation. If you look at Figures 3-7 and 3-8, which show several individual Walbiri designs, you might guess them to be purely ornamental with no clear-cut meanings attached to them (like the lines and circles of chrome that decorate most automobiles), or else purely abstract symbols having meanings but not resembling the things they represent. Munn has shown, however, that neither of these guesses is correct: The designs are actually iconographic.

Walbiri art, whatever the medium, uses a single iconographic technique whereby each one of a small number of elementary figures is given one or more meanings. Figure 3-7 shows three of the elements that women use in telling their sand stories. Note that while the wavy horizontal line (a) has only a single meaning, the circle (c) has 14 meanings and can in fact be used to represent any closed roundish object or any nondirectional encircling movement.

Note too that if we use our imaginations a little, in every case the element bears some similarity to the item or action it represents. For example, element (b) is in practice drawn by putting the finger in the sand and drawing it down, making scallop after scallop, a movement that resembles the repetitive step-by-step movements of dancers. Or, to take another example, the circle represents a fighting stick—but only one that is sticking in the ground and is thus standing upright. (By contrast, a fighting stick that is lying flat on the

a b c

Figure 3-7 Elements used in Walbiri sand story figures. (a) Grove of trees. (b) Dancers(s). (c) Nest, hole, water hole, fruits or yams, tree, prepared food, fire, upright fighting stick, painting material, billy can, egg, dog (when curled up in camp), circling movement, encircling object. (*After Munn, 1973.*)

ground or being held in a horizontal position is represented by a straight line.)

These elementary Walbiri designs may be used individually or they may be combined to make more elaborate figures with more specific meanings. Figure 3-8, for example, represents a tree. Note that only three elements—straight lines, circles, and wavy lines—are used, and since each may have more than one meaning depending upon where it occurs in the total figure, the elements can be used to represent an unlimited number of items or actions.

A representational system such as that of the Walbiri has both advantages and disadvantages. One might perhaps object that the system is too ambiguous: How is a person to know if a particular circle is intended to represent a water hole, a hill, a tree, or some other roundish object or movement? In practice this is not necessarily a problem since the representational context of the figure usually rules out all but the intended meaning. In the Walbiri case, other media may aid in specifying the intended meaning. For instance, as a woman tells a story she often gives some accompanying verbal narration of the tale so that others (including the anthropologist who is struggling to follow the proceedings) can tell which circle is a water hole, which a hill, and so on. Thus in the more down-to-earth usages of the Walbiri system of iconography, contextual clues effectively prevent misinterpretation of designs.

The question of ambiguity takes on a new significance, however, for the designs that are used by men for ceremonial pur-

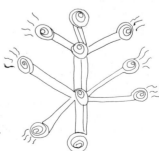

Figure 3-8 Walbiri representation of a tree. (*After Munn, 1973.*)

poses. The rituals themselves fall into several categories, but the most important are those from which women are excluded. These include the circumcision and initiation of young men into the adult men's lodges, and the *banba* ceremonies performed by lodge members to insure the procreative power of the group as a whole.

Objects used in these rituals are decorated with figures that are categorically called *guruwari*; Figure 3-9 shows three *guruwari* designs as drawn on paper by Walbiri with whom Munn worked. These are made using the system described above: Individual elements are given one or more meanings, and these simple elements are combined to create additional meanings. In the *guruwari* designs, the possibility of multiple meanings is not a liability. Rather, in the minds of Walbiri men, it is an asset that broadens the significance and enhances the power of the designs. A given pattern, by conveying several meanings at once, symbolically demonstrates the interdependence of the individual meanings. The term *guruwari* is itself an example of this. The word refers to a specific design—the actual pattern on a ceremonial object that depicts an ancestor and his activities during the Dreaming. But *guruwari* also refers to the ancestor himself and to his power of enhancing fertility and regeneration. Munn describes this power as "an essentially abstract or invisible potency left by the ancestors in the soil as they travelled through the country. *Guruwari* are both the essential visible forms and the essential invisible potency of the ancestors" (1973:29). In still other senses, *guruwari* refers to the ancestral spirit that enters a woman when she becomes pregnant and stays inside the infant when it is born. When the child grows up it shares this *guruwari* with other members of its lodge. Thus in the mind of an adult Walbiri, *guruwari* refers to the decoration on a tangible ceremonial object, and it is simultaneously equated with the essence of one's own life and the quintessence of the lodge's procreative power. And, most importantly, each of these meanings is strengthened through its association with the others.

Many *guruwari* designs, since they represent the activities of individual ancestors, include marks indicating the footprints or the tracks left by the ancestor as he travelled through Walbiri country. Here, too, the duality of meaning is valuable:

> When a man identifies conventional prints as *guruwari*, he may mean that they depict the footprints of the ancestor, and therefore are his *guruwari*, or he may be indicating that the prints are a particular ancestral design. Actually, for Walbiri, the one tends to imply the other. . . . Here we meet again with the circle of reality and reference so characteristic of Walbiri thinking: designs are among the marks made by ancestors in the country and they also *represent* such marks (Munn 1973:126).

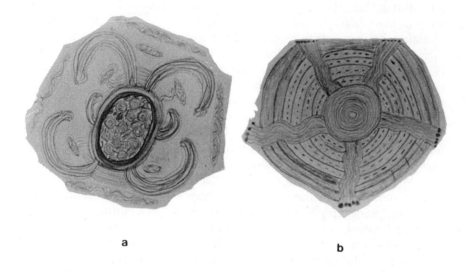

a b

c

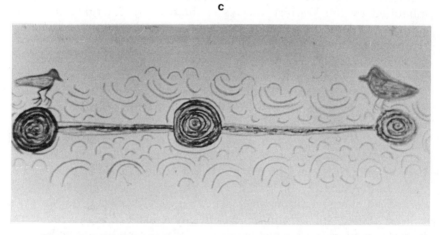

Figure 3-9 Walbiri drawings on paper. (a) Drawing of a ceremonial ground design, ceremonial boards placed around the sides. (b) Drawing of Rainbow Snake design. (c) Drawing of a Honey Ant board design. (*Photos courtesy Nancy Munn.*)

Munn suggests that in addition to the iconic meanings of Walbiri art that have just been described, the drawings also have more abstract, symbolic meanings. She notes that the stories told in each genre often have recurrent themes. Thus for example, stories told by women are ostensibly accounts of the mythic activities of the ances-

tors. But in fact they are seldom fabulous accounts of the deeds of superhuman beings; rather they tend to be homely tales of individuals who leave camp to gather food and then return to camp, who visit with friends and relations, who have families, and so on. That is, the stories depict the actual day-to-day activities that are experienced by Walbiri women themselves. These tales originate in women's dreams and, as Munn puts it, they are narratives in which "daily experience is, in effect, 'rerun' under the guise of ancestral experience. Its meaningful quality here comes to the fore: Life patterns are validated by being presented to the dreamer as 'tradition,' and yet are still constituted directly within experience" (1973:113).

Whereas the women's chief concerns, both in their daily life and in their art, are the practical problems of food and family, the men are preoccupied with problems of a sociocultural and cosmological nature: the relations between one kin group and another; the pattern of a local band's cyclic migration from water hole to water hole through the universe of the central Australian desert; and, most importantly, the ascertainment that the current generation of Walbiri will be followed by another generation. These concerns are mirrored in the art and stories of the Walbiri men. For them the recurrent theme is one of travels by the mythic ancestors through the land now inhabited by the Walbiri, always spontaneously emerging from the earth, traversing their route, and—like mortal Walbiri—ultimately returning to the earth.

Does Walbiri art have any additional symbolic significance? Some time ago Géza Roheim, an individual with a unique background in psychoanalysis and other areas, visited Australia. Based on what he saw, Roheim (1945) suggested that the symbolism of the central Australian peoples is primarily concerned with sexuality, with the many circles and straight lines representing vaginas and penises. Munn reports that Walbiri do indeed assign explicitly sexual meanings to some of the lines and circles in their art, but her more in-depth study of Walbiri thought reveals that the art is concerned with regeneration on a deeper level: It reflects the society's concern about its continued day-to-day existence and procreative powers, condensing several levels of Walbiri thought and action into a single icon. "It is as if," Munn concludes, "this figure constituted Walbiri life experience in time abstracted to its simplest, most general pattern. In the design system this abstract 'shape of space-time' provides the unifying format for the concrete variance of the species world" (1973:221).

Munn's analysis reflects a growing trend toward the application to art of the approach known as structuralism, as developed in cultural anthropology by Claude Lévi-Strauss, Victor Turner, and

others, and in linguistics by Roman Jacobson, Noam Chomsky, and others. The goal in every case is to discern the deeper structural patterns that underlie the surface phenomena of behavior—artifact, cultural tradition, or well-formed sentence. This trend is discussed at length in chapter 5's account of James C. Faris's analysis of Nuba personal art.

In chapter 2's discussion of the functions of art in primitive societies it was noted that art often helps maintain the cultural stability required for a society's continued existence, and that one way in which this is accomplished is through art's reflecting—and validating—the traditional underlying values and patterns of thought of the society. The present discussion of Walbiri iconography and symbolism leads to this same conclusion. Much of Walbiri art "merely" tells stories, but viewed as a whole, from the structuralist perspective of Munn (and her mentors, Turner and Lévi-Strauss), the narratives are actually only a single story—the story of Walbiri culture; and the art is a composite picture of Walbiri sociocultural thought. Both the daily and the cosmic experience of Walbiri life is, to use Munn's graphic phrase, "pumped into" Walbiri art; and from there it is pumped back into the imagination and consciousness of every living Walbiri.

For our present purposes the importance of this mechanism is that it is based on symbolism. Walbiri graphic designs have various kinds of meanings associated with them, ranging from the explicit and iconic to the implicit and symbolic. As vessels for cultural meaning they are sweepingly important for Walbiri society as well as for our own understanding of Walbiri culture.

Universal Symbols?

A discussion of symbolism in art would not be complete without reference to the question of universal symbols, that is, of specific figures that are found in all cultures, each figure having everywhere associated with it a single meaning or a cluster of closely related meanings. At the outset it should be noted that this is a controversial question, and whether or not a particular person feels that universal symbols exist seems sometimes to depend more on the person's disposition than on being convinced by firm and compelling evidence on the issue. One of the most annoying aspects of the debate over universal symbols is the lack of agreement as to just what sorts of evidence would serve to resolve the fundamental question of whether or not universal symbols do indeed exist.

Freudian Iconography. Much of the interest in the subject of universal symbols and icons derives from the psychoanalytic movement that began in the early twentieth century. Freud contended that part of an individual's imagery often has iconographic meanings: The long nose that one visualizes in a dream, for instance, may be both a nose and a phallus. In his earlier work Freud apparently felt that such imagery was personal and idiosyncratic, but by 1910 he had shifted his search in the direction of universal icons (Spector 1972:96), asking questions such as: Is a dream about a nose always and everywhere phallic?

This search has met with only mixed success. It appears that there are genuine cases of sexual iconography in the imagery of some other societies. For example, Munn's Walbiri informants candidly admitted that among other things their designs have explicitly sexual interpretations. They generally equated circular or ovoid figures with women or mothers and long, pole-like elements with men (Munn 1974:199).

There are, however, two difficulties with a narrowly Freudian approach to the imagery of other societies. First, thorough fieldwork in a given society often reveals that libidinous symbols are only part of the picture: Asexual imagery may be very important, too. As mentioned previously, the Freudian interpretation of central Australian art that Roheim made was not inaccurate—it was simply incomplete. To ignore the facts that, in addition to their sexual meanings, Walbiri circles stand for water holes and lines stand for paths is to miss the wider significance of the figures for Walbiri culture as a whole.

The second difficulty with a narrowly Freudian interpretation of artistic imagery is that for every piece of confirming evidence for cross-cultural existence of sexual icons, there are one or more cases that do not fit the pattern. Thus, for example, although the snake image is manifestly phallic to the Freudians, Mundkur (1976) has recently surveyed the cultural contexts of the widespread snake or serpent motif in the Americas and found that it was only rarely associated with sexuality or fertility.

Inasmuch as the sexual figures in question are icons, bearing some resemblance to the things they represent, rather than symbols, it is not surprising that cross-cultural similarities do occur. Sexuality and reproduction are literally vital topics in all societies, and although some cultures deal with these subjects explicitly (cf., e.g., Mountford 1960, Rawson 1973), in others representation may be less literal; and if this latter approach is used the resultant images must inevitably be Freudian icons of a sort.

The important conclusion to draw, I believe, is this: When approaching the art of any society, one may legitimately ask, "Might the Freudian model be helpful in explaining the meaning of traditional imagery?" On the other hand, it is much less useful to ask, "How can I make this society's imagery fit the speculations of a turn-of-the-century medical doctor who never lived outside of Europe?"

Jungian Symbolism. Carl Jung was an important early member of the psychoanalytic movement, although he parted ways with Freud in 1913. In his later days Jung professed no doubts that universal symbols exist; indeed, the notion was central to his entire view of man. Jung felt that all human beings, no matter what their cultural background, held in their minds a share of the "collective unconscious."[3]

The collective unconscious was never explicitly defined by Jung. He claimed, in fact, that its undefinability was one of its characteristic qualities. But whatever it is, Jung's collective unconscious includes the mysterious "human spirit" that reveals itself in all normal individuals, as well as much unconscious information that seldom, if ever, comes to the surface of human thinking and behavior. It does, however, emerge in certain human symbols, and this is where Jung's interests begin to coincide with our own.

Like the collective unconscious itself, Jungian symbols are never realized in their totality, but rather they have "a wider 'unconscious' aspect that is never precisely defined or fully explained. Nor can one hope to define or explain it. As the mind explores the symbol, it is led to ideas that lie beyond the grasp of reason" (Jung 1964:20). Approximations of symbols do, however, emerge from certain kinds of human activity, including dreaming, fantasizing, and the creation of art.

The universal symbols hypothesized by Jung and his followers are more abstract than those of Freud, and their meanings are inevitably imbued with a mystic aura. For example, Aniela Jaffé has claimed the circle, or the sphere, to be

> a symbol of the Self. It expresses the totality of the psyche in all its aspects, including the relationship between man and the whole of nature. Whether the symbol of the circle appears in primitive sun

[3]Members of primitive societies, however, were held by Jung to be in more intimate touch with the collective unconscious (cf. Jung 1964:24, 52). Cultural anthropology was not Jung's long suit, and until his death he clung to the view, proposed in the early 1900s by Levy-Bruhl, that members of primitive societies indulge largely in "pre-logical" thought. A romantic, however, Jung believed that such thought was generally healthier than the "logical" thought of westerners.

worship or modern religion, in myths or dreams, in the mandalas drawn by Tibetan monks, in the ground plans of cities, or in the spherical concepts of early astronomers, it always points to the single most vital aspect of life—its ultimate wholeness (1964:240).

The difficulty with a sweeping thesis such as Jaffé's is that its validity cannot be tested. The non-Jungian may object that although some circles do indeed symbolize unity and self, there are at least some circles that do not. (For example, the roundness of Eskimo igloos surely is largely determined by factors of design, rather than a mystical feeling of oneness.) And, the objector may continue, there are some symbols of unity that are not circles *or* spheres. (In Arabic numerals a straight line—"1"—represents unity, while a circle—"0"—represents either nothingness or is merely a place holder.) But the Jungian advocate may brush aside these objections: Whether he knows it or not, the Eskimo's igloo *does* symbolically reaffirm the oneness of his life; and the Arabic numerals can be discounted as a trivial exception that proves the rule. Or the objection might be turned around upon itself so that the circular zero figure, balanced as it is between positive and negative numbers, does indeed symbolize the real position of unity while the linearity of "1" reveals its departure from the perfect selfhood of zero!

What is one to conclude from an Alice-in-Wonderland argument such as this in which symbols can mean whatever partisans wish them to mean? Only, I believe, that the generality of the Jungian model of symbolism is too broad to be amenable to proof. Most contemporary anthropologists would agree with Raymond Firth's remark about mentalistic theories generally:

> The description of subjective experience, of thought and feeling pattern, is inferential, and should be supported by systematic reference to empirical observed behaviour. And I am willing to assert that this must be so, if anthropology is to maintain its claim to deal with symbolic process on a comparative basis (1973:85-86).

The cross-cultural quest for symbolic themes in the unconscious and subconscious realms is both fascinating and important for our understanding of human culture. Such a goal is at the root of one of the currently most viable areas of anthropology, the structuralism of Claude Lévi-Strauss and his followers. The structuralist approach requires both extensive ethnographic data and subtle analysis. Thus far structuralist methods have been largely confined to the topics of kinship, totemism, and mythology; a complete cross-cultural structuralist study of art has yet to be undertaken.

The "Heraldic Woman" Motif. Neither Freud's nor Jung's theories of universal symbolism has been supported by rigorous cross-cultural research and both are virtually unprovable because of their vague-

ness. There have been, however, a few studies of iconic motifs with very widespread distribution. One of the most convincing of these studies is by Douglas Fraser, a cross-culturally oriented art historian.

Fraser examined a vast number of art works from all over the globe, from both recent and ancient cultures (cf. Fraser 1966, 1972b), and made an interesting discovery: A figure he calls the "heraldic woman" has appeared intermittently for nearly 3,000 years, occurring in many locations ranging from West Africa, to the Middle East, China, Southeast Asia, many islands of the Pacific, and North and South America.

The heraldic woman, as Fraser defines the motif,

> refers to an image of a displayed female figure that is symmetrically flanked by two other beings. By "displayed" is meant a figure that holds its knees apart, exposing the genital area. The position of the hands, knees, and feet may vary somewhat. Femininity is made clear through the representation of the vulva or, in other instances, of the breasts. Symmetrical flanking may be said to occur when two beings, one on either side of the central figure, form mirror images or counterparts of each other (1966:36-37).

Figure 3-10 (p. 76) shows five examples of the heraldic woman, taken from four different continents and Oceania. The similarities between them are amazing; it seems highly unlikely that the resemblance is purely coincidental because the figure is so elaborate. Unlike such Freudian symbols as noses, circles, and the like, the heraldic woman is unlikely to have been simply "stumbled onto" accidentally in each of the several dozen societies in which it was fashioned.

The most likely explanation for the widespread occurrence of the heraldic woman figure is cultural diffusion, whereby it was developed in one locality—probably early in the first millenium B.C. in Luristan, a region now included in modern Iran—and then was adopted by neighboring cultures, leap-frogging its way across continents and oceans. From Luristan the motif probably travelled both southwest (ultimately arriving in West Africa) and east. Fraser suspects that the easterly movement occurred via trade routes that connected the middle east with the flourishing Asian cultures of the period—Late Chou in China and Dongson in Indonesia. From these oriental hubs, use of the design spread to the societies of the Pacific islands and, ultimately, to the western hemisphere. Some parts of this hypothesized journey have yet to be substantiated, but all of the currently available evidence fits comfortable into the theory.

The meaning of the heraldic woman design is more difficult to determine, since most of the specimens were created in nonliterate societies, long before the era of notebook-toting anthropologists. As far as speculation can carry us, however, it seems that the motif was

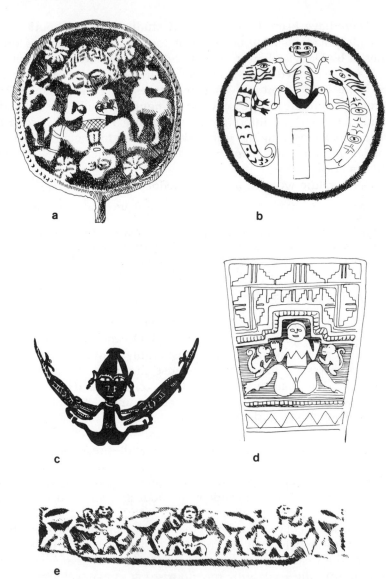

Figure 3-10 Five representations of the heraldic woman: (a) Bronze pinhead, Luristan (Iran). (*David-Weill Collection.*) (b) Nootka house painting, Vancouver Island. (*Originally redrawn from photos in Provincial Archives, Victoria, B.C.*) (c) Solomon Islands paddle (detail). (*Wilkes Expedition, U.S. National Museum, 2653; originally redrawn from photo by C. Schuster.*) (d) Stone slab, Manabí, Ecuador. (*Museum of the American Indian.*) (e) Lintel from a Bamileke chief's house, Cameroons. (*Originally redrawn from photograph from Musee de l'Homme, neg. no. 31.607.*) (*All after Fraser, 1966.*)

always associated with one (or both) of two themes: Either the figure was a symbol of fertility, renewal, and regeneration, or else it was associated with a defensive power against sickness or danger in battle.

The heraldic woman is not a truly universal symbol since there are many societies in which it does not seem to have occurred. (For example figures in European art resembling the heraldic woman are few in number, are apparently not of great symbolic importance, and are always lacking in one or more of the formal features that define the heraldic woman.) Nevertheless, the scope of its distribution, and the apparent continuity of the meanings associated with it, do make the heraldic woman motif a fascinating topic for study.

The crucial question with regard to the distribution of the motif is *why*? Why was this particular design so attractive to people in such diverse cultures that they were prompted to incorporate it into their own indigenous art styles? And why did it remain unchanged for nearly 3,000 years? These questions are truly enigmatic. As Lévi-Strauss has remarked with regard to another geographically wide-spread artistic pattern, "Stability is no less mysterious than change" (1963:252).

Following Jung's theories of the collective unconscious one could contend that the popularity of the heraldic woman results from its symbolic representation of some primal theme that is present in the minds of all humans. Fraser argues against this approach, noting that the two components of the heraldic woman had had a long previous existence. Justifiably, he asks:

> If the theme [of the heraldic woman] is so natural, why did it take the Ancient Near East (perhaps the most creative cultural matrix ever known) so long to synthesize the two elements—the [displayed] woman which dates back to at least 6000 B.C. and heraldic flanking which begins about 3000 B.C.? The two were not combined until after 1000 B.C. and even then only in a marginal area under extraordinary conditions (1966:79).

If a Jungian explanation is unconvincing, we are still left with the puzzling question of why the heraldic woman design, once created, spread through so many different societies. We can note, along with Fraser, that the genitals may be an arresting sight for members of societies in which their viewing is generally taboo. And, beyond that, the relation between female sexuality and the vital issue of reproduction is natural, not arbitrary. But how to account for the constancy of the details of the heraldic woman design? Further research may shed some light on the question, but since most of the information about the cultural context of the design and its diffusion

is irretrievably lost to the past, a complete and certain answer may never be ours.

Conclusion

Symbolism is a broad subject that has relevance for our understanding of many human endeavors, ranging from social structure and politics through religion and ritual to language and art. It is a difficult topic to grapple with because, though the symbols themselves may be tangible, the meanings they carry are intangible and often elusive. The distinctions that Peirce made between index, icon, and symbol are still useful tools for discussion, helping us avoid confusion as we discuss the various ways in which figures are attributed meaning.

Not all art in primitive societies is intended to convey specific meanings. The geometric pattern that colorfully decorates the sides of a pot or basket may be just that—decoration, conveying no more meaning than patterns on most American men's neckties. Careful fieldwork, however, sometimes reveals that patterns which we outsiders cannot decipher are indeed iconic representations of specific things, beings, actions, or ideas. The complex figures that characterize Northwest Coast art are a case in point: No matter how seemingly fragmented and distorted the design, the maker intended it to portray certain individuals or animals, and he had at his command a repertoire of techniques for carrying out his culture's style of iconographic art.

The art of the central Australian Walbiri has some parallels to that of the Northwest Coast in that specific objects, individuals, and their activities are represented iconographically. But whereas the only additional meanings associated with Northwest Coast designs is their function as "status symbols" for their owners, Walbiri symbolism has a deeper significance: Walbiri art symbolically reflects life and belief, both on the level of individual day-to-day activities and interests, as well as on the level of larger spatial, sociocultural, and cosmological issues.

The subject of universal symbols is fascinating; part of its attraction perhaps lies in its implied promise to provide a basis for shared understanding between all people regardless of their cultural diversity. Unfortunately, little substantial headway has been made toward rigorously establishing the existence of such symbols. The biggest stumbling block has been the vagueness with which the supposedly symbolic figures and their meanings have been defined.

There have, however, been a few well documented studies of

widespread graphic motifs. The heraldic woman, for example, has turned up on four continents and throughout the Pacific, always seemingly associated with one of two sets of related meanings. Careful studies such as Fraser's pursuit of this motif will lead to a better understanding of the process of cultural diffusion and of the appeal of such figures.

Symbolism is an iceberg whose tip is obvious, whose massive importance can be guessed at, but whose submerged features are currently either inaccessible or else accessible only at the cost of a great outlay of effort and ingenuity. In the past, very little enlightenment has been provided by either the tough-minded scientist with his penchant for classifying and quantifying, or the armchair romantic with his weakness for grand but unverifiable theories. The modicum of insight we now have has come from pursuing a middle course between these two extremes.

GUIDE TO ADDITIONAL READINGS

As noted at the beginning of this chapter, symbolism is a subject that concerns writers not only in anthropology but in a number of other disciplines as well. Anthropologists themselves have in recent years found it very profitable to consider cultures as symbolic systems and to analyze them accordingly. Firth (1973) and Geertz (1973) both provide useful overviews of the most important attempts in this direction. Notable ethnographic and analytic efforts are the writings of Lévi-Strauss (e.g., 1963, 1966), Victor Turner (1967, 1969), and Mary Douglas (1970).

The iconography and symbolism of Northwest Coast art is discussed in Boas's *Primitive Art* (1955:186-298); and the material is brought up to date by Bill Holm (1965, Holm and Reid 1975). Munn's *Walbiri Iconography* (1973), along with her shorter papers (1962, 1964, 1970, 1971, 1974) constitute an anthropological *tour de force*.

Other significant attempts to apply structuralist concepts to art appear in Leach (1974) and in Faris's treatment (1972) of Nuba design, discussed later in chapter 5.

Mundkur (1976) discusses the serpent motif, a theme which, like the Heraldic Woman, is distributed across several continents. The feline figure has received similar attention (cf., e.g., Benson, ed., 1972).

Other works of interest on art and symbolism (or iconography) are Paula Ben-Amos's "Men and Animals in Benin Art" (1976b), Forge's "Art and Environment in the Sepik" (1971) and Flam's "Some Aspects of Style Symbolism in Sudanese Sculpture" (1970).

Chapter 4

The Artist's Life and Work

The preceding chapters have discussed art as cultural artifact (chapter 2) and art as meaning (chapter 3), but what about art as the product of one person's—the artist's—creative activity? After all, the definition of art we are using focuses on the artist: Art results from a particularly skillful individual's work in one of the visual media. What, then, of the highly skilled individuals? Where do their abilities come from; what motives prompt them to make art; what status do they have in their society; how do they go about their work?

This personal aspect of art from primitive societies interests laymen and anthropologists alike. Over 50 years ago Franz Boas exhorted his students, "We have to turn our attention first of all to the artist himself" (1955 [orig. 1927]:155). However, with few exceptions, Boas's dictum went largely unheeded until the 1960s. Since then a number of anthropologists (and art historians interested in

nonwestern art) have lived with, and recorded the activities of, artists in a number of primitive societies. Nevertheless, there are still major gaps in the literature. First, the relative abundance of studies from Melanesia and from West and Central Africa makes all the more noticeable the unfortunate shortage of studies from the remaining parts of Oceania and Africa, to say nothing of Australia and the Americas. Second, virtually all the artists described to date have been men (notable exceptions are Bunzel 1972, O'Neale 1932, and R. Thompson 1969), but in many societies women are artists too, and our general level of ignorance of female artists in primitive societies is lamentable.[1] Finally, even if a fieldworker spends several years in a particular society, he or she will probably not be there long enough to follow the long-term development of individual artists. These shortcomings of the extant literature should be borne in mind by anyone attempting to draw cross-cultural conclusions.

Although we clearly are not operating in an area of perfect knowledge, neither are we in a state of total ignorance. Some very interesting information about artists in primitive societies has been collected. This chapter presents it in two sections, discussing first the development and training of the artist and his or her place within society, then turning to the artist's work techniques, tools, and materials, and the rewards he or she receives for producing works of art. (Several closely related topics are not presented here but are dealt with in subsequent chapters. Chapter 5 discusses the psychological aspects of the artist's training and the interplay of old and new ideas in the creative process. The last chapter of the book notes some of the similarities and differences between artists in primitive societies and those in the contemporary western world.)

The Artist's Life: Training

How does a member of a primitive society become an artist? This section will deal with this question in general terms, often illustrating particular points by looking at the development of an individual artist, Chukwu Okoro, a master carver among the Afikpo of West Africa.

[1]The relative numbers of male versus female artists in primitive societies are unknown. In the past most researchers have been men and they have, for various reasons, tended to focus on male artists. Throughout this book I have avoided using "he" and "him" with reference to artists except when the person in question is male.

Who Becomes an Artist? At one time or another each of us probably has wondered about the origin of artistic talent. Why is it, say, that I might have some musical ability while my good and otherwise able friend is tone deaf? Or why are your drawings of things easily recognizable while another person's best efforts need captions to help the unfortunate viewer make sense of them? As in all "nature-nurture" problems, there logically seem to be only two alternatives: The individual may either be born with talent, or else it may be acquired after birth through exposure to the person's sociocultural environment. The trouble is that upon closer examination neither of these two explanations seems very plausible. If talent is inborn then it must be transmitted genetically, but genetic research has not isolated an "artistic talent" gene, and most specialists do not expect to discover such a gene in the future. On the other hand, environmental explanations, such as formal and informal teaching and exposure to certain kinds of experiences, seem unable to account for the wide range of human variation, extending as it does from the child prodigy to the person who is "all thumbs."

If we ourselves are uncertain as to whether artistic talent is inborn or acquired after birth (or both), the same disagreement prevails cross-culturally. At one extreme are those societies in which it is believed that all individuals begin life with equal artistic abilities and that quirks of experience alone lead one person to develop his talents to an extraordinary degree. Thus, for example, Crowley, whose account of the Central African Chokwe was mentioned in chapter 2, says, "Every Chokwe considers himself at least a potential artist" (1973:222). A similar view is held by the Anang of Nigeria. John C. Messenger did fieldwork in an Anang village noted for its art. He found that not only could all men carve but that they could not understand the sense of his questions about the possibility of some youths failing to learn to carve (1958:22). Messenger does not report how the Anang account for the fact that some carvers develop skills that are exceptional even in Anang terms. That, of course, is the interesting question. Since Anang youths learn carving from their fathers or through an apprenticeship with a master carver, these environmental factors might well be called in to explain excellence.

A similar situation prevails among contemporary Eskimos in northern Alaska. Many men carve, but, as Ray notes, the carver himself is "the first to become realistic and to explain that the reason he carves so well is because his father began teaching him when he was very, very young" (1961:26). Indeed, so much importance is attached to parental training that of one who could not carve it was said, "He did not have a father" (1961:26).

The Afikpo of Nigeria have more ambivalent views with regard to the origin of artistic talent, as evidenced by the life history of Chukwu Okoro, a master Afikpo carver. (Simon Ottenberg's account of Chukwu appears in his excellent 1975 monograph, *Masked Rituals of the Afikpo; The Context of an African Art*. Ottenberg's book provides a great wealth of data, and interested readers are encouraged to go directly to it for additional information on Afikpo art and culture.)

Chukwu was a little over 50 years old when Ottenberg talked with him in 1960. Describing his childhood Ottenberg relates,

> Chukwu's father died when he was a year old and his mother remarried shortly after that. Both his father and stepfather were farmers. Chukwu believes that as a young boy he was "ordinary." He liked to fight and wrestle. He and his friends caught crickets and grasshoppers, pulling off their wings and roasting them or making grasshopper stew; they also caught and cooked rats and mice. They built miniature playhouses, played in the boys' house (ulote) in the compound, and took part in various children's games. Chukwu never went to school (Ottenberg 1975:67).

Teenage Afikpo boys are members of a mock secret society patterned after that of the initiated men. They stage masked plays, making their own masks for the performances. Chukwu's special artistic abilities were becoming apparent by this early time: The masks he made were, he says, the most popular ones; and in addition to masks for himself he made extra masks that he sold to other boys, "at a price of three medium-sized yams" (Ottenberg, 1975:68). Why was Chukwu specially blessed? When pressed on the point, Afikpo individuals fall back on supernatural explanations: "Skills are sometimes believed by Afikpo to pass down through reincarnation. Chukwu is a reincarnation of a former secret society priest. . . . While this man was not a carver, his association with the Mgbom secret society . . . puts Chukwu within a special group of ritual experts" (1975:69).

Finally, there are many societies in which artists are explicitly believed to be born, not made. The German ethnographer, Carl Schmitz, has reported that in the Sepik River area of New Guinea, one of the most fertile sources of art in the world, women believe that an infant born with the umbilical cord wrapped around its neck is destined to become a great carver (Schmitz 1962:xv, cited in Biebuyck 1969:14). Similarly, Margaret Mead (1971:137) has noted that the Mundugamor of the New Guinea highlands also believe that being born with the umbilical cord wrapped around the neck is a necessary requirement for a male infant to become an artist. (Interestingly, such a birth does not insure that the child will become an

artist: Mundugamor recognize that training is also necessary.)

Speaking from his experience in West Africa William Bascom notes,

> Whether a boy learns quickly or slowly and whether or not he becomes a successful carver or a poor one is explained by the Yoruba in terms of personal destiny *(iwa)* assigned to him at birth by the Sky God *(Olorun)*. If an apprentice can do better than his teacher, people know that his skill was given to him by the Sky God. . . . Soon after a child is born, the parents consult a diviner *(babalawo)* to learn about its destiny, and in order to achieve it, an individual may have to sacrifice to the Sky God at various times during his lifetime when instructed by a diviner to do so (1973:68).

In some cases the supposedly inborn artistic talent is a mixed blessing. The Gola of Liberia, for instance, feel that anyone who excels in the arts—not only carving, but also singing, dancing, music making, and story telling—was born with what we ourselves would call a "creative personality." But, according to Warren d'Azevedo, who worked among the Gola in 1956 and 1957, a child whose unique behavior indicates that he has special creative abilities,

> is an immediate as well as a potential danger to his family and fellows. He may be the agent of malevolent forces which bring sickness and death. He may be in league with an angry ancestor or a subversive soul from a rival lineage or chiefdom. Sorrow and fear surround such persons, and they may die young through the violence of some super-natural agency or of the righteous community itself. . . . If he achieves a degree of success in the world, and brings honor to his family and community, it is believed that he has mastered these forces and turned them to benevolent ends (1973b:283).

Thus folk explanations of the source of artistic ability parallel our own beliefs: Some are convinced it's inborn while others prefer to look for causal factors during the individual's life. Of course, folk explanations are merely attempts to give culturally satisfying answers to thorny problems, and such accounts may or may not reflect what truly occurs. Although it is a less satisfying answer, the actual situation surely must be that *both* inborn and environmental factors play a part in determining one's artistic abilities. The factors that combine to form what we call talent—inventiveness, hand-eye coordination, self-discipline, and so on—are highly plastic traits, reflecting both nature and nurture in varying degrees. The only real problem lies hidden in the phrase, "varying degrees." As in the western world, it is very common for artists in primitive societies to be the son or daughter of an artist. But until we develop a reliable method for objectively measuring talent or a means for quantifying the aesthetic value of individual works of art (neither of which is likely to happen

in the foreseeable future), there is no way to determine how much of the individual's abilities derive from his biological heritage and how much from his sociocultural heritage.

The Artist's Training. Given that at least part of the artist's competence is acquired from his or her cultural environment, how does this process take place? How does the artist acquire the motor skills and the knowledge of tools, materials, and traditional aesthetic values that are the prerequisities of being an artist? As might be expected, these questions do not have a single answer: There are various learning methods, ranging from informal self-teaching to highly formalized systems of apprenticeship.[2]

The importance of informal learning is significant, even in societies in which aspiring artists apprentice themselves to a master. Consider, for example, the man who is an expert carver. As a child, long before he attempted his first art work, he had probably used woodworking tools for other purposes, such as gathering firewood for his family's hearth. Also, he and his young friends probably had been making their own wooden toys for some time. The motor habits acquired in these extra-artistic chores eventually were adapted to artistic activities.

The skills gained through informal channels of learning are usually thought of as being generalized and diffuse, but a team of psychologists has shown that some well-defined cognitive abilities are also involved (Price-Williams et al., 1969). The psychologists gave tests to 12 boys living in a Mexican village well known for its pottery making; the test results were compared to those from another group of 12 boys living in a nonpottery-making village. It was found that the boys from the pottery-making village performed consistently better than the others in realizing that manipulating a given piece of clay—for example, starting with a ball of clay and rolling it out into a long cylinder—does not change the amount of clay present.

In addition to "learning by doing," there is a high likelihood that the neophyte artist watched the members of an older generation of artists pursuing their craft. (An important exception to this rule occurs in those societies in which artists work alone—by preference, in secrecy enforced by supernatural stricture, or because they wish to guard their trade secrets.) In any case, the young person certainly heard adults discussing art, picking out the strengths and weaknesses of individual mature artists and their works.

Informal learning is illustrated by the artistic development of

[2]Only the social and institutionalized aspects of art training are discussed in this chapter. The cognitive level of aesthetic instruction is dealt with in chapter 5.

Abatan, a Yoruba woman famous in her native Nigeria for her pottery, mud sculpture, and poetry. Although both her mother and maternal grandmother were also potters, Abatan received "no formal training, no deliberate lessons. She absorbed, very gradually (*díè-díè-díè*), technique and inspiration from constant observation of *Agbédèyí* [her mother] at work" (R. Thompson 1969:157). Abatan began making pottery herself when she was 12. Significantly, at first she only made items intended for everyday use—undecorated clay containers for food and water. Gradually her repertoire grew to include traditionally decorated pieces; but, as she reported to Robert Thompson, she was "between thirty and forty when she accepted and successfully finished the most demanding commission of all, the *awo ota eyinle*," that is, a large, earthenware vessel of central importance to shrines of the cult of Eyinle, one of the major gods of the Oyo Yoruba (1969:157). (An *awo ota eyinle* made by Abatan is shown in Figure 4-1.) With the creation of an *awo ota eyinle*, Abatan, whose first lessons came from watching her mother at work, attained the status of master of ceramic art.

A final note with regard to informal means of acquiring artistic skills concerns travel, an activity that is often mentioned as an important source of new ideas for artists in primitive societies. For example, the young carver among the New Guinea Abelam who is looking for commissions may, if he pursues his kinship ties, find himself working with artists in villages five or more miles away from his home. Although this is not a great distance topographically, there is such a diversity of art styles in this area that the would-be artist is exposed through such travel to a far greater range of approaches to art than he could possibly get if he only remained in the village of his birth (Forge 1967:78-79).

The Liberian Gola place a very high value upon travel to strange and distant places as a means of artistic development:

> Such travel is thought most likely to provide dramatic success and is a romantic and adventurous theme of Gola legend. It is said that very few can become great among their own people, but everyone knows of the marvelous exploits of those [artists] who have gone away and returned after many years, rich in money, wisdom, and followers (d'Azevedo 1973b:288).

Clearly the belief that talented youths can profit from travel is not limited to the administrators of student exchange programs in western colleges and universities.

Although informal channels of art instruction are important everywhere, many societies that produce a large amount of art provide some means of additional formalized instruction to those

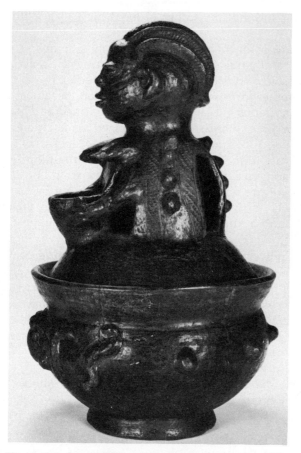

Figure 4-1 Ceremonial vessel made by Yoruba potter Abatan. *National Museum of Natural History, Smithsonian Institution.*

young people who are especially inclined to become artists. Often the teacher is an older, close relative of the aspiring artist—a parent, aunt, or uncle, for example. Such arrangements have been reported among people in the Eastern Solomon Islands of Melanesia (Davenport 1971:400), the Asmat region of New Guinea (Gerbrands 1967:170), the Nigerian Anang (Messenger 1958:22) and one group of artists among the Bangwa of West Cameroon, West Africa (Brain and Pollock 1971:44). The advantages of learning from one's near relatives are obvious: They live close at hand and the price is right in that instruction is free. One candid African artist told Himmelheber (1963), "I did not want to become a carver. I would have preferred to become a weaver. But since my uncle was a carver and was willing to

teach me for nothing, my father ordered me to learn this trade" (p. 84).

The flaw in such a system is equally obvious: If only a few individuals attain the status of master artist, then not all aspiring artists can have a master as a parent nor perhaps as a classificatory mother's brother or sister. Such a situation becomes increasingly common as societies get larger and more stratified and as the skills of the artist become increasingly specialized and different from the techniques used by non-artists (d'Azevedo, personal communication). A solution to the problem lies in providing some means whereby young artists can get instruction from master artists to whom they are not related. A simple method used by some neophyte Afikpo carvers is to work independently and then take the masks they've made to a known carver and ask for his suggestions (Ottenberg 1975:75).

Often, however, the relationship between student and teacher is institutionalized, with the young person formally becoming an apprentice to the master. The duration of the apprenticeship may or may not be culturally prescribed; payment to the master may come before, during, or after the training period, and may take the form of goods (food or trade items), services (helping in the master's household or with some part of the artist's work), or both. Having noted these possible variations that exist from one society to another, let's take a more detailed look at art training in a single society—the Chokwe of Central Africa.

Becoming a Chokwe Artist. As noted previously, the Chokwe and their art have been described by Daniel Crowley (1971, 1972, 1973), who conducted fieldwork with the Chokwe of Shaba (formerly Katanga) Province, Zaire. Chokwe art is attractive to westerners—specimens have found their way into numerous collections; and it is diverse, practiced in the media of wood, iron, clay, leather, bark cloth, and fiber. Some of it is used for religious or magical purposes, but much Chokwe art is secular.

Every Chokwe man considers himself a potential artist, but only a few are recognized experts who pursue art semiprofessionally and derive part of their income from making art items for sale to other Chokwe. (Even these individuals grow their own staple foods as a supplement to their art-derived income.) All Chokwe boys, at some time between the ages of 7 and 15, go through a formal initiation called *mukanda*. The affair lasts three months or so, and during that period the boys get their first instruction in the visual and performing arts—as well as in the subjects of sex, religion, and magic. Boys who show special aptitude in making the bark cloth and wooden

masks for which they are responsible may, after the conclusion of the *mukanda,* seek out a well-known carver for further instruction.

For such aspiring artists, Crowley says,

> the choice of carving teacher is based on convenience and family connections. Among the artists studied, many had learned from their father, but a large number had also been taught by maternal uncles or maternal grandfathers, since many rural Chokwe are matrilocal. Older brothers, nonrelated older boys and age peers were also mentioned as teachers. Most of this education is casual and unpaid, but sometimes a formal apprenticeship relationship is set up when a carver is otherwise unwilling or when there are a number of boys requesting training (1973:234).

When a formal apprenticeship is arranged between a young Chokwe carver and a master, payment to the master takes several forms: Sheep and goats are the most common medium of payment, but cash may be given too. And, of course, "the boy is expected to do all the hard work, gathering suitable materials, finding trees of the right size and species, sharpening tools, and what is more important, taking over the hated agricultural labor every Chokwe must do for sustenance" (Crowley 1973:234). The boy receives expert instruction (and, later, the prestige of having worked with a well-known carver), and there are some fringe benefits too: "Chokwe boys are glad to get away from their family elders, finding the carvers demanding in labor but lax in discipline, and enjoy the camaraderie of the other apprentices" (Crowley 1973:234).

Finally, with regard to the Chokwe case, some interesting signs of the times might be noted. Crowley (1973:235) reports that some young Chokwe now get art instruction not from traditional local carvers, but rather from the Ecole des Beaux Arts in Lubumbashi (formerly Elizabethville). Europeans at missions have taught others to carve. (Chapter 6 discusses in some detail the establishment of formal art schools in Third World countries.)

Art Training in Primitive Societies: Final Remarks. Before passing on to the next topic it seems appropriate to take stock of the material relating to the training of artists in primitive societies. It is clear, first of all, that learning *does* indeed take place; the artist is not a free spirit who spontaneously puts knife to wood to produce striking works of art. Rather he or she is one who has learned to use the artist's tools, the capabilities of materials, and, most importantly, the aesthetic values of his or her people.

Second, there has never been any doubt as to the importance of informal learning—of watching master artists at their work, of transferring into art work the skills that were first acquired in play,

subsistence activities, and so on. Nevertheless, the subject has sel-
dom received rigorous study, perhaps because informal learning is,
by definition, not institutionalized. Despite the difficulties involved,
however, it is a topic that should be the focus of future research.

Third, formal art instruction occurs in many societies, with
many variations in the actual arrangements. Although more is cur-
rently known about formal teaching methods than about informal
techniques, there are still many interesting questions to be answered.
For example, Ralph Linton suggested some time ago (1941:43) that
apprenticeships tend to occur in those societies in which an eco-
nomic benefit accrues to individuals with special training in art.
There is now enough data to put Linton's educated guess to the
test—at least for Africa.

Finally, the training that has been discussed above deals largely
with the skills of the artist. But what about his sensibilities—how
does he acquire the artist's vision? This topic will be touched upon
in chapter 5: suffice it here to say that this question is as important
as the ones we have been dealing with in the present chapter.

The Artist's Life: The Fruitful Years

What is it like to be a recognized artist in a primitive society?
How is one regarded by fellow society members? What are the
rewards of being an artist, and how does the artist fit into his native
society? Despite their intrinsic importance, these questions have just
about as many answers as there are primitive societies—or, even
worse, as many answers as there are individual artists in primitive
societies. But while every group and every artist is ultimately
unique, some patterns can be discerned. The following three sections
attempt to bring these patterns into focus and note the issues of
particular interest.

The Social Status of the Mature Artist. The artist, as defined in
chapter 1, is a person who displays exceptional skill in visual media
such as wood, clay, or fiber. Because of the person's special skill, the
artist is almost universally thought of in some special terms; most
societies have some sort of stereotype of the "typical artist." Al-
though there are inevitably some artists who do not fit the stereo-
type, the general views reflected in the stereotypes do illuminate the
artist's social status.

Just what that status is varies widely cross-culturally, but a
polarity does seem to exist: In many societies the artist is a highly
respected individual, while in many others the artist is relegated to

the lower rungs of the social ladder. Let's look, first, at a few cases in which the artist has a relatively high social status.

Often the artist's high position in his society is only an indirect result of his artistic activities. Northwest Coast carvers, for example, were generally accorded a relatively high social standing, but apparently this was because some of the pieces they carved could only be made by members of certain secret societies. Artists were initiated into the societies, and as a result of their membership they were looked up to by others. Although the "totem poles" and other items he created were very important for his fellows, the Northwest Coast artist seems to have received no material fringe benefits from his profession: He had no special privileges, wore no special clothes, and, interestingly enough, he had "no extra orientation to the supernatural in spite of his continual engagement in portraying supernatural beings" (Hawthorn 1961:63).

Sometimes the relatively elevated position of artists results from the economic aspects of their profession. Thus, for instance, a woodcarver in the Asmat region of New Guinea often has a somewhat better house than other people because the men he has carved for are obliged to help him build it, and their assistance results in his having a bigger house (Gerbrands 1967:36). Likewise, while he is engaged in a carving commission his patron will hunt, fish, and pound sago for him. While carving for festivals he and his family often get extra delicacies—"the hind foot of a pig, the tail of a crocodile, and especially the larvae of the capricorn beetle, the most ambrosial of all" (Gerbrands 1967:36).

In many New Guinea societies, and through much of the rest of Melanesia, men are avid "social climbers," each trying to surpass the other in gaining prestige. The ultimate goal is to become a "big man," that is, one who has gained enough prestige and political influence to get others in his village to provide goods for the feasts he gives and to generally accede to his will. In many groups one becomes a "big man" only through fairly ruthless economic and political maneuvering, but in others art provides an alternative avenue to success. In the above-mentioned Asmat region, high social standing is accorded to the successful artist—success being measured by the number of commissions he successfully executes. And in Abelam society, a man who is known for his artistic abilities, who can speak reasonably well, and who can grow satisfactory yams for exchange with his trading partner is considered a "big man." Significantly, though, the Abelam individual who becomes a "big man" through artistic expertise tends to be of a different temperament than other "big men" in that he is a less aggressive entrepreneur (Forge 1967:73).

Finally, there are some cases in which the artist is revered simply because he *is* an artist, rather than because of the social importance of the items he produces. For example, the Bush Negroes of Surinam, in northeastern South America, give much credit to persons who excell in any of the arts—the skilled carver, the exceptional singer or dancer, the outstanding story teller: All are said to be literally "favored by a god" (Herskovits 1959:42). Similarly, the Anang of Nigeria, like the Bush Negroes, admire artistic merit in all its forms. But as previously noted with regard to the Anang, a prestige-bringing artistic temperament is viewed as a mixed blessing: The artist's creative spirit may get the better of him and bring him harm, perhaps even an early death. Messenger records that one artist

> was compelled to discontinue carving for us as the result of almost nightly attacks by female witches, who forced him to copulate continuously and scratched his body during orgasm. We often dressed wounds inflicted on him by these beings, and he and others suffering from their assaults came to us for medicines to alleviate the various illnesses visited on them (Messenger 1973:103). ·

If some societies put their artists on a pedestal, others are much less charitable in their estimates of artists. No clear pattern has yet emerged to explain which view a given society will take. For instance, although artistic skill is a means of upward mobility among the above-mentioned Asmat and Abelam people in one part of Melanesia, just the opposite is the case in another Melanesian society. In New Ireland, an island in the Bismarck Archipelago off the northeast coast of New Guinea, adult males also aspire to become "big men." Here, however, the competitive game is played principally with native shell money. Being a carver of the ceremonial objects called *malanggans* does give a man some prestige, but Philip Lewis claims that "it is quite possible that of all the specialist roles [in New Ireland society], that of carver was most likely to have been a *cul de sac* on the road to becoming a 'big man.' Carvers spent more time at their work and thus had less time to pursue other 'big man' activities" (Lewis 1961:74). Prestige in New Ireland societies seems to come despite one's being an artist rather than because of it: In an early study of New Ireland, Hortense Powdermaker (1933:109) reported that the carver in one village was a "nonentity," whereas the carver in another village had much prestige—not due to his carving, but because of his extensive knowledge of *malanggans* and folk tales and because of his position in his clan.

Worse than being a dead end on the road to success, the practice of art may even be considered a useless waste of time. The Fang of western equatorial Africa, for example, feel that responsible

grown men should be occupied primarily with providing for their families and protecting the interests of their own lineages (Fernandez 1971b:200). But Fang religious belief requires the production of reliquary sculpture, so someone must take time off from his workaday activities to carve the pieces. Those who develop skill in carving are not, however, highly regarded. Fernandez sums up their status thus: "They rarely participated in debates in the council house though they occasionally contributed caustic commentary and ribald impieties from the peripheries. The contributions were appreciated, but carvers were not infrequently referred to as *okukut*—good for nothings" (1971b:202).

The Fang carver is not alone in his status as a "good for nothing." His counterpart in Dahomey, West Africa, is described in similar terms: "The Dahomean view of the carver . . . is that he seldom has the prudence to amass any wealth by his work—a very reprehensible fault, indeed, in the light of generally accepted native values" (Herskovits and Herskovits 1934:128).

The Afikpo mask carver is viewed in a similar light. He is often "considered a person who is foolish or silly; he is doing a 'funny thing' but nothing very serious"; his is " 'lazy man's' work" (Ottenberg 1975:66).

A final possibility with regard to artists' status is that they may constitute a distinct social caste. We westerners tend to think of the artist's status as one that is achieved rather than ascribed—that is, one that the individual works his way into, rather than being born into it. But such is not necessarily the case. Vaughan (1973), in one of the few in-depth accounts of an African blacksmith caste, notes that among the mountain Marghi of northern Nigeria members of the smith caste are viewed by other Marghi as a breed apart—not so much inferior or superior: just different. Their separateness reflects both their monopoly on metalworking and other cultural differences that set them apart from nonsmith Marghi.

To conclude this discussion of the social status of the accomplished artist in primitive society, a few summary observations are in order. First, it is noteworthy that the artist seems everywhere to *have* some special status. Whether he or she is looked up to or down upon, the artist is inevitably the focus of a special set of social beliefs and expectations. This fact may be overlooked in societies in which, say, all men display some proficiency at wood carving. But even in cases such as this, the expert carver, the person acknowledged to have significantly greater technical skill or more sophisticated aesthetic sensibilities, is inevitably thought of as somebody special.

Just how special, and whether the artist is considered "favored by the gods" or a "good for nothing" or something else again, varies widely, as does the extent to which art works reflect the personal and unique style of their makers.[3] In all likelihood the variation is not random, but probably reflects some other aesthetic or, more likely, social factors. It is probably significant, for example, that in two of the societies (New Ireland and Fang) in which artists are not given a high status, the individuals merely make the art works and have no special role to play in the use of their products. Is this a general pattern? It's an interesting question that deserves serious study; it would seem to have some relevance for artists in our own society.

Motivation: The Rewards of Being an Artist. Making works of art is not an easy business; it requires materials, time, energy, and concentration on the part of the artist. (When Hans Himmelheber asked one African carver whether he would rather work at carving or farming, he got this reply: " 'Carving is hard work. I even prefer bush-cutting to carving. For when cutting the bush I may pause once in a while to talk to the girls, whilst in carving I have to think all the time whether I should proceed this way or that way' " [1963:85-86].) Why does the artist go to all the trouble? "The answer," Edmund Leach has succinctly remarked, "is 'partly for fun and partly because the public provides a market for his work' " (1961:34).

Fun may be part of the artist's inner motivation for working, although pleasure seems more accurately to capture the satisfaction many artists derive from doing their work. The enjoyment may come directly from the act of making art itself, or else from the work's being a haven from the workaday world of the artist's society. Thus Ottenberg remarks, "In the achievement-oriented, individualistic way of life at Afikpo, [the artist] is free to carve as he chooses, regulated merely by his own strong sense of tradition" (1975:67). Chuku, the Afikpo artist whose life and work Ottenberg studied most closely, "is a quiet and nonabrasive person in a society in which a good many men love to talk and argue and give forth with oratory. He lives in a small compound, distinctly separated from others in the village, that is itself a peaceful place, lacking the bustle of some of the larger compounds" (1975:74).

[3]Thus d'Azevedo has suggested that "in some societies the identity and personality (style) of the producer adheres to the product and to some extent mediates its relative stature; in other societies the producer's identity is obliterated or usurped by those who commission the work or who take possession of it. Among the large-scale societies of West Africa the identity of great craftsmen is often an important factor in the value and appreciation of their work" (personal communication).

The artist may get other kinds of intangible rewards. The preceding section described several societies in which the artist's achievements bring prestige and high social standing within his or her group. And, insofar as the works take on a larger social importance, the artist can justifiably take pride in creating them. This can be particularly important if the products have religious significance: Through art the artist may be heir to all the emotional satisfaction that the supernatural realm can provide. (The romantic picture of the artist in primitive society who works in religion-inspired rapture seems, however, to be an overdrawn caricature.)

In addition to the possible pleasures of pursuing one's craft, the artist also often gets tangible rewards for his or her work—there is, in Leach's phrase, "a market." And the possible markets, Leach goes on to note, fall into three categories: "Firstly, the furnishing of religious ceremonial; secondly, the decoration of houses, boats, and personal equipment of wealthy and important persons; and thirdly, the provision of memorials for the celebrated dead—the last being a category that combines both secular and sacred functions" (1961:35).

The artist can capitalize on the market for art work in one of several ways. If there are apprentices the master will receive goods, services, or both in return for his instruction. More important, however, are the rewards the artist gets in exchange for the art he or she produces.

Chukwu Okoro, the master Afikpo carver in Nigeria who has been mentioned on several other occasions in this chapter, again provides a useful example. Afikpo carvers, you remember, are not held in particularly high esteem: Carving is "lazy man's work" in Afikpo society. Chukwu does, however, reap some economic benefits as a result of his artistic endeavors. The most important Afikpo art objects are masks that are worn by secret society members during performance of the numerous plays that the societies stage periodically. (Figure 4-2 shows Afikpo masks in use.) When a secret society member intends to participate in a play, he approaches a known carver such as Chukwu with his request for a mask. He may choose to commission a mask of his own, in which case he will pay the carver a small fee in cash or with some palm wine or tobacco. (It was Chukwu, remember, who even as a young boy was successful at mask making, selling his creations to other boys for "three medium-sized yams.")

There is, however, another option open to the Afikpo man who needs a mask. Some carvers have a stock of masks that they rent for ceremonial use. When Ottenberg talked with him, Chukwu Okoro

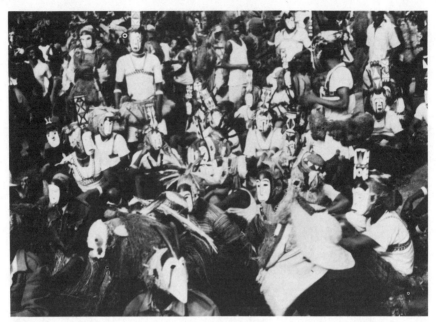

Figure 4-2 Afikpo masks in use. *Photo courtesy of Simon Ottenberg and the University of Washington Press.*

had 30 such masks that he retained for periodic rentals. When a secret society member wants to rent one of them from Chukwu,

> he makes arrangements a few days before the ceremony in which he will use it. Chukwu has a boy in the compound . . . who receives a small commission for assisting when he is not around. Persons usually ask for a specific type of mask. . . . Chukwu usually does not tell them what to bring in exchange for the rental, only "something" if they ask, and he seems reluctant to put the matter on a strict cash or contractual basis (Ottenberg 1975:75-76).

In practice the cash payment is small, amounting to about 20 cents in U.S. currency, perhaps supplemented again by some palm wine or tobacco. (That amount, which gains the use of the mask for only the few days during which it is used for a specific ceremony, appears to be roughly one-tenth the amount Chukwu would get for selling a comparable new mask outright.) Whether the mask is sold or rented, no ritual accompanies its transfer to another person, although Chukwu may give his client some advice on storing the mask or recoloring its surface before use.

Although a carver such as Chukwu may provide masks to several men before a big festival, mask making is far from a lucrative activity. Carving does not provide enough income to support artists as full-time or even half-time professionals; it must be supplemented

by subsistence activities such as farming, by trading, or by working in other traditional occupations such as carpentry.

Chukwu seems typical of many artists in primitive societies who have been described in the literature. Carving is not a road to riches and power, but Chukwu—in his small shed at the edge of the bush (Figure 4-3), working quietly by himself at his own relaxed pace, or listening to the gossip of his friends as they watch him at his work—seems to be living a life that is well suited to his temperament.

The Artist as an Integral Member of Society. One important aspect of the mature artist's life remains to be discussed, namely the extent to which the artist is an integral part of the society in which he or she lives and the mechanisms whereby integration is effected. This topic is especially interesting because it is a major way in which

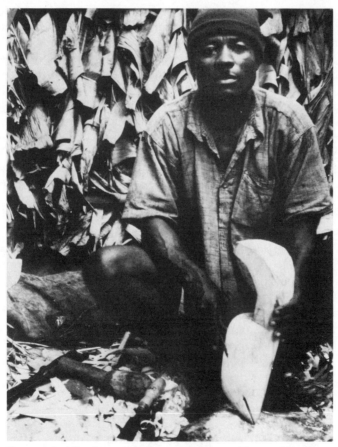

Figure 4-3 Nigerian master carver, Chukwu Okoro, 1952. *Photo courtesy Simon Ottenberg and the University of Washington Press.*

artists in primitive societies significantly differ from their counterparts in the contemporary western world.

The artist's ties with his or her surroundings are of various sorts. In the preceding discussion of artists' informal training, for instance, it was noted that the motor skills used in the production of art are often applied to other activities. Subsistence activities and the making of undecorated, utilitarian items both provide practice areas for art techniques. This is particularly important for the artist in primitive societies since, as a less than full-time professional, the individual may go for long periods without actually working on art items. Thus the techniques used in making art seldom set the artist apart from the social milieu but rather are an extension of the skills that are used in the day-to-day life of the artist and by other members of the society.

There is an even more important way in which the artist is an integral part of society: He or she typically shares the same value system as the society's other members. This applies to both aesthetic values as well as to standards in other areas of life. This point should not, of course, be carried to extremes. The artist is not "just like everybody else." But even though the artist is special, he or she can seldom adopt a style of belief or behavior that is radically different from that of others in the society. The artist lives and eats with nonartists, sharing their beliefs about the supernatural, enmeshed in the same web of kinship relations, and so on. In direct contrast to the often-heard stereotype of the contemporary western artist, with a Bohemian life style and eccentric beliefs, the artist in primitive society is usually a well-integrated member of his or her group.

The integration of the artist into the sociocultural milieu stems from two fundamental features of primitive societies. First, the relatively low degree of economic specialization characteristic of them means that the artist must participate in many non-artistic activities. Second, the fact that such societies have relatively small populations insures that the artist is in daily, face-to-face contact with many nonartists. In such a setting it is virtually impossible for the artist *not* to be highly integrated into the social system—either as an "unknown" whose skills go unrecognized, or as an eccentric who relishes a life of self-imposed alienation.

The Artist at Work

The preceding sections looked at the artist as a social personage. Here we see the artist at work—selecting materials, using tools, actually making art.

Tools and Materials. The term "primitive" sometimes carries connotations of simple and less developed. As noted in the first chapter, these meanings can appropriately be applied to the art of small-scale societies in one (and only one) way, namely with regard to the technology used to produce the art. The relative technical simplicity of art from primitive societies is seen in several ways.

Most significantly, art in primitive societies is based on a low-energy technology. The only source of power in most such societies comes from human muscle or from the heat given off by wood fires. The amount of energy available from these sources is minuscule by comparison to that which our own technology requires for such operations as sophisticated metal processing (mining, refining, alloying, casting, welding, etc.), chemical purification and synthesis (to produce and refine pigments, mediums, and so on), and other physical processes such as the production of large quantities of wood, paper, and canvas. As practiced today in our society, all these activities require energy in much greater amounts than is available solely from human muscle power and wood fires. The products are in a sense only tangential to the artistic process itself, but unquestionably the nature of western art would be drastically different in their absence.

The technology of art in primitive societies is less complex than its western counterpart in two additional ways. First, all (or most) of the materials used are derived from the artist's local area. This, of course, limits the range of materials available for the artist's use. (Granted that extratribal exchange of art materials is relatively common and that far-flung trade networks have sometimes existed in the past. Nevertheless such importing of materials is the exception rather than the rule. By and large artists' work is conditioned by the materials available in their local environments.) Second, the artist can seldom call upon the skills of others to supplement his or her own expertise. Apprentices and patrons may help with the less complicated parts of the work, but the artist obviously can never consult with a metallurgist, a paint chemist, or a lumber importer.

It must be stressed that the technological simplicity being discussed here is only relative, based on a comparison with our own society's elaborate methods. In absolute terms, the tools, materials, and methods used in primitive societies are often ingenious. Again, Chukwu Okoro, the master Afikpo carver, illustrates the point.

Chukwu uses only two or three kinds of wood for masks. These species are apparently chosen for practical reasons: An analysis of samples taken from masks he made revealed that they were all made from woods that are relatively light in weight and that have short, parallel fibers. Of these woods, Chukwu uses the lightest for masks

that have no major projections; a stronger, somewhat heavier wood is used for masks that do have projections. If possible, Chukwu cuts wood for a mask as much as six months before he intends to carve it. This gives him time to soak the wood in water for a while before drying it, a process that Chukwu considers necessary to soften the wood for carving and also to prevent its splitting. Apparently the method works: Ottenberg remarks that "none of the masks that he made for me has cracked seriously; only a few have minor splits, although some of them are now twenty years old and have been through all sorts of climates" (1975:76).

In contrast to the pattern found among artists in many primitive societies, traditional Afikpo carvers did not make their own tools. Chukwu himself now includes several western items in his tool kit— a penknife, sandpaper, and so on. Previously carvers got their tools locally from men who were members of kinship groups that specialized in blacksmithing. In Chukwu's father's time, carvers used the following tools:

1. A small adz called *atɔ*, short for *atufu* (to burrow out), a term used for a range of carving tools. This one had a wooden handle and was employed for general shaping and rough work.
2. A U-shaped blade of iron with wooden handles at both ends, also called *atɔ* and used to cut out the insides of the masks.
3. A long iron chisel, without a handle, again called *atɔ*, which was employed to carve out eyes, mouth, and other parts by being hit with a rock or a piece of wood.
4. A long, thin rod of iron, about 10 inches long and ¼ to ½ inch wide, called *ahia* (borer), which was heated in the fire and used to bore holes for the raffia attachment and for other purposes, as well as being used heated to blacken small surface parts of the mask.
5. A wide, flat piece of iron, or a machete, also heated in the fire and used to blacken larger surfaces.
6. Another machete was used to cut the original block of wood and for rough work on the mask.
7. A leaf, *anwɛrɛwa*, which is used when fresh, acts like sandpaper, being fairly fine-grained.
8. An iron needle, *ntutu*, about 3 inches long, for sewing up the raffia on the backing of the masks (Ottenberg 1975:76-7).

The traditional Afikpo tool kit, small though it is, is larger than that used by artists in many other primitive societies. Yoruba carvers, for example, use only two knives and two adzes (shown in Figure 4-4), plus a larger adze for the felling of trees and an ax for splitting logs.

After carving is complete, Chukwu adds a raffia backing. Currently the raffia is purchased from traders; presumably it was produced locally in the past. The addition of color is the last stage in the

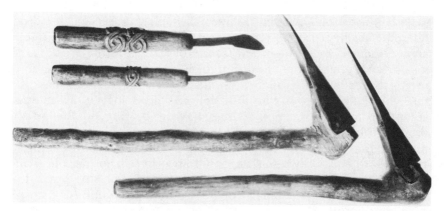

Figure 4-4 Yoruba carver's tools from Oyo, Nigeria. Sizes (top to bottom): 9¾ inches, 9½ inches, 14 inches, 16 inches long. *Lowie Museum of Anthropology, University of California, Berkeley.*

creation of an Afikpo mask. Feathers were traditionally used as paintbrushes, sometimes supplemented by thin wood sticks or wood shavings. The traditional palette had four colors, each of local origin. Ottenberg describes their production as follows:

Black. The traditional way to achieve this coloration is to blacken the surface with a very hot iron rod, a flat iron piece, or a machete. If the oil from a few roasted palm kernels is applied to a surface that has been blackened by searing, it becomes darker. . . .

White. Traditionally *nzu*, a chalk mined at Afikpo, is used to add white to a mask. It is also produced in considerable quantities in nearby Edda Village-Group, from where it is traded to Afikpo. . . . Another white chalk sometimes used is *nzu ɛja*, which is mined at Afikpo. Although prepared in the same manner as *nzu*, it is not as smooth and fine. . . .

Yellow. This coloring is traditionally made from the yellowish bark of the ɔkwoghɔ tree. . . . The bark is rubbed on a moist, flat stone, *npumɛ odo* (stone-*odo*), usually by women, and a substance comes off that dries into a powder and is kept in cake form.

Red and orange. The *uhie* color is traditionally made from camwood . . . by rubbing its wood (not its bark) on a moist, flat stone, *npumɛ uhie*, and collecting the powder, which is stored in cakes (Ottenberg 1975:81).

Considering the tools and materials that are used in Afikpo art production one by one, each is seen to be an ingenious utilization of something from the local environment. But considering the Afikpo art technology as a whole, the range is far narrower than that available to the contemporary western artist.

A fundamental question regarding technology remains unanswered, however: Does the relatively limited range of tools and

materials available in primitive societies place a serious handicap upon the aesthetic expression of the artist? On the one hand it can be argued that the most important feature of art lies in the artist's skill, vision, and sensibilities, and that tools and materials are merely a means for realizing these quintessential qualities. Common sense, on the other hand, tells us that although the technology of art may be secondary to other factors, it does have a bearing on the artistic product, placing restrictions on the options available to artists and limiting the range of things that can be created. For example, a palette such as Chukwu's, with only four colors including black and white, unquestionably can be used to produce fine art, but a less chromatically restricted palette opens up new possibilities. With regard to color it is significant that artists themselves in primitive societies are usually eager to enlarge their palettes when possible. Chukwu, for instance, now gets blues, browns, and greens from imported paints and shoe polishes.

Perhaps the best answer to the question posed above is this: Primitive technology does indeed place some restraints on artists in primitive societies, limiting the range of what they can do. But if art is thought of as the skillful manipulation of visual media, then even the simplest material cultures have some domains in which a high level of skill can be exercised; that is, even the least complex human technologies provide a sufficient basis for the production of valid art.

Making a Work of Art. Creating a work of art is a process that takes place on two levels, in the artist's mind as well as in his or her hands. Chapter 5 looks at the former of these two levels—the cognitive aspects of artistic production. The other level, the actual material creation of the piece, will be dealt with here. As has been the case throughout the present chapter, diverse primitive societies exhibit a wide range of approaches. Again our approach will be to note the many possible methods and then describe in more depth the situation in one particular society.

The artist in primitive society may have certain ritualistic restrictions placed upon his mode of work. Our Afikpo friend, Chukwu, for example, can only work in a place where he won't be seen by women or by young males who have not yet been initiated into the secret society whose members use Chukwu's masks (Ottenberg 1975:72). (Navaho and Pueblo silversmiths sometimes also prefer to work in solitude, but not for ritual reasons. They merely want to avoid distractions, and some wish to protect their trade secrets, thereby keeping a partial monopoly on the market [cf. Adair 1944:92].)

A different type of prohibition is placed on the Anang carver:

He should avoid sexual intercourse on the night before he begins carving a major piece because, the Anang believe, intercourse weakens one and diminishes a carver's skill, creativity, and desire to carve (Messenger 1973:109). Cross-culturally, restraints such as these seem more the exception than the rule. As the Afikpo and Anang examples illustrate, they may be based upon beliefs about either the artistic product or the artistic process itself.

A second area of variation lies in the pace at which the artist works. Most Fang carvers, for instance, proceed in a leisurely fashion, interrupting work on a mask for several weeks or a month, whenever other duties such as plantation work beckon them (Fernandez, 1971b:200). Two carvers told Fernandez that "a figure or a mask only took shape gradually, as the spirit moved the carver, and it could be rushed only at the sacrifice of its quality" (1971b:200).

At the opposite extreme from the Fang are the carvers among the Anang and Yoruba. They typically work with intense absorption, going from the beginning right through the end of a project, pausing only long enough to appraise their progress occasionally or allow the completed work to dry (Messenger 1973; Bascom 1973).

The Abelam Artist at Work. Anthony Forge's description of artists among the Abelam can be used to breathe some life into the foregoing generalizations regarding the artist at work. About 30,000 Abelam live in the north-central foothills of the New Guinea highlands. (This location is not far from the Sepic River, and Abelam art shares many common features with the well-known art from the Sepic region.) The Abelam live in villages of 300 to 800 people each, subsisting on cultivated vegetables as well as food obtained from hunting and gathering.

Most Abelam art is made for use in the so-called tambaran cult, an institution into which young men are initiated by means of eight successive ceremonies that occur over a period of ten or more years. Forge describes the cult and associated ceremonies in some detail (1967; 1971), but for our present purposes only a few features need be mentioned. During each of the eight tambaran ceremonies, initiates are shown art objects of one sort or another and are told that the objects are manifestations of a major class of spirits. (At each ceremony after the first, the initiates learn that the previously viewed objects were not actually the spirits themselves, but that this time they will see the "real thing.") During the last ceremony the initiates are shown the most sacred objects, and after that the whole process begins again, with the new cult members acting as initiators for the next generation of Abelam males.

The items shown to the tambaran initiates require carving and

painting. The first ceremonies in the cycle involve painting only—on the floor of the ceremonial house and on flat wooden panels. Such panels are used in all eight stages of the ritual cycle, but in later stages they are supplemented by increasingly elaborate items carved in the round from softwoods. These too are painted, but painting and carving are always two distinctly different processes, carried out in different settings and manners (see Figure 4-5).

Abelam painting is supervised by one man who is recognized for his artistic skills, but he is assisted by several other initiated men. The artist apparently has the whole design in his head before he begins. With materials at hand, he starts by outlining a design in white paint, using as a brush a single chicken feather, made pliable by bending. He may use some mechanical aids—a length of split cane to work out the proportions of a design relative to the panel upon which it will appear, or a piece of cane tied into a circular ring to serve as a template for curved lines. Usually, though, he works freehand, building up the design from one side of the panel to the other, or from the head of a sculpted figure downward.

When painting, the Abelam artist works with great speed, boldly laying out the white outlines of designs that are traditionally appropriate for the panel or sculpture he is working on. As soon as he finishes outlining a small part of the design he tells one of his more skilled assistants to go around it, painting a red or yellow line right beside the white one he has just put down. He himself continues, outlining more of the planned design with his chicken-feather brush, but keeping an eye on the work of his assistant, whose own work may be followed by that of another assistant, using another color. As the doubling, or trebling, of the design in one area is completed, the artist instructs yet another assistant to fill in remaining solid spaces with single colors, a duty that requires less skill than the painting of outlines. Even less skill is needed by the additional assistants who paint rows of dots or who work at making more paint. In all the artist is typically supervising the work of eight to ten helpers, in addition to drawing the outline of the design itself.

The swirl of activity attendant to Abelam painting stands in marked contrast to the quiet, contemplative atmosphere that surrounds the Abelam artist as he carves. He works in a place that is set off from the normal activities of the village, always in the shade to minimize the possibility of the wood's splitting. One assistant may be present to do some occasional minor task, but otherwise company and conversation are not welcome. A person interested in learning the carver's skill—whether he is a young Abelam man or a visiting anthropologist—must be prepared to spend a great deal of time

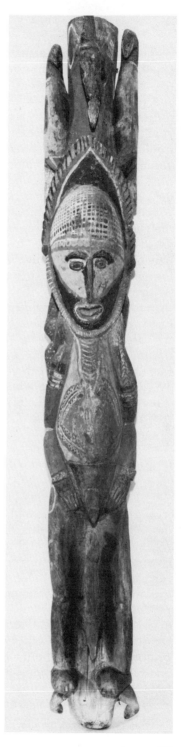

Figure 4-5 Male figure, northern Abelam area, New Guinea. Painted wood, 81 inches tall. *Spencer Museum of Art, University of Kansas.*

silently watching the artist as he carves or as he simply sits staring at and thinking about the piece he is making.

Besides the strikingly different pace at which Abelam carving and painting are carried out, there are also differences in the ritual restrictions placed upon the artist. According to Forge, "Men who are going to participate in painting bleed their penes and must abstain from all sexual contact until after the ceremony; meat and certain vegetable foods are forbidden, but they can and do eat large quantities of the yam soup and finest steamed yams" (1967:75). By contrast, the artist as carver is under no ritual prohibitions whatsoever.

This account of the Abelam artist at work illustrates several of the generalizations made in the preceding section. It shows that the artist's work—his pace, his use of assistants, and so on—varies not only cross-culturally but may also vary within a single society. Interestingly, at least one art historian with no first-hand experience in Abelam culture feels that the Abelam practice of combining two distinctly different techniques is "unsuccessful"—at least in terms of his own aesthetic values. He claims that while "the painted designs of these forms . . . create an intense, spiritual quality, particularly in the faces, they produce an over-all visual excitation that tends to fragment the object both compositionally and expressively" (Wingert 1962:210). That native Abelam art critics would concur in this opinion seems unlikely, but Wingert is correct in his educated guess that Abelam art reflects two dissimilar styles of approach.

Conclusion

The task of all the sciences, the social sciences included, is to look at the world around us with all its variety, to discover and describe patterns in this diversity, and finally, to try to understand the fundamental principles that underlie these patterns. The cross-cultural study of artists thus far has been largely confined to description, but even here there are interesting variables that remain to be explored, such as differences in the rates at which art works are produced.

As a catalog of diversity, the present chapter should convince the reader that easy and certain generalizations about "the artist in primitive society" should be viewed with much suspicion. There is enormous variety from one culture area to another, from one society to another within a single area, from one artist to another within a given society, and sometimes even between an artist's work in one setting and another. Some broad patterns can be discerned, however, and they are listed below. They are highly general and, for the most

part, they tell us more about what artists typically are not rather than what they are. Nevertheless the generalizations have some value in that they are antidotes to some popular misconceptions about artists in primitive societies.

First, primitive art is not anonymous. A given piece, by the time it finds its way into a museum collection in Europe or America, may seem that way to us, but this fault is ours: We may be ignorant of the maker, his background, and his purposes, but in its society of origin the maker's signature is written all over the work (cf. Gerbrands 1967:13-15; Sieber 1976). The exceptional person who creates art is inevitably recognized as being the possessor of special skills and abilities. The nature and extent of this recognition varies widely, but it seems to exist universally.

Second, art in primitive society is nowhere a simple untutored outpouring of emotion on the part of the artist. The society from which the art comes has traditional aesthetic standards, and the artist strives to meet these standards. In some instances the artist, once started on a piece, works with abandon, but even in these cases the product reflects much practice and forethought. As the case studies presented in this chapter have shown, any supposed parallel between the work of a mature artist in a primitive society and the creations of children or psychotics in our own society is altogether spurious.

Third, the artist is not necessarily an impractical person, totally engrossed in art and oblivious to other matters. An important feature, indeed a definitive feature, of primitive societies is the fact that no individual specializes full-time in any one activity. Thus the person who is an artist is also by necessity a hunter or gatherer, a father or mother, and so on. The artist's personal status may range from that of a respected elder to a good-for-nothing but he or she is never an alienated rebel, marching to the beat of a different drummer. Thus it is imperative that the artist be considered in the context of his or her own society and that art work be viewed in the context of the traditional values of the maker's fellow artists and critics.

Finally, the artist's social integration sets certain limits on the artistic freedom he or she has. Not only is the art work constrained by traditional tastes, but also the media in which the artist works is limited. One source of limitation is technological: Only certain tools and materials are available to members of primitive societies. But societies commonly limit the range of usable media even further. Often the limitation is sex specific. For example, male Northwest Coast artists worked in wood and similar media, and painting "totem poles," masks, boxes, and many kinds of decorated utilitarian objects. Female artists in the same societies did not carve at all; weaving and basketry were the media of their aesthetic expression.

Interestingly, the styles adopted by male and female Northwest Coast artists differed significantly too. Men utilized a curvilinear style to depict people and animals, utilizing the elaborate techniques described in chapter 3. By contrast, women used an angular, geometric style to portray plants and inanimate objects and to make (for the most part) nonrepresentational designs. Look at the Tlingit baskets shown in Figure 4-6 and compare them to the Tlingit mask of Figure 3-1; the contrast between men's and women's styles is striking. The sex specificity of art styles found in Northwest Coast societies occurs elsewhere also. The important point is that artists' usable media may be restricted not only by technology but by cultural convention as well.[4]

The cross-cultural study of artists is still in its infancy; much research and analysis has yet to be done. Specifically, and as noted previously, more information is needed on female artists and on artists from places other than West and Central Africa and Melanesia. Also there is a serious need for descriptive studies of artists in prehorticultural societies such as those of the Eskimo, Kalihari Desert, and central Australian groups.

Description, however, is only the first step toward understanding. The search for patterns, and more importantly, the explanation of patterns, is a job that has hardly begun. Certainly there are many interesting issues to be explored. For example, whether or not an artist receives extrinsic rewards for his or her work varies cross-culturally; is this variable correlated (and if so, how) with any aesthetic differences in the art or economic differences in the society? What sociocultural factors tend to promote a high level of artistic output in a society? This question has been asked for some limited areas (Houlihan 1972; McGhee 1976; A. Wolfe 1969), but a synthesizing, global approach might now be attempted.

[4]With regard to sex specificity of media, there might be a cross-cultural tendency for men to carve wood and stone and for women to work in fiber. There are so many exceptions to this pattern, however, that the apparent rule may partly be a result of reporting bias. Daniel Crowley has noted some of the exceptions:

> Women are the weavers in the American southwest, but men are in Africa. Men of the Northwest Coast Indians design the Chilkat blankets by making drawings on boards, but women do the actual twining process. Men are the potters in Europe, India, and central Africa, but women are in west Africa and the Americas. Bark cloth is made by men in Africa, but by women in southeast Asia. Baskets made for the home are usually the domain of women, but men may make baskets for sale (1968:431-32).

In view of all this diversity, perhaps the most nearly universal rule is that, as Crowley has observed, in every society the division of labor does exist and a given society's rules are "usually considered a 'law of nature,' the breaking of which brings serious consequences" (1968:432; see also Burton, Brudner, and White 1977).

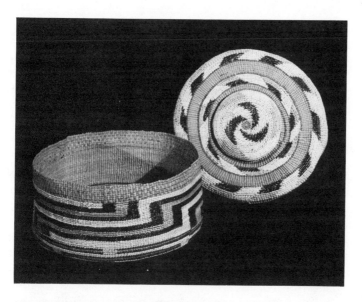

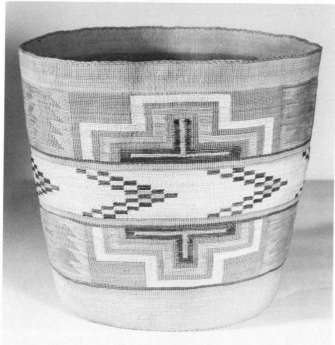

Figure 4-6 Tlingit baskets. Top, lidded rattle basket. Probably collected ca. 1900; 8 inches in diameter, 3½ inches high with lid. *Courtesy Kansas City Museum of History and Science.* Bottom, unlidded basket, nineteenth century. 16 inches by 13 inches. *Nelson Gallery-Atkins Museum, Kansas City, Missouri (Nelson Fund).*

There is, so to speak, an art to doing science. The art lies first in deciding which questions are important and interesting, and second, in selecting from these questions those that can profitably be pursued, given the information presently available or obtainable. The future should see some artful asking—and, one hopes, answering—of questions with regard to artists themselves.

GUIDE TO ADDITIONAL READINGS

Detailed accounts of individual artists in primitive societies are few in number. Two symposia have been held on the subject; in both instances the papers that were presented have been published: *The Artist in Tribal Societies* (1961), edited by M. W. Smith, has articles dealing with artists from several continents, while *The Traditional Artist in African Societies* (1973), edited by Warren L. d'Azevedo, confines itself to sub-Saharan Africa. Himmelheber (1960) also deals with artists from Africa.

Traditional African artists have been the subjects of several papers, with Carroll (1961) and Chappel (1972) discussing Yoruba artists, d'Azevedo (1966) dealing with Gola artists, and Wolfe (1951) briefly describing the work of an innovative Ubangi carver. Brain and Pollock (1971) provide substantial information on traditional Bangwa artists.

Culture areas other than Africa have received relatively less attention, although books and articles about art in particular societies typically give some information about artists' training, status, methods, etc. For the Americas, the classics by Bunzel (1971 [orig. 1927]) on Pueblo potters and O'Neale (1932) on Yorok-Kurok basket weavers have been supplemented only by Ray's account (1961) of Alaska Eskimo artists.

For Oceania, Gerbrands (1967) provides an extended discussion of carvers in the Asmat region of New Guinea, while traditional Maori artists were described quite some time ago by Firth (1925).

Chapter 5

Where Does It All Come From: The Psychology of Art

From one point of view, all of human culture exists only in people's heads. From this perspective culture is composed solely of traditional rules, beliefs, and expectations, all of which are actually mental constructs; human behavior and artifacts reflect culture, but are themselves once removed from culture itself. A psychological definition of culture such as this one has some shortcomings: How, for example, is culture to be studied if it has only an abstract cognitive existence? Nevertheless, such an approach clearly has applicability to the cross-cultural study of art: Traditional aesthetic standards, the artist's own imagination, and the viewer's affective reaction to a work of art are of primary importance; the object itself and the skillful activities that went into its production are interesting, but they, again, are imperfect reflections of the mental processes and constructs that exist only in people's minds.

The present chapter surveys the current state of our knowledge

of the psychological level of art cross-culturally. A number of specific questions will be dealt with, but two general issues weave their way through the entire chapter: What is the source of the artist's ideas for the art works he or she creates? And what are the processes through which these ideas are developed and modified before becoming manifest in actual works of art?

Sources of Ideas: Creativity and Copying

The chief concern of the present section is the wellspring from which the artist's ideas flow. But before tackling that subject, two preliminaries must be dealt with: First, a working definition of "creativity" will be presented; then some background information on Pueblo history and culture will be given, data that is relevant here in that Pueblo pottery and its makers are a central concern of the pages that follow.

The Meaning of "Creativity." When theologians speak of "creation," they are referring to an act whereby a divine agent brings something into existence where previously there had been only a void. With reference to the natural world, however, creation is usually given a somewhat different meaning. An an oak tree grows, "created" by natural biochemical and physical processes, what is new is not the components of the tree itself, since they had all existed previously somewhere else in the earth's crust or atmosphere. Even the tree's design is not new: This too predated the tree, present as it was in the genetic code carried by the acorn from which the oak tree sprung. What *is* new is the unique arrangement that these elements have taken on; never in the history of the universe have these particular components been in this particular arrangement.

When humans create something, the process is like that of natural forces creating an oak tree rather than like supernatural forces creating something from the void. The process is often awe-inspiring in its results, but for the present we can only assume that it is natural, not supernatural. When a person creates something, close examination of the product inevitably reveals that it is actually only a new arrangement of things or ideas that had existed before (cf. Barnett 1953). It may be more complex than any of its antecedents in the same way that an oak tree is far more complex than the carbon dioxide, water, and other chemicals that compose it; nevertheless, it does have antecedents.

Every human-made artifact is the result of an act of creation; even if it closely resembles another artifact, it is in some respects a

unique arrangement of things and ideas. The topic that concerns us here is the creation of those artifacts that we call art. What are their antecedents; what are the sources of the artist's inspiration?

Pueblo Culture and Pottery. Information bearing upon the pychological level of art comes from field studies in many societies, but the richest single source is Ruth Bunzel's *The Pueblo Potter: A Study of Creative Imagination in Primitive Art.* To put Bunzel's work in its proper ethnographic perspective, a brief overview of Pueblo culture and pottery is in order here.[1]

The American Southwest is a veritable gold mine for archeologists for several reasons: First, the dry climate increases the likelihood that prehistoric human artifacts and plant pollen still remain for us to study; second, until at least 1300 A.D. the region was probably the most densely populated area north of Mexico; and, finally, the societies that inhabited the Southwest had a rich and varied repertoire of utilitarian, decorative, and architectural products that evolved with time. All of this, and the fact that the area is geographically accessible, has resulted in the Southwest's being an immensely productive area for archeological study. It is one of the few regions in which ethnographic accounts of contemporary small-scale societies are complemented by careful, if tentative, reconstructions of how previous generations lived.

The dating of the very earliest human arrivals to the American continent remains in doubt, but it is certain that by at least 10,000 years ago humans were living in the region that is now Arizona and New Mexico. Early cultural influences may have come from the Northwest Coast or the Great Plains areas, but as the cultures of southern Mexico and Guatemala increased in complexity with the passage of time, they became the chief cultural benefactors for the Southwestern Indian societies. Certainly two of the most important features of Southwestern cultures diffused from the south: The domestication of plants (maize, squash, and beans) arrived during the second millenium B.C., and the first known pottery appeared around 400 B.C.

Although the hunting and gathering of wild plants and animals was still a major source of food, the adoption of horticulture had major repercussions for the Southwestern societies, making them distinctive from their neighbors to the north, east, and west, none of whom adopted horticulture in this early period. As a result of their farming, the Southwestern groups settled in permanent villages, and, with the passage of time and the development of more productive

[1] The account given here follows that of Willey (1966).

strains of domesticates, there was an increase in population density and a lessening of the dependence on hunting and gathering. People gradually moved out of pit houses and into the above-ground, apartment-like dwellings made of adobe and stone that we now call pueblos. Pueblo villages seem to have had relatively autonomous existences since there is no archeological evidence of intervillage political organization or chronic warfare. By the thirteenth century A.D. as many as 1,200 people lived in each of the many large D-shaped pueblos throughout the area.

For a long time the cultures of the Southwest had flourished, but soon after 1000 A.D. their luck turned bad: A gradual diminution of rainfall made farming in this semiarid area increasingly difficult, even with the use of irrigation; and a concomitant reduction in the mean temperature, by two or three degrees (Fahrenheit), shortened the growing season appreciably. Tree-ring and pollen analyses indicate that the climate continued to worsen, culminating in a severe drought that lasted from 1279 to 1299 A.D. Entrances and windows to the majestic pueblos were sealed during this period, and the muti- lated and unburied human skeletons that have been discovered indicate that warfare became more common—both between pueblo villages and also, perhaps, against the hunting and gathering Athapascan peoples who were pressing in from the north at this time.

Although Pueblo societies suffered, Pueblo culture was not destroyed. The social, political, and religious institutions remained. Even after the sixteenth-century arrival of Europeans, the Pueblo people retained their cultural integrity. The best-known contemporary Pueblo groups are the Zuni and Hopi; their Navajo and Apache neighbors are descendants of the late-arriving Athapascan peoples. The pueblo-dwelling groups have maintained an active ceremonial life into the twentieth century, with all men belonging to religious societies that frequently carry out ritual performances to insure either agricultural success or good health to ill individuals. Members of nuclear families—mother, father, and their children—reside together, with men responsible for farming the land allotted the family by the wife's clan. Men also hunt and weave, while women gather and make pottery and baskets.

The Southwest, through all its checkered history, has been a continuous and important source of pottery. (As a cross-cultural rule of thumb, pottery tends to occur in sedentary, horticultural societies and not in nomadic or hunting and gathering societies. Waterproof containers are better than baskets for storing a year's supply of food for horticulturalists; nomadic peoples, by contrast, tend to prefer baskets to pottery, since baskets are lighter and less easily broken.)

Although the first-known pottery in the Southwest dates from 400 B.C., the earliest Pueblo pots date from the 400 to 700 A.D. period. As was the case through the rest of the Americas, the potter's wheel was unknown in the Southwest. In its absence all vessels were made by rolling balls of clay into long, snake-like cylinders and then coiling these strips of clay into pots of the desired shape. A gourd shell, roundish stone, or wooden paddle was used to smooth the partially dried vessel. From the earliest period, common forms have been hemispherical bowls, globular shapes with small-necked openings at their tops, and pitchers with small handles. Pots from the historic period show that every Pueblo has distinctive traditional shapes, but a strong impulse to sphericality informs virtually all examples of Pueblo pots.

After the clay has dried, Pueblo pots are further decorated. Depending on the locality, part or all of the pot is first covered with a "slip," or watery suspension of clay. A design is then painted onto the dried slip; grey-white, tan, reddish brown, black, and various red slips have been used by Pueblo artists. Initially most decorations were confined to the interiors of open bowls, but by 700 A.D. closed forms (like the Zuni storage jar shown in Figure 5-2) were being decorated on their outsides. Even the earliest decorations were geometric—triangles, zigzags, steps, and so on. It has been surmised that these rectilinear designs originally developed out of the figures that had adorned Pueblo baskets long before the introduction of pottery making. Unlike coiled ceramic pots, whose spiral bands of clay may be obliterated by smoothing over them, baskets inevitably reveal their geometric structure, and designs worked into a basket's woven or coiled members must necessarily follow this linear structure.

During the period for which there is written record, Pueblo potters have been women, and there is nothing in the archeological record to indicate that the situation was different in the past (cf. Longacre 1968). True to the pattern described in the preceding chapter, a Pueblo woman acquires skill at pottery making by informal observation supplemented by some formal instruction, usually provided by the novice's mother or another close female relative.

Pueblo pottery, after 1,500 years of evolutionary development, has gone through rapid and substantial changes in the twentieth century. Fortunately for us, Ruth Bunzel, a student of Franz Boas and Ruth Benedict, was present to record many aspects of traditional pottery making before it changed drastically. Bunzel spent the summers of 1924 and 1925 living in the Pueblos of New Mexico and Arizona. (Even at that time pottery was no longer made in some Pueblos, while in others pots were made largely, or solely, for sale to

outsiders.) Bunzel's information came both from the extensive inter-
viewing of accomplished potters and from apprenticing herself to
potters in order to study techniques of manufacture as well as to
discover the ways in which the potter's skills were handed down
from one generation to the next. Bunzel's monograph was first pub-
lished in 1929 but has recently been reissued in a paperbound edi-
tion. It contains a wealth of descriptive information beyond that
which is discussed here.

Aesthetic socialization. Every viable society perpetuates itself: Its
members procreate to provide a new generation of individuals, and
society educates (formally and informally) the new generation in
traditional culture. Thus infants born in the United States grow up to
be Americans, while those born in China develop into mature Chi-
nese. The process through which one acquires the traditional culture
of his or her people is called socialization, and the first place to look
for the sources of the artist's inspiration is in the individual's aes-
thetic socialization.

There can be little doubt that one's aesthetic tastes and sen-
sibilities are acquired largely or entirely from the sociocultural milieu
in which the person is raised. Every individual's socialization in-
cludes the acquisition of notions about art, and presumably the
artist's aesthetic socialization is even more exensive. Unfortunately,
however, there is a dearth of ethnographic accounts of the way in
which aesthetic socialization occurs—either for artists or for non-
artists. As the preceding chapter indicated, in many primitive so-
cieties the artist receives no formal training whatsoever. And in those
societies where formal training is available, it seems to be primarily
concerned with matters of technique, with the novice learning practi-
cal skills that are required of his or her craft. Ruth Bunzel's descrip-
tion of the aesthetic socialization of Pueblo potters provides a good
illustration.

As previously noted, Bunzel not only interviewed potters, but
she also took lessons from them in pottery making. Much of Bunzel's
training dealt with technical issues: where to get clay, how to pre-
pare the clay for working, how to roll balls of clay out into long,
slender cylinders and coil these into a vessel, and so on. This infor-
mation is handed down from mother to daughter, partly through
didactic teaching but largely by demonstration: As the mother goes
through all the phases of pottery making her daughter watches,
imitating her techniques, benefiting from her occasional practical
hints such as a warning that the novice's pot will probably crack
during firing unless the daughter does so-and-so.

The general principles underlying the pot's shape are apparently

never verbalized by Pueblo pottery teachers. The woman may say, "It must be even all around and not larger on one side than another" (Bunzel, 1972:8), but more specific rules such as being certain that a jar's neck is two-thirds the size of its base, or that a certain number of strips of clay are needed to make a pot of the proper height—these are never stated by the teacher. When Bunzel pointed out such regularities, the potters agreed that they were generally true, but they said they had never noticed them before, much less included the principles in their instruction of their daughters.

Euroamericans might assume that making a pot provides two separate avenues for aesthetic expression—the shaping of the pot and the decoration of its surface. But in the minds of Pueblo potters, a pot's form is determined by tradition: In a given Pueblo there is only a small number of proper shapes, and virtually all pots made there conform to one or another of these shapes. Most Euroamericans find the compact gracefulness of the shapes of Pueblo pots very attractive, but their makers take the shapes more or less for granted. "Anyone," they told Bunzel, "can make a good shape, but you have to use your head in putting on the design" (1972:49).

If didactic teaching of general aesthetic principles was lacking for the shape of Pueblo pots, so also was it absent from instruction for the painting of pots. One potter from the Pueblo of San Ildefonso told Bunzel:

> If I were teaching a young girl, I should tell her that she must be most careful with the polishing—not to scratch the pot and to make it nice and smooth. . . . In painting [designs] I should not tell her what to put on, but I should say to her: "Use your own brain and paint anything you like, only put it on straight and even." She would learn the different designs by watching the other women and by using her own brain and making the kind she wants (1972:61).

Another potter, a Zuni woman, explained to Bunzel how she would give a novice potter elaborate instructions for laying out decorations on a pot, utilizing the width of one finger as a unit of measure, and using her fingernail to mark on the clay the places where designs should be placed. The only nontechnical advice this woman would give a student was this: "The jar must be covered all over [with designs] but there should be plenty of white showing. I should tell her not to use too many small designs, because then it is too black and that is not nice" (1972:50). Bunzel herself discovered some principles that underlie pot decoration (such as an aversion to using certain designs together on a single pot), but these too were tacit, never explicitly taught to young potters.

Put designs on "straight and even" and don't use too many small ones—that is as far as Pueblo potters go in terms of explicitly

teaching the next generation the aesthetic principles that underlie the traditional decoration of pots. Bunzel herself was frustrated by the sparseness of instruction: "When we started to paint, I was told once more to paint whatever I wished. When I insisted on more definite instructions, one woman, though amazed at my stupidity, said she would paint one of her bowls while I did mine, copying her design, stroke by stroke as she made it" (1972:61).

The most telling feature of this quotation is that the potter was "amazed" at Bunzel's "stupidity." We have no reason to believe that Ruth Bunzel was deficient in native intelligence, perceptual abilities, or motor skills; she did, however, lack one vital thing that was possessed by her Pueblo mentors and by everyone else who had ever tried to learn to make Pueblo pottery: She did not have a lifetime of intimate exposure to Pueblo pots. The only conclusion we can draw from Bunzel's account of Pueblo potters (and from similar reports from other societies) is that aesthetic socialization occurs on both a conscious level and also on a more subtle unconscious level.

The covert, inexplicit transmission of aesthetic standards from one generation to another has not received the attention it deserves. In the absence of a substantial body of empirical data on the subject, we can fall back on an analogy between art and language—an analogy that will be used again in the last section of this chapter when discussing James Faris's theories regarding Nuba iconography.

The parallels between language and art are numerous: Both serve as a medium through which information may be conveyed from one person to another. In both cases the information may be either explicitly straightforward or else nebulously emotion-provoking in nature. In both language and art information is conveyed by means of one individual (the speaker or the artist) imposing order on the natural medium (the audible sound spectrum or the visible light spectrum) in accord with a partially, or wholly, arbitrary set of traditional rules. Grammatical rules serve to differentiate gobbledygook from utterances that we consider to be well-formed sentences, and aesthetic rules differentiate nonart from art.

For our present purposes the most interesting similarity between language and art is that each is transmitted from one generation to the next, usually with only minor alterations in its structure, and this transfer occurs without explicit, didactic teaching of fundamental principles. And, indeed, socialized individuals are only unconsciously aware of the rules themselves. Our own culture is unusual in that we do indulge in some explicit teaching of grammatical principles, with primary and secondary school teachers sometimes acting as if our civilization will stand or fall depending on whether or not members of the next generation are able to parse sentences. In

fact, however, most children already "know" a large number of complex grammatical rules before they even begin school. In societies that do not have a tradition of grammatical analysis and teaching, the rules for speaking "properly" are as numerous as in our language, but they remain largely implicit and untaught. (One apparent *difference* between language and art is that whereas all of us become speakers of our native language, only some of us become artists. The difference, though, lies in the degree of proficiency attained: All of us use language satisfactorily to communicate with others, but few attain the level of artistry of the highly skilled writer or orator. Conversely, although only a small number are accomplished in the visual arts, we all have acquired some aesthetic standards and ideas from others.)

The exact nature of the fundamental structural principles of language and the way in which they are acquired and used by individuals—these issues are the subject of a serious debate among contemporary linguists. The problem is all the more baffling because although grammatical rules can themselves be thought of as being precise in nature, in actual day-to-day usage the rules are often applied with some degree of imprecision. That is, we all make grammatical "mistakes" even though we know what's right: Given the opportunity, we can correct ourselves. But since actual linguistic performance is flawed, how does the child who is just learning the language ever discover just what the "correct" grammatical rules are?

These questions about linguistic socialization can be left to the linguists to argue about; for us, they're interesting because of their similarity to the situation in the realm of aesthetics. The remark, "I don't know much about art, but I know what I like," is often derided as being philistine, but in fact it reflects some very important features of the human mind: All of us, even in the total absence of formal training in "art appreciation," have acquired aesthetic standards; these values are derived wholly or partially from other members of our society and are acquired during the process of socialization; and most of us have difficulty verbalizing the rules in general terms. But however unconscious they may be, we can use the rules to evaluate art works we see, allowing us to say with conviction, "I like this one better than that one." And, as in the case of grammatical standards for language, we have arrived at our aesthetic views despite the fact that no single work of art embodies the standards with absolute perfection.

How does one acquire such standards? Certainly extensive exposure to art objects is an absolute necessity, but beyond that nothing is certain. Does the young person unconsciously and

independently deduce the basic principles? Is the human mind and perceptual apparatus "programmed" in some way so that certain qualities such as balance and symmetry are discerned with particular ease? And what is the role of offhand remarks by art cognoscenti who freely voice their opinion that one piece is a "better example" than another, but who fail to specify what it's a better example of?

We can, finally, return to the scene of Ruth Bunzel, in the summer of 1924 or 1925 sitting in the shade with a San Ildefonso potter, trying to learn how to paint designs on the sides of a hand-built clay pot. The potter is "amazed" at Bunzel's "stupidity" because all people—certainly any woman of Bunzel's maturity—could reasonably be expected to know a large number of individual design figures and also to share the views of others as to what decorations "look good" to San Ildefonso eyes. Thus, the San Ildefonso potter expected to have to teach Bunzel certain practical techniques; the rest she expected to take care of itself.

And, oddly, it does indeed take care of itself. After having gained a modicum of skill at making San Ildefonso designs, Bunzel went to a Hopi village to get instruction in Hopi pottery making. Again she was given clear instructions for the technical processes required to form a pot, but when it came time to paint decorations onto the vessel she was told to make a design "out of her own head" (1972:62). This she was able to do for pots that were characteristically Hopi in shape, but when she came to a round jar whose shape strongly resembled a type of pot common in San Ildefonso, the decoration she put on it was far more in the San Ildefonso style than in the Hopi style she was trying to learn. In retrospect, Bunzel observed, "Apparently in even so short a period of observation and imitation (ten days), I had assimilated the San Ildefonso style to such an extent that I unconsciously reproduced it when confronted by a vessel of the familiar proportions. *It must be by some such process that the traditional styles are passed on*" (1972:62, emphasis added).

The methods of teaching art in the Pueblos of the Southwest are paralleled by those described elsewhere. Apprentices to African carvers typically are given technical information regarding methods of production, but their aesthetic standards are acquired by virtue of their socialization into their culture, sharpened by watching their master as he works and by emulating his methods (cf. Himmelheber 1963:90-101); the same apparently holds true for African potters (cf. R. Thompson 1969:156). And, of course, methods of teaching art in western society are not, in practice, greatly different. Much instruction consists of teaching technical skills, familiarizing students with "good examples" of work by artists whom the teachers admire, and

criticizing students' work in fairly general terms—"this painting is better than your last one; it's more interesting especially right here."

Just because the process of aesthetic socialization occurs largely unconsciously and is little understood at the present time, we should not conclude that nothing is really occurring during the process. The sharpening of aesthetic sensibilities—as distinguished from technical skills—is a vitally important part of the training of the artist. For example, while William Davenport was doing fieldwork in the Eastern Solomon Islands it became common knowledge that he was interested in purchasing high quality sculpture for display in an American museum. This new market prompted several men who were not recognized carvers to try their hand at making sculpture. At least some of these men possessed the necessary technical skills that are required for good woodcarving, but the works they produced were far below the standards of those made by accomplished carvers, not only in Davenport's view but also in the view of the native population: They lacked the subtle compositional balance that characterizes carvings made by traditional carvers in the Eastern Solomons (Davenport 1971:401).

Other Sources of Artists' Ideas. If, as the Biblical aphorism has it, there is nothing new under the sun, the most important means whereby old ideas are given new artistic expression is through socialization. But often there are additional sources of ideas, and the resulting hybridization can have a dynamic effect on an artist's production.

For example, in chapter 4 it was noted that the artist may travel beyond the boundaries of his own group and, by so doing, acquire new techniques and inspirations. Chukwu Okoro, the Afikpo carver who was discussed at some length in chapter 4, spent five years of his early life traveling and working at various jobs (Ottenberg 1975:68). Besides benefiting from the exposure to diverse art styles which his travels afforded him, these experiences provided Chukwu with some useful techniques. For example, unlike other carvers in his area Chukwu makes a paper pattern before beginning work on a mask, and he uses pieces of reed or grass to check the proportions of masks as he works on them (1975:74).

Whereas Chukwu traveled through space, some of the Pueblo potters interviewed by Bunzel had the unique opportunity to travel through time. About two miles from the Hopi village of Hano lies Sikyatki, an uninhabited mound that once was the site of an ancient Pueblo. The Pueblo is gone now, but the mound holds many prehistoric items. At the time of Bunzel's research, Hopi women regularly visited the mound to collect old potsherds; particularly fruitful

were visits right after a rain, when a new crop of finds had been exposed (Bunzel 1972:57). Do the Hopi women copy the old designs? Bunzel says they do not. Rather, the fragments of old pottery are merely a starting point which modern Hopi potters combine and modify as they see fit.

Ideas for art productions can come from traveling through space, through time—or from excursions through one's own mind, via dreams or other altered states of consciousness. The use of dreams as a source of artistic innovation has been reported in numerous places, but again Bunzel's Pueblo studies provide the richest single source of information. A Hopi potter told Bunzel, "One night I dreamed and saw lots of large jars and they all had designs on them. I looked at them and got the designs in my head and next morning I painted them. I often dream about designs, and if I can remember them, I paint them" (1972:51). Another woman, a Zuni, said, "Sometimes when I have to paint a pot, I can't think what design to put on it. Then I go to bed thinking about it all the time. Then when I go to sleep, I dream about designs. I can't always remember them in the morning, but if I do, then I paint that on the pot" (1972:51). (It should be noted that although some Pueblo potters use dreams as a source of design ideas, many others do not do so.)

Finally, there is the case of the Tukano, who live in the northwest Amazon region of Colombia. Like many of their neighbors, adult Tukano males regularly indulge in the ceremonial drinking of *yajé*, a hallucinogenic drink made from a species of vine that is native to their region. Yajé plays an important role in Tukano mythology, and, as Gerardo Reichel-Dolmatoff has shown (1972; 1975), use of the drug is intimately related to the strengthening and legitimization of traditional Tukano social structure. Reichel-Dolmatoff's accounts of yajé, including his own experiences upon taking the drug, are fascinating, but the aspect of yajé that interests us here is the role it plays in Tukano art.

Tukano art takes the form of figures painted on housefronts, on musical instruments, and on utilitarian items such as pottery vessels, benches, and bark cloths. The figures range from clearly representational designs to geometric figures that are at most semi-iconic. What inspires these designs? The Tukano told Reichel-Dolmatoff, "These are the things we see when we take yajé; they are the *gahpi gohori*—the yajé images" (1972:104). The ethnographer gave several men paper and colored pencils and asked them to draw the images they had seen while under the effects of the hallucinogen; the result was a collection of figures just like those included in traditional Tukano paintings. (When asked the meanings of the figures, the men at-

tributed to each a subject that was related in one way or another, to procreation, kinship, or social structure in general.)

Dreams and hallucinogenic drugs may provide motifs that can be incorporated in art works, but one might well ask, what is the source of the stuff of dreams and hallucinations? The answer lies largely in culture itself. Consider the Tukano case, for example. Reichel-Dolmatoff (1972:110) notes that since infancy every Tukano male has been exposed to his society's art, so even before his first experience with yajé he knows what he'll probably see after he drinks the beverage. Also, during and after the yajé-drinking ceremony individuals commonly discuss the hallucinations they have, thus increasing the likelihood that yajé users will for the most part see just those visions that traditional Tukano culture prescribes, namely the motifs that occur in Tukano art.[2] With regard to dreams, cross-cultural studies suggest that they reflect the individual's waking experience, albeit in a selectively edited and sometimes highly distorted version (Reichel-Dolmatoff 1972:112; cf. also D'Andrade 1961).

Copying. If, on the surface, art production is a matter of combining old ideas in a new way, then we should pause here to consider the extreme possibility: What about a case in which an individual copies a pre-existing art object in an attempt to duplicate as precisely as possible a pre-existing work.[3] Interestingly, such behavior is extremely rare. In a traditional setting, artists in primitive societies get many ideas from pre-existing art works, but each piece they make is usually made at least a little differently from its predecessors. Sometimes the differences seem slight to us who are unaccustomed to the genre, but differences there always are. (Like most generalizations in the social sciences, this one has some exceptions. Ray [1961] claims, for instance, that copying did occur in the prehistoric art of the North American Arctic, noting, for example, that many decorated Punuk harpoon heads are "so much alike that they are indistinguishable one from the other" [p. 136].)

Even when the artist is specifically asked to replicate an older

[2]Reichel-Dolmatoff (1972:112) has suggested that an additional factor in determining the nature of visual hallucinations may lie in the biochemical effects of the drug on the subject's sensory apparatus, noting, for example, that the rhythmic pulsing nature of hallucinations "seems more likely to be organically based than determined *only* by a visual and culturally molded memory" (1972:111). Confirming and disconfirming evidence for such a hypothesis is limited as yet, but such a possibility certainly should not be ruled out.

[3]By "copying" I refer to attempts at exactly replicating pre-existing works. Excluded are instances of duplicating a pre-existing work but with any modifications that might be added by accident or design.

item, the result is almost inevitably an object that has been "personalized" in some way. For example, in 1950 when he was studying Yoruba carving in Nigeria, William Bascom came across a carved ceremonial staff that he wanted to buy. The owner did not want to part with the item but suggested to Bascom that he have Duga, a recognized carver, make one for him as it had been Duga who had originally carved the staff in question (Bascom 1969:114-15; 1973:74, 76). Bascom did indeed commission Duga to carve a copy of the original staff, but the result of Duga's efforts was not an exact duplicate of his earlier work. His new staff was, in the first place, larger than the original—perhaps because Bascom had promised Duga a good fee for his services. Also the new staff had several modifications in the details of its caring. Finally, Duga painted the staff with different colors than he had used on the first staff. The result was a staff (shown in Figure 5-1) that strongly resembled the original staff, but that had been modified by Duga in several ways as he worked on the commission.

Bunzel's study of Pueblo potters provides information on copying that is relevant. With regard to pots' shapes, there is not a

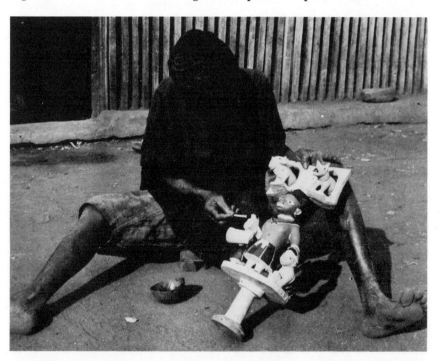

Figure 5-1 Master Yoruba carver, Duga of Mękǫ, painting a ceremonial staff. Wood, 20 inches tall. *Photo courtesy Mr. and Mrs. William Bascom.*

verbalized proscription against copying, but nevertheless no two pots are identical in shape.

As for the decorations that are painted on Pueblo pots, there is a strong aversion to copying. One Zuni potter told Bunzel, "I never copy the designs of other women. It is not right to do that. You must think out all your designs yourself. Only those who do not know copy" (Bunzel 1972:52). And, in fact, mature, traditional Pueblo potters do decorate each pot in a manner unlike any other pot.[4] In some Pueblos the avoidance of copying even extends to pottery made for sale to outsiders: Bunzel watched three potters in the village of Isleta decorating wares that would later be sold in Albuquerque. They laughed and talked as they worked, but in less than two hours they completed 42 pots, each with a design unlike any of the others (1972:63). (Other Pueblo makers of trade pottery do, however, repeat designs; cf. 1972:62).

Bunzel also had an experience similar to Davenport's in the Solomon Islands and Bascom's in Nigeria. She showed a Zuni potter photographs of pots made in other villages. One jar from the village of Santo Domingo struck the Zuni potter's fancy, so Bunzel asked her to copy the design onto a jar of her own. The potter agreed and the outlines of the Santo Domingo design were carefully copied, down to the smallest detail. But when it came time to fill in the figures that were black on the Santo Domingo pot, the Zuni potter asked if she could make a few changes, "because," she told Bunzel, "she was afraid the jar would be 'dirty' if she used so much black paint. She considered red as an alternative, but thought the surfaces were too large for red, and finally decided on the typically Zuni hatching, which, of course, completely destroyed the original character of the design" (1972:28).

In Pueblo ceramic tradition there is one and only one feature that is inevitably copied onto every jar, namely a heavy line (or double line) that goes around the jar with a small gap between its

[4]The unanimity with which Pueblo potters condemn the copying of designs makes one wonder if the emphasis on it may be a value that has been at least partially acquired by contact with whites, for whom the concepts of copying and art are virtually incompatible. Bunzel herself does not mention this possibility, but Ruth Benedict, who was Bunzel's teacher and friend and who was studying the personality structure of Zuni at the same time Bunzel was studying their art, portrayed the Zuni as being highly conformist in their thinking, claiming that they place little value on innovation (Benedict 1934:57-129). The precontact situation may never be ascertained, but the diversity of prehistoric Pueblo pottery suggests that whether or not previous generations of Pueblo artists verbally espoused an ethos of originality, there was at least a tacit convention that every potter made each pot a little different from all others.

ends, dividing the upper from the lower areas. The line can be clearly seen in the Zuni jar illustrated in Figure 5-2. This line, called *onane* ("road") is the one true symbol used in Zuni pottery in that it represents the life of the potter who made the vessel. Even this figure verges on the iconic, however: It is always left unjoined to represent the fact that, when the pot was made, the potter had not "finished her road," i.e., had not passed from the earth.

After the Zuni potter has painted the *onane* on the jar, she must decide what decorations to use to fill the lower and upper zones that remain. For these she relies upon tradition: Every potter has learned a repertoire of individual figures, such as the large circular design on the "stomach" of the pot shown in Figure 5-2. These unit designs are traditional, often learned by a potter from her mother. The uniqueness of each pot's design is due to the *arrangement* of the traditional designs on a pot. Thus, the same potter who told Bunzel, "Only those who do not know copy," also said, "This is a new design. I learned the different parts of it from my mother, but they are put together in a new way. I always make new designs" (1972:52)!

Thus we meet again the now familiar pattern: Ideas gleaned from pre-existing art objects are freely used by the artist, but always with some modification. The dogged copying of pre-existing art objects, by contrast, seldom occurs.

Why is Copying so Rare? The general absence of copying may strike the Euroamerican non-artist as puzzling. If the artist is technically able to make an exact duplicate and if pre-existing art objects are recognized as being aesthetically effective, why not copy the old objects as accurately as possible?

One can only speculate as to the answer to this question, but several possibilities present themselves. The simplest answer is to assume that humans—or artists, at least—have a "creative urge," a desire to express themselves and their vision in constantly new and untried ways. Perhaps such a drive does exist, but the more importance we attach to it, the more difficulty we have explaining societies in which change occurs only very slowly. For example, the arts of ancient Egyptian civilization did evolve through time, but the rate of change was so slow that the nonexpert must look very closely to see the differences between a sculpted human figure from the Fourth Dynasty and one from the Eighteenth Dynasty, over a thousand years later (cf. Spencer 1975:25-27). If there is indeed a creative urge, there must be other, sociocultural factors that enhance or discourage its effect.

Our puzzlement about the general absence of copying in art results in part from our making an unwarranted assumption, namely that it is easier to copy a pre-existing piece than it is to use the piece

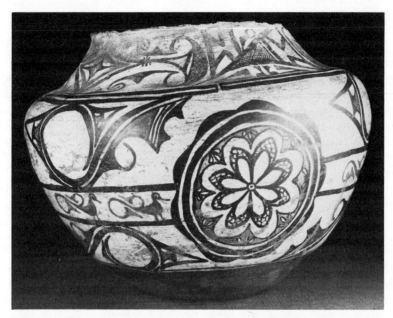

Figure 5-2 Zuni storage jar, ca. 1875. Clay and paint. Maximum diameter approximately 14 inches; 11 inches high. *Nelson Gallery-Atkins Museum, Kansas City, Missouri (Gift of Miss Katherine Harvey).*

as a starting place for modification. There is only one way in which something can be accurately duplicated, but the ways in which it can be altered are limitless in number; at least in terms of skill, copying is more difficult than is innovation. Himmelheber reports being told this very thing by a Cameroons artist (cf. 1963:106-7). Bunzel makes the same point: Hopi potters "constantly invent new patterns . . . because it is as easy as painting the old ones and very much more enjoyable" (1972:57).

Finally, it might be noted that in highly stratified societies works of art often function as indicators of prestige. In such societies the careful copying of pre-existing art works could be considered equivalent to counterfeiting, in that it results in increasing the supply of items that are valued partly because of their very scarcity. A taboo on "faking" is inevitable in such situations.

The Creative Process

Surely there is more to the creative process than a simple, mechanical reshuffling of old concepts to arrive at novel ones. There must be, we westerners feel, a spark of genius involved. Creativity is

more than just synthesis, it is, in the phrase of an eminent psycho-analyst, a *magic* synthesis (Arieti 1976).

But what exactly is the nature of this "magic"? Given the personal and fleeting nature of the creative process, it comes as no surprise that the social sciences have discovered few "facts" about creativity. There is, however, a sizable body of opinion concerning the creative process. This body of opinion has its roots in classical western thought, and many modern thinkers—philosophers, social scientists, and others—have contributed to it. For convenience I will refer to this composite theory as the "western folk model" of creativity.

A folk model is a set of theories that is prevalent in a given population; it provides a means of explaining some phenomenon that is deemed to be important. It is supported less by empirical data than by the sheer intellectual momentum given it by an age-old need to make sense of the significant unknown. Not all individuals in the society necessarily embrace all parts of the folk model, but it nevertheless informs most people's thought on the subject in question. Whether or not a folk model is "true" is another matter: Some such models are simply not amenable to proof; others, like the western folk model of creativity, are testable only in some of their details and then only with considerable methodological difficulty. So by labeling western opinion regarding creativity a folk model, I am not saying that it is or isn't accurate, but simply that it is a widely held set of beliefs whose accuracy is as yet unknown.

Three salient features of the western folk model of creativity are particularly interesting: First, the creative individual is considered to have a mental constitution unlike other people's: He or she may be described as merely "lacking common sense," or, in the extreme, as being mad. Second, creativity is thought to require a special sort of mental acrobatics. The artist, specifically, is believed to be able to use and manipulate visual imagery with much more adroitness than non-artists. Finally, the western folk model suggests that the creative process itself is characterized by what has been called "passion and decorum," that is, an alternation between concentrated, conscious mental effort and passive, out-of-awareness operations in the unconscious mind of the creative individual.

How well does the western folk model of creativity stand up cross-culturally? If creative individuals (or if artists, as a subset of that group) in every society seem to function in accordance with the western folk model, this would suggest that the model reflects some fundamental, pan-human processes. If, on the other hand, the western folk model is soundly contradicted by the folk models of creativity found in other societies and by those aspects of the creative

process that we can discern in the work of artists elsewhere, this finding would suggest that the western folk model might have more limited applicability.

The following three parts of this section attempt such a comparison. As elsewhere, we are hampered by the sparseness of relevant data, and the results will necessarily be tentative. Nonetheless, a surprising amount of evidence suggests that the western folk model does indeed have some cross-cultural basis.

The Madness of Genius, One salient theme in the western folk model of creativity is that the process is somehow irrational. Plato wrote that the poet, for example, is "indeed, a thing ethereally light-winged and sacred, nor can he compose anything worth calling poetry until he becomes inspired and, as it were, mad" (quoted in Hatterer 1965:17; see also Dodds 1951:80-82). It was not until the Romantic Period, however, that the claim that the artist is "mad" was taken literally. Freud systematized this part of the western folk model, claiming that the creative artist tends to be more sexually frustrated than others; creativity, by this view, serves as a means of substitute gratification. (The fact that the biographies of many creative individuals revealed them to have had active sex lives made even Freud have second thoughts about such a formulation. Cf. Trilling 1945.)

As shown in chapter 4, stereotypes of artists in primitive societies are highly diverse. The west African Afikpo, for example, generally consider their carvers to be "foolish or sily," and artists among the Fang, Dahomeans, and New Irelanders are considered such "good-for-nothings" as to be aberrant in their native cultures. Just the opposite is true, however, in the Asmat region of New Guinea and among the Bush Negroes of Surinam. Whether artists around the world are actually more or less mentally sound than their non-artist peers is uncertain; and given the difficulties involved in even defining neurosis in a way that is cross-culturally meaningful, it seems doubtful that such a conclusion can ever be substantiated.

There is, however, one feature of the psychoanalytic account of creativity that receives some support from the ethnographic data, namely the apparent correlation between creativity and short-term sexual abstinence. In many societies (e.g., Anang, Abelam) a person engaged in creating a major art work is under a sexual taboo during—and, sometimes, preceding—the artistic activities. Presumably the reason lies in the channeling of sexual energies into artistic activities, but one wonders if the energy involved is mental, physical, or both, since sexual abstinence is also required in many societies for people engaged in endeavors that are demanding but non-

artistic, such as participating in warfare, making difficult journeys, or—in our society—participating in some professional sports.

The Role of Imagery. A second salient aspect of the western folk model of creativity involves imagery. Psychologists have claimed that the artist has a superior ability to manipulate mental images and that creative individuals generally are abnormally skilled at "associational thinking." The twentieth-century English sculptor, Henry Moore, describes it thus: "The sculptor gets the solid shape, as it were, inside his head—he thinks of it, whatever its size, as if he were holding it completely enclosed in the hollow of his hand. He mentally visualizes a complex *form from all round itself*: he knows while he looks at one side what the other side is like" (1952:74). Moore's statement implies—probably correctly—that the artist's mental "picture" is not quite like a tangible picture one sees with the eyes. Rather, it is conceived in such a way that it can be simultaneously "seen" from more than one viewpoint. Is such a thing possible? Perhaps so. Moore goes on to say that one accomplishes this feat of mental acrobatics thus: The sculptor "identifies himself with [the sculpture's] center of gravity, its mass, its weight" (1952:74). That is, the conceptualization is only partly visual; in addition, it is tactile and kinesthetic. And while the non-artist finds it difficult to simultaneously *visualize* both the front and the back of an object, one can to a certain extent imagine *touching* front and back at the same time.

The role of imagery in the creative process has been noted among artists in several primitive societies. An African carver's remarks to Hans Himmelheber are particularly vivid: This carver relied upon fetish-like objects for inspiration, rubbing his hands with them before beginning to carve. "This magic," he said "shows me all the different forms of masks and spoons which men have ever made. They show up in my head *like something coming to the surface of the water*" (quoted in Himmelheber 1963:107, emphasis in original; cf. also Messenger 1973:113).[5]

Sometimes there is observable evidence that the artist had in mind a clear image of the finished product before actually beginning a work of art. For example, some of the intricate curvilinear designs

[5]This carver's fetishes are made by obtaining a certain type of leaf from a particular kind of bush, pulverizing it, mixing the powder with some other substances, and rolling the mixture into "little sausages with pointed ends." The compulsiveness of this ritual may strike us as being somewhat bizarre, but it differs little from the textbook writer who, before sitting down at his typewriter obtains roasted beans from a particular type of tree, pulverizes them, mixes the powder with boiling water and other substances, pours the concoction into a special cup, puts the vessel on the corner of his desk—and then forgets it.

carved by Maori artists on housepanels can only be made sense of by assuming that the carver first conceptualized a figure larger than the board itself, and then carved onto the panel only that part that would fit (cf. Linton 1941:47). Similarly, Bunzel reported that when potters in the Acoma Pueblo decorated small pots made for the tourist trade, they used traditional designs but instead of reducing them in size, they made the figures the same size as those that are drawn onto larger pots but used fewer of them on each pot (cf. Bunzel 1972:36).

Bunzel's book provides a wealth of additional material on imagery. She notes (1972:7-8), for example, that Zuni water jars are so large that they must be made in two stages. The lower portion is coiled and smoothed, and then it is allowed to dry for several hours until it is firm enough to support the upper part of the vessel. By the time this upper part is added, however, the lower portion can no longer be changed in shape. Thus the form of the completed jar must be accurately visualized before the half-finished pot is set aside to dry.

Pueblo potters are generally unaware of their planning of a pot's form, but they are quite explicit about the imagery required for the designs that are painted on pots. As noted previously, some potters report seeing designs in their dreams and then copying these onto the pots they are making. Others see designs while daydreaming and still others simply close their eyes and consciously summon up images of possible designs: "Whenever I am ready to paint, I just close my eyes and see the design, and then I paint it," a Hopi potter told Bunzel (1972:49). In some Pueblos, potters sketch tentative designs on the ground or on paper before beginning, but whatever their method, all Pueblo potters would concur with the Laguna woman who said, "Pottery . . . means a great deal to me. It is something sacred. I try to paint all my thoughts on my pottery" (1972:52).

One last interesting feature of Pueblo artistic imagery should be noted. In some Pueblos (Acoma, San Ildefonso, and Hopi) two distinctly different styles of decorating pots were in vogue during Bunzel's study. But except under abnormal circumstances, in each location the two styles remained separate, with no hybridization between them. Thus, like Beethoven, who composed his Seventh and Eighth Symphonies at the same time but never allowed the themes of one to slip into the other, the Pueblo potter is able to couch her images in one traditional style or another and execute the design without interference from other information that is present and active in her mind. Or, to, return to the analogy between art and language developed previously, the artist who has mastered working in two different styles is like the bilingual individual who is fluent in two

languages but who rarely mixes both languages in a single sentence.

"Passion and Decorum." What is the nature of the mental processes that go on in one's head preceding and during the creative act? According to the western folk model, the process often consists of several distinct phases. First one consciously examines the issues, defining the problem involved, considering the relevant information, going through traditional solutions, and so on. If no good solution is found, the individual, out of frustration, puts the matter out of his or her head for a period of "incubation," until, with a flash of insight, the novel solution pops into the conscious mind unexpectedly. Finally the new answer must be put into effect, tested, and so on. The total creative process, then, is thought to be a combination of careful, disciplined conscious thought combined with apparently free wheeling, spontaneous work by the unconscious mind (cf. MacKinnon 1968; Martindale and Hines 1975). As Jerome Bruner (1963:12-13) has succinctly remarked, creativity requires both "passion and decorum." A remark made by the photographer Henri Cartier-Bresson reflects this aspect of the western folk model of creativity: "Thinking should be done beforehand and afterwards, never while actually taking a photograph" (quoted in Sontag 1977:53).

Solid cross-cultural support for this part of the western folk model is scant. There is abundant evidence that the artist goes through a process of conscious planning and, once a plan is clearly fixed in mind, that the artist executes it in a well thought out, "decorous" manner. But what of the "passion" in Bruner's phrase? Is a period of incubation necessary before new ideas come in an avalanche into the mind of the creator? Such a period has not been reported, although in at least one instance (Goodale and Koss 1971) it has been looked for. There is a distinct possibility that the process does occur but that due to its being entirely within the mind of the artist, it has gone unnoticed or unreported to date by other ethnographers.

The infrequency with which an incubation period is noted cross-culturally may be due in part to the fact that the amount of novel thinking required for making a given work is relatively small—a factor that impedes all attempts, such as the present one, to look for cross-cultural correlates of the western folk model of creativity. The artist in a primitive society seldom has to wrestle with totally new or unfamiliar materials or techniques in an effort to determine their most satisfactory application to his or her craft; and although the artist seldom if ever copies an old piece, the extent to which a given work differs from its predecessors is often relatively small. Thus the strikingly innovative effort is doubtless an even greater rarity in primitive societies than it is in nonprimitive ones. For lesser acts, the

unconscious component of creativity is perhaps submerged in the total activity of art making, observable only in such situations as when an artist remarks upon completing a piece, "It's not exactly as I'd planned—it's better!"

The mind, in Sheakespeare's phrase, is "a very opal," scintillating rays of pure colors from unexpected places at unpredicted times. Mineralogists have discovered the source of the opal's "fire," but how far social scientists are from understanding the fire of the artist's mind! About the best we can do at the present is to spell out the two topics that are promising areas of inquiry. First, one would like to know more about how the artist acquires special cognitive abilities, how one becomes inbued with the aesthetic values of his or her society. How do we ourselves do this? Sometimes, as a young person, we are given overt aesthetic training ("Don't wear stripes and plaids together"), but more often the process of socialization is inexplicit, requiring the individual to deduce general principles, based on day-to-day experience.

Second, we need more understanding of the way in which the artist transmutes past experience into new and different works of art. Is what I have termed the western folk model of creativity valid—for all humankind or even for us? An answer to this question will be difficult to attain, but the closer we approach it, the closer we come to understanding what is probably the most fundamental issue in the human endeavor we call art.

Representation and Stylization

Look at the West African masks shown in Figure 2-1. The masks portray some features that are common to the human face, but great liberties have been taken: The proportions are changed, ears are lacking, and so on. But why, we may well ask, are these liberties taken? Since there are at least a few pieces of art from primitive societies (e.g., the Northwest Coast mask shown in Figure 3-1) that give a photographically accurate rendering of the subject, the answer cannot be simply that the artist lacked the technical skills needed to make a more accurate mask. If the answer does not lie in manual skill, it must, then, be sought in the realm of psychology. Although many artists claim that they are merely making a reproduction of what they see, we must remember that the total aesthetic process includes two distinctly psychological phases: The subject is processed through the artist's visual and mental apparatus, and, later, through our own as we look at the object the artist has produced.

With respect to representation in art, two extreme positions are

possible, and it seems wisest to avoid both.[6] On the one hand a person could assert that since no attempt at representation can be perfectly accurate, any talk of accuracy is senseless. But we are here speaking only of relative accuracy, and it is counterintuitive to hold that a color photograph of a particular individual is no more or less accurate than a portrait of the same subject made by a cubist painter. Granted that neither is a perfect representation, that the interpretation of even the best photograph requires knowledge of some arbitrary conventions, that the cubist painting may provide an insight into the subject's personality (as opposed to appearance) that may be lacking from the photograph, and that we may disagree as to which of two cubist paintings is more accurate—granted all these things, it still seems reasonable to assume that it is the photograph, rather than the cubist painting, that more closely resembles the image that falls onto the retina of the viewer's eye when he or she looks at the subject.

But equally untenable in the extreme is the opposite view, that is, the assumption that a given object provides a simple, straightforward subject to be copied by the skilled craftsman. The piece of stone or wood in the artist's hand can never be *exactly* like the model; for better or worse, Pygmalion is only a character of myth, and stone is not flesh nor paint a passing blush on the cheek. The artist is, at most, an illusionist.

Consider, for instance, the human face. One's expression changes with every waking moment, and both the bony structure and the soft tissue change drastically between infancy and old age (cf. Sarles 1972). The artist must decide which one of the subject's many faces to portray, since wood or stone, once carved, is stationary. (We have all seen photographs of ourselves or of people we know and felt them to be a "poor likeness." To have this reaction to a photograph is to acknowledge the fact that while the camera can't quite lie, it can easily capture a face in a position that is contrary to our stereotype of the face in question.) And, as if these were not enough problems for the artist, we also know that extremely subtle changes in the human face are responded to by viewers. For example, Eckhard H. Hess has shown experimentally that when American men are shown a photograph of an attractive young woman, they are more likely to describe her as "soft," "more feminine," or "pretty" if the pupils of her eyes have been retouched in the photograph to slightly enlarge them (Hess 1975:110). Since facial cues vary widely

[6]Here, as on several other points in this chapter and in chapter 3, I am making a case with regard to art from primitive societies similar to the one that Gombrich (1972b) makes for western art.

from one society to another, there is probably a substantial amount of truth in the assertion by Paul Byers, a photographer, that "Americans . . . tend to take 'American' pictures of people looking like Americans with American expressions" (1964:82).

A final general point might be mentioned here as an aside. It has sometimes been suggested that members of primitive societies have perceptual abilities that are substantially more accurate than those of westerners. Testing such assertions is very difficult, beset by all sorts of problems in communication and motivation. It now appears, however, that although a cross-cultural ranking of people's perceptual skills in terms of a superior-inferior dimension is not justified, people do differ from one society to the next with regard to their perceptual habits. For example, a number of studies have presented individuals with various cut-out figures, asking them to group together those figures that are "more alike." Whereas American adults tend to respond by grouping together objects of the same *shape*, West African individuals tend to group the figures according to their *colors* (cf. Cole and Scribner 1974:90-94). The implications of such results for cross-cultural differences in making and viewing art objects have not, so far as I know, been investigated. We can surmise, however, that such perceptual and conceptual differences would influence the way in which an artist goes about creating the illusion of likeness.

Patterns of Representation. Given that the artist must choose to represent some of the subject's features while (at most) implying the rest, what principles are the artist's choices based upon? Boas (1955:71-72) noted one dimension of choice, namely, that the artist may either attempt to portray the subject as it appears at a given moment from a single viewing point or that the goal may be to depict those features of the subject that are, in the artist's opinion, most important. Since art is inevitably a cultural endeavor, it is little wonder that the latter ·approach is far more common, with artists acting as "editors of visual reality," using cultural relevance as a guideline for determining which features to emphasize and which to ignore. As Linton remarked, "The aim of the primitive artist is to present his subject as he and his society think of it, not as he sees it" (1941-48).

If the artist uses this editorial style of representation, the features that are portrayed may be physically present but not visible. Thus, the so-called X-ray drawings of people and animals that occur in various places around the world presumably depict those inner organs that the artist considers to be particularly vital. The representational style of the Northwest Coast Indians provides an eth-

nographic example: As noted in chapter 3, a Northwest Coast drawing of a halibut may portray not only the fish's fins and gills, but also its intestinal tract, parts of its skeleton, and even the clot of blood that is found beneath the vertebral column of a dead halibut.

Often, though, the artist need not portray hidden traits such as the skeleton and internal organs; rather he or she may choose which ones among the visible features to illustrate or emphasize. For example, the prominence of noses in masks made in the New Guinea highlands probably is a reflection of the importance that the local populations assign to the nose as a focal point of personal beauty (Paul Wohlt, personal communication). Or, to take another example, if a sculpture is to depict several people, and if everyone agrees that the subjects are of unequal social or cultural importance, then the artist may quite reasonably scale the sizes of the figures accordingly, making the most important person substantially larger than the others. Figure 5-3 is an example of such "hieratic" representation. It is a bronze plaque, produced in the sixteenth or seventeenth century by Benin artists, members of an important art-producing society in what is now Nigeria. The differences in size between the "nobleman" and his "attendants" does not reflect a difference in stature but rather in social importance.

Extreme Stylization: The Case of the "Trobriand Medusa." Although creation myths typically claim that humans were formed in the shape of their supernatural maker, albeit with important modifications, when humans attempt to portray supernatural characters in their art, the exact reverse occurs: Deities are made in human form, but, again, with important differences. The result may be a figure whose resemblance to humans is so tenuous that the uninitiated might interpret it as being completely abstract, having either a symbolic meaning or no referent at all. In the native's eyes, however, the resemblance is clear, despite the stylizations.

The best ethnographic examples of this come from Melanesia, the most interesting being Edmund Leach's attempt to explain the designs that were traditionally painted by Trobriand Islanders on the shields known as *vai ova*, which were used in warfare by the bravest and most distinguished Trobriand warriors. Before Leach advanced his theory the designs had been assumed to be nonrepresentational, and since their makers have long since departed, a positive interpretation of their meaning is not possible. Nevertheless, based on ethnographic accounts of Trobriand mythology and some clever deduction, Leach has argued convincingly that the designs are highly stylized representations of a winged anthropomorphic figure, most likely the "flying witch" that plays an important role in Trobriand

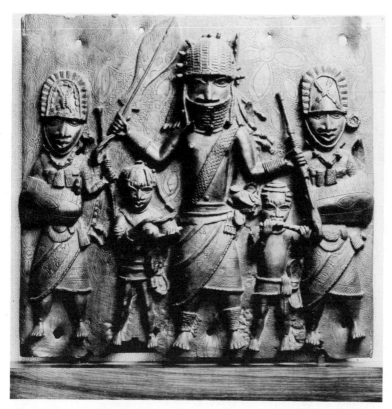

Figure 5-3 An example of hieratic representation: "Nobleman and Attendants," Benin culture, Nigeria, sixteenth or seventeenth century. Bronze plaque, 14¾ inches by 15½ inches. *Nelson Gallery-Atkins Museum, Kansas City, Missouri (Nelson Fund).*

supernatural belief. Leach suggests that the design emphasizes those parts of the witch's body that are believed to be most important, namely the anus and vulva, from which come highly dangerous forces. (It is these forces that give the figure efficacy upon a war shield and which prompted Leach to dub the figure a "Trobriand Medusa.") Figure 5-4a shows the hypothesized witch's figure; 5-4b shows the same figure as it appears on a shield, folded in upon itself so that some parts, such as the anus and navel, coincide.

Some writers have disagreed with the particulars of Leach's interpretation of the designs of Trobriand *vai ova*. Ronald Berndt, for example, has claimed that a more likely interpretation is that the figure represents "a male and female engaging or about to engage, in coitus" (1958:65). But the weight of evidence strongly favors Leach's

Figure 5-4 Interpretation of the design on a Trobriand *vai ova* shield. (*After Leach, 1972.*) Left Design as originally painted on shield. Right Design as conceptually "unfolded" to form Trobriand flying witch figure. Interpretation: a. Wings and arms. b. Face. c. Ears and breasts. d. Feet and hands. e. Anus and navel. f. Buttocks and, perhaps, womb. g. "Witch testicles." h. Pubic hair. i. Vagina. j. Knee joints. k. Clitoris.

fundamental assertion, namely, that the seemingly abstract *vai ova* designs are in fact representations of natural or (more likely) supernatural inhabitants of the Trobriand world.

Another Step in Stylization. Richard F. Salisbury (1959), in a comment on Leach's Trobriand Medusa paper, illustrates the results of stylizing a traditional figure to the point of its becoming a simple, geometric pattern. Working among the Siane of the New Guinea highlands Salisbury noticed that two common patterns occurring on men's shell headdresses and elsewhere were crosses and diamonds, as shown in Figures 5-5a and b. He was told that the cross designs were called *sirirumu*, the diamonds, *gerua*, and that both designs were love charms, helping the male wearer gain the sexual favors of women who looked at the designs. More explanation of the figures was not forthcoming, but one day by coincidence Salisbury happened to see two boys playing: One "stood with his back to the sun, his arms bent, and his hands held out on each side of his head at the level of his ears. The other boy was tracing the outline of his shadow in the dust" (1959:50). When the boys saw Salisbury watching them they obliterated the drawings and looked guilty, but eventually they told him that they had been drawing *gerua*.

Later, using this and other clues, Salisbury made line drawings similar to those shown in Figures 5-5c and d. When alone with his best informant, Salisbury revealed the drawings. The man's reaction, Salisbury writes, "was one of extreme horror and shock, as he shuddered and told me to hide them again" (1959:50). Salisbury suspected that the man's indignation was partially feigned, but through questioning he learned that the design shown in Figure 5-5c was considered to represent an opossum, and that it should be called *sirirumu*, the same as the name for the simple cross design. Figure 5-5d was said by the informant to represent a pig, but was called *gerua*, the name for the diamond pattern. In Siane thought, Salisbury reports, the opossum is closely associated with fertility and sexuality; and in

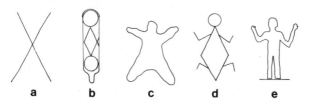

Figure 5-5 Design figures made by the Siane, New Guinea. (*After Salisbury, 1959.*)

other New Guinea highland societies pigs are also associated with regeneration, although Salisbury fails to note whether this is the belief among the Siane. In any case there is an equivalence between the diamond and the cross designs: Salisbury was told by another man that a diamond design could also be called *sirirumu.* "I took this up with my first informant, who saw no conflict. He said, 'Yes, they are both sirirumu; can't you see they are the same? I asked him to explain and he held his hand over the right half of the design and then over the left half, to show how the two halves of the cross, if joined at the extremities, make a diamond" (1959:50).

This information reveals, generally, the elaborate psychological machinations that may underlie artistic production in primitive societies. Specifically it explains why the diamonds and crosses on Siane men's headdresses are effective love charms. The figures are actually iconic representations of two species of animals, and these particular species have a symbolic association with women and sexuality. Why not just decorate the headdresses with accurate representations of women? Because, Salisbury learned, "A naturalistic drawing of a woman would make any woman recoil in horror, and would have no practical effect, while a stylized design enables her to look at it for a long time, without realizing its significance—long enough for the design to have its magical effects" (1959:51). Thus, stylization may be motivated by attempts to partially conceal the referent of a representational drawing.

Learning to See in New Guinea. We seem to have arrived at a point quite distant from the one with which this section started. We began by assuming that the artist typically takes some item from the material world as a model for his or her art work; but in the Siane case, the model is a traditional set of mental associations. Actually, though, the difference between the two approaches is not that great: The artist always and only brings into realization an object that corresponds to a mental image. The only question is the degree to which the artist attempts to lessen the gap between the image and some object in the visible world. If no attempt is made, if the artist seeks to depict a mythical being, then the only problem is the issue of socialization that has already been discussed: How does the artist learn the form of the mythical being? The answer lies in art itself, in that throughout their lives artists have been exposed to the designs that are traditional in their own society.

In his study of the New Guinea Abelam and their art, Anthony Forge has examined the ways in which artists acquire the traditional imagery that becomes the subject matter of their art; his findings were brought together in a paper aptly titled "Learning to See in

New Guinea" (1970). The Abelam have already been discussed in several other contexts in this book. It will be remembered that much of their art is associated with an extended cycle of rituals through which young men are initiated into the so-called tambaran cult. Sculptures and painted boards are made for use in these rituals; they are displayed in a special ceremonial house, the front of which is itself covered with painted tambaran designs.

Tambaran art depicts the *nggwalndu*, the roughly anthropomorphic spirits associated with Abelam kin groups. Although only fully initiated Abelam males have seen all of the tambaran figures, young people are constantly exposed to one or another of the figures. Thus, for example, all people in a village are well aware of the presence of the figures on the facade of the ceremonial house, since the structures sometimes are built to a height of 60 feet, visually dominating the village. This informal exposure to tambaran representational style appears to be even more important than the actual tambaran initiation ceremonies, since during some phases of the ceremony the initiates are merely onlookers who may even miss parts of the show, having wandered away from the ceremonial ground out of lack of interest, or because during other phases the initiates are in a state of bewildered terror as a result of all the frenzied activities and harrassment that occurs.

The mythical spirits that are depicted in the tambaran designs are elusive in appearance, sometimes manifest as incorporeal mysterious noises, or seen in dreams as strong, tall men in full war paint, and depicted in still another style in face painting and body decoration. In carvings, the more or less human proportions of the spirits are altered so that, for example, arms are represented by three or more white lines emerging from beside the nostrils. The young Abelam artist-to-be must, then, not only deduce the nature of the spirits, he must also learn the stylistic elements that characterize the spirit in a given medium.

But for all these vagaries, Abelam do learn the proper visual elements necessary to represent *nggwalndu*. Indeed, since the only representational designs that Abelam ever normally see are the tambaran figures, the stylistic conventions of tambaran art are used for *all* art activities. For instance, when Abelam children playfully make drawings in the dust, the figures they make have multiple outlines, just like the tambaran figures that are painted on boards by adult Abelam artists and their assistants, as described in chapter 4. Similarly, when Forge gave children paper and paint, they drew people and animals, but again the figures were inevitably given multiple, polychrome outlines. (One repercussion of this is that Abelam adults

find it difficult to interpret photographs, presumably because the photographed subjects lack the distinctive multiple outlines that they have come to expect. Young Abelam, however, learn to "read" photographs more easily.)

The artist may say, "I draw what I see," but "seeing" is anything but a simple process. Perceptual psychologists have demonstrated that when an individual looks at something the eye does not randomly scan about the whole scene, but rather it flits back and forth between a small number of information-rich points (cf. Noton and Stark 1971). More importantly, the incoming information is combined with information from the past as recorded in the person's memory. The resulting impression is thus an amalgam that is unique to the individual viewer, but with a strong admixture of conventions derived from the person's cultural heritage. If the individual is an artist, an attempt to realize this vision in an expressive medium will necessarily reflect both the personal and the cultural components of the image.

What factors determine the relative importance of the literal versus the conventional? The answer seems to lie primarily in art's function and in the cultural homogeneity of the society in which it occurs. Stylization can run rampant in a society that is so homogeneous that all its members are socialized into the conventions of its art. In practical terms, this would apply to a society such as the Australian Walbiri (described in chapter 3) whose small numbers insure a high degree of cultural uniformity, and also to larger societies that happen to be changing only slowly with the passage of time and which have an effective system of intrasocietal communication. Or, if art serves some function other than the explicit communication of culturally important information, it may be conventionalized to an extreme degree. Thus, as noted in chapter 3, an elaborate work of art from the Northwest Coast communicated the elevated social status of its owner regardless of whether viewers could decipher the stylized animals and people portrayed in the piece. Otherwise, if the referents for the art works of a society are to be communicated to individuals who lack thorough aesthetic socialization, stylization must be kept within certain bounds: A work must give the less-than-perfectly socialized individual enough visual hints to allow accurate interpretation.

Of course, factors such as these can be altered with the passage of time, allowing a naturalistic art style to evolve into a highly conventionalized style, ultimately reaching a point at which referential meaning is lost altogether. Also logically possible is the opposite

process whereby meanings come to be read into a design that was previously without meaning. To discover examples of either of these two processes is difficult, since it requires information with some historical depth and since archeological data seldom tell us much about the cultural interpretation of art styles. Judging only from appearances, there does indeed seem to be an ebb and flow in the accuracy of interpretation, although Boas was uncharacteristically incautious in asserting that such patterns have long since been proven "beyond cavil" (1955:127).

A Generative Approach to Aesthetics

Previously in this chapter some of the fundamental similarities between art and language were described. Art and language are also similar in that the goals of an objective study are largely the same for each discipline: In each area it would be interesting to discover the nature of the underlying ideal rules and exactly how individual events, whether linguistic or artistic, are related to them. In recent decades the study of language has been revolutionized by the "generative" approach, which was first proposed in 1957 by Noam Chomsky and which has been developed and extended by the subsequent generation of linguists.

Generative linguists holds that when a person utters a sentence it is useful to conceive of the utterance as being the result of a complex set of mental operations.[7] (Whether or not a speaker actually goes through these operations while speaking is another question. The generativists usually claim only that it is worthwhile to assume that the process might have been carried out.) The process is governed by various kinds of rules; speakers of a language are seldom consciously aware of these rules, but they demonstrate that they "know" them by being easily able to recognize grammatical errors when they occur. Some rules are obligatory, while others are optional; generally, the rules are "ordered," in that to produce a grammatical sentence, one rule must be applied before another and not in the reverse order.

Given the fruitfulness of a generative conception of language, and given the significant similarities between language and art, one

[7]Thus, sentences may be thought of as being "generated"—hence the name generative linguistics. A similar notion is at the base of the structuralist approach to cultural anthropology, as it has been developed by Claude Lévi-Strauss and others, and it also underlies the newly developed field of ethnoscience. (Nancy Munn's structuralist analysis of Walbiri design, discussed in chapter 3, is thus an intellectual cousin of Faris's treatment of Nuba art, a discussion of which follows.)

must be curious about the possibilities of applying a generativist approach to art. One major published effort in this direction is James Faris's analysis of Nuba body decoration (1972).

Nuba Personal Art. Faris spent 15 months living with approximately 2,500 southeastern Nuba in three villages in Kordofan Province, Democratic Republic of Sudan. The Nuba are agriculturalists who supplement their farming and herding with hunting and gathering. Nuba art takes the form of body decoration, with the application of paint and oil to the body, decorative shaving of the hair, and scarifying the body; jewelry is also worn by members of both sexes. The goal is to enhance one's natural beauty and give the impression of strength and good health. (Also, as noted in chapter 2, Nuba body decoration serves to mark an individual's age, kin group, and ritual status.) A great amount of effort is expended on obtaining the necessary materials for decoration, on shaving off all pubic and body hair (both for appearance's sake and also to insure the adhesion of pigment to the skin), and on oiling and painting the body. Young men, aged 14 to 25, are the most avid body decorators, oiling themselves daily and painting new designs on their bodies every day or two (except during the busiest part of the agricultural cycle). This is no small task since the painting of the more complex designs requires an hour's time. As Figures 5-6 and 5-7 indicate, however, the

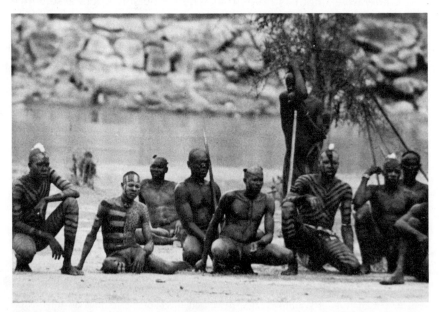

Figure 5-6 Nuba men with several *tōmā* and *pacōrē* design form types. They are watching tribal sport. *Photo courtesy James C. Faris.*

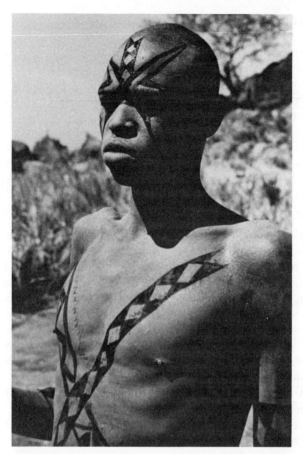

Figure 5-7 Nuba man wearing *nyūlaŋ* design form types—radiation from upper abdomen and nasal dip. These are both representational and nonrepresentational linear designs. *Photo courtesy James C. Faris.*

results are (to our eyes) quite striking, combining the beauty of the well-formed human body with effective, colored designs. (The excellent illustrations in Faris's book, many of them in color, make this point even more convincingly.)

The general aesthetic principles that guide Nuba body decoration are balance and symmetry, with the former taking precedence over the latter: Virtuoso Nuba body painters delight in making asymmetric designs that are brought into balance by the skillful playing off, say, of a small dark area painted on one side of the face against a larger, lighter colored area on the face's opposite side. The natural symmetry of the human body, both bilaterally and top to bottom, is always the starting point, to be enhanced or modified in appearance

by body painting. Needless to say, some Nuba are more skillful and attempt more difficult designs than do others, who limit themselves to the simpler patterns or just cover their bodies all over with oil and black pigment. An individual's decoration may fall short of perfection in one of two ways—either by being a poor execution of a satisfactory design, or else by making designs that, although they are well executed, are unorthodox and outside the realm of traditionally meaningful Nuba art. (The analogy with language errors should be made explicit at this point. The utterance of a sentence may be flawed in one of two ways: Either it can be poorly executed—with an unexpected sneeze in the middle of it, for instance—but grammatically well formed; or else it can break a grammatical rule, although its execution is flawless.)

Nuba Iconography. A great number of the designs painted onto their bodies by Nuba men are nonrepresentational. The body, for example, may be divided into several parallel bands, drawn in a vertical, horizontal, or diagonal direction, with alternate bands being painted in contrasting colors. Such a design is named, but it is not intended to represent anything in the natural world of plants, animals, or human artifacts. Other designs, however, are thought of as representing actual things—most commonly, particular species of animals. Some species may be meaningfully depicted simply by drawing their two-dimensional projection onto any part of the body. This method is also used to portray figures that are alien to this part of Africa. Faris drolly observes, for example, "My own visit introduced new sources of inspiration—I once observed the Middle-Eastern skyline, which is featured on the back of Camel cigarette packages, very accurately represented on a young man's back" (1972:18-19).

The most interesting of the Nuba styles, however, are those figures that are iconic, but in which representation depends partially or wholly upon portraying characteristic features of the subject's surface. The following discussion of Nuba art will be confined to figures of this sort.

Figure 5-8a, in Nuba body decoration, represents a particular species of poisonous snake, known by the native name *dēŋā kwa.* Presumably the series of diamonds corresponds to the pattern of scales that characterizes this particular species. If the design is painted onto a wider part of the body, the *dēŋā kwa* figure may be drawn in a wider version, as shown in Figure 5-8b, with no danger of confusing viewers as to the figure's meaning. Such alternative figures with the same meaning have been termed "allophanes" by Faris.

Such variations are, however, highly constrained. If, for exam-

ple, the diamonds (or, as an allophane, the spaces between the diamonds) in the narrower *dēŋā kwa* design are filled with color, as in Figures 5-8c and 5-8d, it is no longer interpreted as a certain type of poisonous snake but rather it represents *ŋōrā,* or cowrie shells on leather strips. If, on the other hand, the wider *dēŋā kwa* is similarly filled in (as in Figure 5-8e) the result is a particular species of anteater! If the Nuba artist errs in making one of these designs the result may be a body decoration that is faulty as a whole, despite the fact that it is composed of units which are independently valid, in the same way that the utterance, "Colorless green ideas sleep furiously" is absurd for English speakers although the words that make it up are all in the common vocabulary and each word is of the proper grammatical type for the position it occupies.

As an example of this second type of error that is possible in Nuba body decoration consider the design shown in Figure 5-8f, which represents another kind of poisonous snake, a type of python called *dēŋā kaperget.* If instead of the proper triple diamond an artist makes a double or quadruple diamond pattern, as in Figures 5-8g and 5-8h, however, the result is considered a mistake: It simply has no meaning.

A Generative Model of Nuba Figures. As previously noted, generative linguistics attempts to account for well-formed sentences by positing various kinds of rules which, if followed, lead to the production of such sentences. Faris has attempted to construct an analogous model to account for the type of Nuba designs that have just been described.

Nuba individuals attach no meaning whatsoever to elementary figures such as circles and simple zigzag lines—just as we attach no

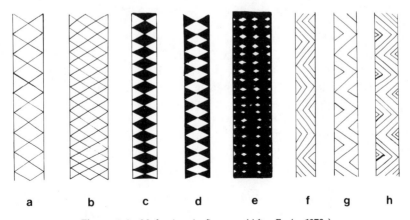

a b c d e f g h

Figure 5-8 Nuba iconic figures. (*After Faris, 1972.*)

meaning to individual elements of sound such as "p," "t," or "k." (This, of course, stands in contrast to the way in which Walbiri interpret their designs. See chapter 3.) Faris has discovered, however, that by choosing a few basic elements and defining a few simple operations, all 65 of the meaningful Nuba designs can be generated. The five unit elements Faris uses are: a pair of short, perpendicularly-oriented lines joined to form a right angle; the same figure rotated 45 degrees; a half-circle; a short diagonal line; and a short vertical line. Seven operations are necessary to generate any of the traditional Nuba figures (although for the creation of many of the figures some of the operations are unnecessary). Each of the operations is an algorithmic statement, i.e., each gives directions for carrying out certain manipulations on what has been created up to that point.

The way in which the *ŋōrā* design (Figure 5-8c) might be generated illustrates the model that Faris has developed. The first step is to choose the color of the figure and its background color. Then, starting with the half-diamond shown in Figure 5-9a, we may follow one of the options of the "horizontal" algorithm, namely to duplicate the original element, but reverse it and place it adjacent to the original element, thus producing a complete diamond (Figure 5-9b). The next algorithm, "vertical," permits the same type of diamond formation, but this time in the vertical direction, thus producing a string of diamonds such as shown in Figure 5-9c. A series of at least four such diamonds is needed to avoid ambiguity; beyond that, the string could go on indefinitely. A subsequent operation permits the filling in of any enclosed figures, thus producing Figure 5-9d. One final operation, the framing of the string of diamonds by vertical lines along the left and right points of the diamonds completes the figure: The result is *ŋōrā*, the design for cowrie shells on leather strips (Figure 5-9e).

By making changes in the generation of *ŋōrā*, different legitimate Nuba designs are produced. If, for example, the shading had been omitted, the final figure would have been the now-familiar *dēŋā kwa*; a horizontal duplication before framing would have given *karaca*, the anteater. The entire model can be reduced to definitions and algebraic statements. Faris explores several of the implications of the generative approach, and the interested reader is referred to his original work for additional information on this and on other aspects of Nuba personal art.

Estimate of the Generative Model of Nuba Art. Faris's model of Nuba iconography has been discussed in some detail because it is the first full-blown attempt to apply to art some of the approaches

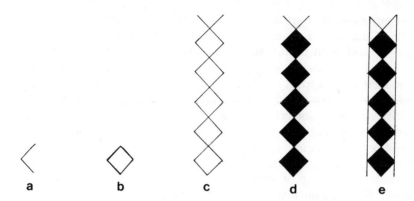

Figure 5-9 Generation of Nuba *ŋōrā* design.

that have been so widely heralded in linguistics. But what are we to make of the model?

First, some of the less damning objections to Faris's thesis should be put into proper perspective. It may be objected, first, that even if such a model were valid, it leaves unanswered many other questions about Nuba art. A generative model of aesthetic production tells us nothing, for instance, about the sociocultural functions of the art in question. But this is an unfair criticism in that we can hardly hope to find any single theory that by itself explains everything we wish to know about art. Thus, Faris supplements his generative model of Nuba design by providing a traditional ethnographic account of other aspects of Nuba art and culture.

One could also object to the fact that although Faris has adopted a quasi-linguistic approach, he is copying a linguistic model that is more than a little outmoded by now. Chomsky's analysis of syntax has been largely superseded by models that attach less importance to syntax and more importance to semantics. This objection too, however, is rather beside the point in that Faris's approach could be a major step in the right direction despite the possibility that it may benefit from future modifications.

The really serious objections to Faris's model are the same as those that have been directed at generative theories in linguistics. First, what is the "psychological reality" of such theories? Does the Nuba artist actually have in his mind, if only unconsciously, all the algorithms (or comparable algorithms) that are the heart of Faris's model? If so, does the artist actually use them as he creates designs or as he evaluates the designs made by others? For his part Faris (personal communication) claims that his model of Nuba personal art is meant only to be descriptive, i.e., to be a process that can generate certain Nuba designs: Whether this process resembles the psycholog-

ical processes that are at the basis of Nuba personal art is irrelevant. But ultimately our interest must turn back from abstract, hypothesized models to living, breathing human beings who create art.

These questions lead to another sort of problem: What kind of evidence can support or disprove Faris's hypothesized model? The tendency of Faris—and of most generative linguists—is to use simplicity as the major criterion for judging competing theories: Given two theories, each of which satisfactorily accounts for the data in question, that theory is preferable which does so most simply. But simplicity alone, unsupported by empirical evidence, cannot be trusted. What sort of empirical evidence can be adduced in such cases? The generativists (and quasi-generativists such as Faris) have yet to answer that, and indeed have yet to try to answer. (Dunn-Rankin's theory of how readers of English recognize letters and words [1978] has many interesting parallels with Faris's model of Nuba figures. Significantly, Dunn-Rankin has obtained some empirical evidence for the psychological reality of his theory.)

The approach of some generative linguists is to suggest that language is an intrinsic aspect of human mentality, the human brain being "wired," as it were, for operation according to the generative principles they have proposed. But this is itself a less-than-parsimonious solution, assuming as it does that the psychological level of human language operates (or is acquired) in a way that is fundamentally different from that of all other human behavior and of the rest of the animal kingdom. The problem is doubly difficult for Faris: Is the generative character of Nuba iconography proof that not only language but also art operates in a different psychological mode than does everything else; or are Nuba figures merely an aberrant extension of "linguistic thinking" into the realm of aesthetics? The success of future applications of linguistic models to art depends upon finding answers to these difficult questions.

Conclusion

Repeatedly throughout this chapter the most important issues have been left in something of a state of limbo. Relevant information on each one can be discussed, but inevitably the most fundamental questions have been left in doubt.

The sparseness of sound information regarding the psychology of art is partly due to methodological difficulties: How are we to gain access to the psychological level of art? Contemporary academic psychology tends to focus on behavior, giving greatest emphasis to those topics that can be studied in the laboratory. Needless to say, things

such as the creative process hardly lend themselves to such an approach. Alternatively, information can come from introspection, with individuals describing the way they believe they function psychologically. Some important insights can come from introspection, but there is no doubt that many unconscious factors go into the creation of art—motivations that one is not consciously aware of, information stored in the least accessible parts of memory, and so on.

An even more important source of difficulty stems from the proximity of the psychology of art to the philosophy of art and of human beings generally. Consider, for example, the problem of representation. The question, "What does the artist portray?" presupposes that one has satisfactorally answered the question, "What is real?" I myself skirted the issue by asserting that it seems more *useful* to assume that a material world exists and that, through our several senses, we apprehend this world with a greater or lesser degree of accuracy. But "most useful" does not—and should not—carry the same conviction as "truthful," and many thoughtful people, from Plato through Descartes to Chomsky, have claimed that the world of our senses is spurious and that only the abstract and timeless deserve the title of "reality." Neither logic nor experiment can resolve the debate. At best one can only assume that one position is the best bet and proceed from there. But whichever route is chosen, there are problems in store. If one adopts the empiricist position, as I have tended to do, it becomes quite difficult to conceptualize in naturalistic terms—much less collect data upon—the processes by which the artist acquires and acts upon general aesthetic principles, despite the fact that everything we know about representational styles leads us to believe that the artist does indeed do this. But to discard empiricism and embrace the rationalist position is, I believe, even more frustrating: We may concoct seemingly satisfactory theories, but how to test them if we deny their applicability to the mundane world of the senses? Perhaps, as Gregory Bateson has suggested (1972c), a necessary feature of art (and of religion) is that we conceive of it simultaneously in both literal and figurative terms—a mask, for example, *is* both a face and a piece of wood. When we concentrate solely on either one interpretation or the other the magic, the art, is lost. In terms of our affective reaction, this is no doubt true. The question is whether or not a one-sided approach also precludes intellectual understanding.

Ultimately the issue is this: Can we conceive of ourselves in naturalistic terms, as members of a species that is unique but not different from other species in any supernatural way? And, having made this ego-shattering leap, can we then make any sense of our

most distinctive trait, human culture? The answer lies, I believe, as much in our self-image and our motives for altering it as it does in the particular methodologies we develop.

GUIDE TO ADDITIONAL READINGS

The psychological aspects of art are nothing if not inaccessible. As a result, writing on the subject ranges from grand works of unbridled speculation to narrow theories derived from specific empirical data—plus a large dose of speculation. Access to the pre-1965 literature, most of which deals with art and artists in the West, may be gained via Kiell's extensive bibliography, *Psychiatry and Psychology in the Visual Arts and Aesthetics* (1965).

Heroic, if not always successful, attempts by social science writers to construct large-scale theories relating to the psychological level of art are Kavolis (1971) and the writings of Otto Rank (e.g., 1943, 1959). Howard Gardner (1973) has applied Piagean structuralism to art and artists, while Getzels and Csikszentmihalyi (1976) have produced one of the few works that begins with an empirical basis and proceeds to develop nontrivial conclusions.

Finally in the area of nonanthropologists writing, largely, about nonprimitive societies, mention must be made of the work of the art historian, Ernst Gombrich (e.g., 1972a, 1972b; Gombrich et al., 1972). Gombrich combines a vast knowledge of western art with a toughness of mind and rigorousness of approach to ask—and attempt to answer—important and interesting questions.

Except for the structuralists, few anthropologists have ventured into the psychological level of art, although the importance of the subject is widely appreciated. Forge's "Learning to See in New Guinea" (1970) offers some interesting insights, as does Bunzel's *The Pueblo Potter* (1971).

Among attempts to apply the generative model to art from primitive societies, Faris's Nuba work (1972) is unique for its thoroughness. Other generativist descriptions of art include William Sturtevant's treatment (1967) of Seminole clothing and Flora Kaplan's study (1977) of folk pottery from the Valley of Puebla, Mexico.

Chapter 6

Art in Transition

Change is problematic. A butterfly, dead and pinned to a specimen board, can be observed in minute detail, its parts dissected and studied at our leisure. But of course it isn't really a butterfly at all— it's a lifeless bundle of tissue, quite different from the free-flying butterfly of a summer's day. For the specimen butterfly the dimension of change has been removed: Artificially stopped in time, it no longer moves from shrub to flower to grass, and the egg-larva-cocoon-butterfly-egg cycle cannot run its course. Although it may be easier to study, by limiting ourselves to the specimen butterfly we ignore the real-world problems of locomotion and life cycle.

In the preceding chapters art has been pinned, as it were, to a specimen board and treated as if it were a fixed, unchanging *thing*. But, like a real butterfly, living art is actually a *process*, always in transition, changing from day to day, generation to generation, and epoch to epoch. A given society's art may change so slowly that

many years must pass before the outsider notices the replacement of the old by the new, but there always is change.[1]

Besides the intrinsic interest we westerners generally have in the subject of change, there are some practical reasons why the study of change in the arts of primitive societies is important. For one thing, a systematic study of evolving art traditions provides a basis for classifying and dating art objects from the past. This in turn can serve as a basis for ordering our thinking about the diverse range of available artifacts, and it provides a basis for organizing museum collections of items from other societies. The study of stylistic changes in art motifs was particularly valuable as a means of determining the relative age of items before the development of carbon-14 dating methods.

But the most compelling reason for studying the changes that have occurred (and that continue to take place) in the arts of primitive societies is the fact that we actually have little choice in the matter. Whether we like it or not, these arts have changed constantly throughout the past, and since the beginning of the age of western exploration the rate of change has increased dramatically. Most societies have adopted iron tools and other items from the west's technological bag of tricks; many have incorporated western themes as subject matter; and everywhere the influence of our cash economy has been significant. Living in the late twentieth century we tend to think of this as a recent phenomenon, but on reflection we remember that Europeans were making their presence very strongly felt in Africa and the western hemisphere 400 years ago. And even recently contacted societies have usually been quick to show the effects of western influence, both in their social organization and in cultural activities such as the visual arts. This being the case, we can only recognize the pervasiveness of change and capitalize upon it as an interesting area of study.

For convenience, this chapter deals first with cases of internal (or autonomous) change in art; then the spotlight shifts to transitions that result from contact with other—usually western—societies. The largest single topic is the commercialization of art that has occurred in many societies that are primitive or that have only recently changed from that status to being ethnic minorities in modern political states.

[1]Change in art, of course, falls within the general area of "culture change," a large and growing domain of contemporary cultural anthropology. General treatments of culture change may be found in Barnett (1953), W. Moore (1974), Hogbin (1971), and Steward (1967).

Autonomous Change

Autonomous change, i.e., change that does not result from contact with other societies but rather from processes within a given society, occurs everywhere and at all times. Most often it occurs slowly, but nevertheless it moves inexorably onward, with the aesthetic tastes of yesterday evolving into today's preferences, and so on into the future. This pan-human trait seems to extend even to our distant relatives, the apes and monkeys: Paul Schiller (1971) gave a chimpanzee named Alpha paper and pencil every day for six months. Not only did Alpha adopt a fixed style of drawing on the paper, but as months passed the style evolved into a distinctly different manner of drawing. By our definition, Alpha was not making art, but the gradual change in her style illustrates the pervasiveness of autonomous change in art.

Because autonomous change is usually a gradual process, it can seldom be studied during the typical fieldwork period of one of two years. Indeed, under such conditions it may go totally unnoticed so that the strongest impression made upon the ethnographer is that the art of a given society is totally changeless. But our colleagues, the archeologists, are always at hand to remind us of the shortsightedness of our vision. Inevitably when they excavate a site that contains the remains of many generations of human habitation, archeologists find a succession of artifacts that evolved from one style of production or decoration to another.

The history of the Eskimos of northern Alaska is an excellent example of gradual autonomous changes in art style. The topic is doubly relevant here in that contemporary Eskimo art is highly commercialized and, as such, will be discussed again later in the chapter. In that context it will be of interest to examine, among other things, the similarities and differences between modern Eskimo art forms and those of the past.

The Evolution of Prehistoric Eskimo (Inuit) Art.[2] The ancestors of the modern Inuit probably came from northeastern Asia sometime between 4000 and 2000 B.C.; by 1000 B.C. they had spread all the way across the arctic as far as Greenland. Their arrival had been preceded

[2] Some groups of the native inhabitants of the North American arctic prefer to be known as "Inuit," their name for themselves in their own language, while others prefer "Eskimo." The issue is an important one, dealing as it does with the ethnicity and self-image of a sizable minority population. In the absence of a consensus among the people involved, I have chosen to use the terms interchangeably, giving equal time to both sides of the question.

by a much earlier wave (or waves) of Asian immigrants, the ancestors of the other native populations of the Americas. The Eskimos, thus, have always been distinct from other Native Americans genetically, linguistically, and culturally. Living in the treeless arctic tundra, never very far from the waters of the Arctic Ocean, they have subsisted largely upon fish, sea mammals such as seals, and land mammals such as caribou.

Since the 1920s archeologists have been gradually piecing together the prehistoric development of Inuit culture. The emerging picture is complex (but not as intricate as one might suppose for so vast an area). It reveals a history of constant change, with cultural diversity resulting both from autonomous development and from contact with neighboring areas. (Surveys of the development of Eskimo art may be found in Rainey 1971, Collins 1962, and Martijn 1964.) As an illustration of the changes that occurred in prehistoric Inuit art that were probably autonomous in nature, we can follow the evolution of the "winged objects" from northern Alaska (cf. Collins 1962, 1964).

Ten of these ivory objects are shown in Figure 6-1. Despite obvious differences in appearance, each one has a deep socket carved into its lower side; on the opposite side of each there is a shallow pit or notch. Although it is only conjecture, probably the winged objects were attached to the butt end of a harpoon or dart. The harpoon or dart would have fit tightly into the socket, and the composite projectile would have been hurled by means of a spearthrower, the bone or ivory spur of which would have fit neatly into the small notch in the winged object. So used, the objects would have acted as a weight to counterbalance the heavy harpoon head and socket at the other end of the projectile. This explanation of the use of the winged objects is given credence by the fact that modern Greenland Eskimos are known to have used bone harpoon "wings" that served the same counterbalancing function.

The winged objects shown in Figure 6-1 were made over a period of more than 1,000 years; *a* is the oldest, dating from around 100 B.C., and *j* the youngest, from about 900 A.D. While all have the definitive traits of socket, notch, raised central portion, and (except for *j*) bilaterally symmetrical wings, the overall shape of the objects changed drastically during this time. Most noticeable are the modifications that occurred in the shape of the wings: Beginning as rather irregularly rounded extensions coming directly out of each side, they soon became more carefully shaped and began to sweep backward a bit. The backward movement continued, ultimately producing the gracefully formed specimens, *g* and *h*. With *i* the process was completed, the wings being swept back to the point of being joined with

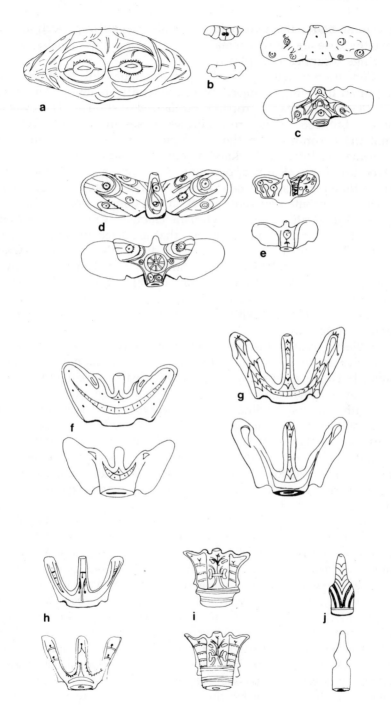

Figure 6-1 Prehistoric North Alaskan winged objects. (*After Collins, 1964.*)

the central body; the two pairs of small triangular projections just above the base are all that remain of the outer wings. Finally, with *j*, the wings disappear completely.

Concurrently with these changes in shape, the decorations incised upon the winged objects were constantly changing. The oldest piece clearly has a face, probably human, carved on it: The eyes are obvious, but also visible are eyebrows, nose, and nostrils. Whether or not the decorations on the subsequent pieces were meant to be representational cannot be known, but the distinct stylistic changes that occurred are clearly apparently. Although many artifacts from various time periods must be examined before the patterns of decorative change become apparent, a look at the winged objects shown in Figure 6-1 illustrate some characteristic changes. Consider, for example, the linear and circular elements that are used in decorating the objects. On *a*, in a style common in the earliest so-called Okvik period, the lines tend to be short, straight, and detached, many of them being doubled. With *c*, small double-edged circles become popular design elements, and, in *d* and *e*, the circles work themselves into elaborate patterns with lines being used to demarcate larger rounded design areas.

Object *f* marks the transition from a culture known as Old Bering Sea to that known as Punuk. Circles remained popular in Punuk, but with a difference. Old Bering Sea carvers engraved their somewhat irregular circles by hand, making them in various sizes, often with a double perimeter. Punuk carvers must have made their circles by using a stone bit in a hand-twisted drill, because the circles used in Punuk decoration are uniform in shape, usually about an eighth of an inch in diameter, and never concentric. Later, with the circles reduced to incised points, sinuous linear designs became dominant, resulting ultimately in the rather geometric patterns on the last winged object, *j*.

The art of the prehistoric Inuit consisted of many other things in addition to the incised winged objects: Figurines of animals and humans were carved out of ivory and bone; and tools, utensils, and other utilitarian items were often engraved with designs comparable to those appearing on the winged objects. At various times and places in the arctic, pottery, wood, and hide were decorated; tattooing provided another avenue of aesthetic expression. But the case of the winged objects from northern Alaska illustrates very well the general point that no matter how remote a society, no matter how simple its technology and how sparse its population, the group's art styles change with the passage of time. The changes are not necessarily cumulative: Except for the possible adoption of more complex media or tools, each style emerges from its predecessor, not seeking

Figure 6-1 Prehistoric North Alaskan winged objects. (*After Collins, 1964.*)

the central body; the two pairs of small triangular projections just above the base are all that remain of the outer wings. Finally, with *j*, the wings disappear completely.

Concurrently with these changes in shape, the decorations incised upon the winged objects were constantly changing. The oldest piece clearly has a face, probably human, carved on it: The eyes are obvious, but also visible are eyebrows, nose, and nostrils. Whether or not the decorations on the subsequent pieces were meant to be representational cannot be known, but the distinct stylistic changes that occurred are clearly apparently. Although many artifacts from various time periods must be examined before the patterns of decorative change become apparent, a look at the winged objects shown in Figure 6-1 illustrate some characteristic changes. Consider, for example, the linear and circular elements that are used in decorating the objects. On *a*, in a style common in the earliest so-called Okvik period, the lines tend to be short, straight, and detached, many of them being doubled. With *c*, small double-edged circles become popular design elements, and, in *d* and *e*, the circles work themselves into elaborate patterns with lines being used to demarcate larger rounded design areas.

Object *f* marks the transition from a culture known as Old Bering Sea to that known as Punuk. Circles remained popular in Punuk, but with a difference. Old Bering Sea carvers engraved their somewhat irregular circles by hand, making them in various sizes, often with a double perimeter. Punuk carvers must have made their circles by using a stone bit in a hand-twisted drill, because the circles used in Punuk decoration are uniform in shape, usually about an eighth of an inch in diameter, and never concentric. Later, with the circles reduced to incised points, sinuous linear designs became dominant, resulting ultimately in the rather geometric patterns on the last winged object, *j*.

The art of the prehistoric Inuit consisted of many other things in addition to the incised winged objects: Figurines of animals and humans were carved out of ivory and bone; and tools, utensils, and other utilitarian items were often engraved with designs comparable to those appearing on the winged objects. At various times and places in the arctic, pottery, wood, and hide were decorated; tattooing provided another avenue of aesthetic expression. But the case of the winged objects from northern Alaska illustrates very well the general point that no matter how remote a society, no matter how simple its technology and how sparse its population, the group's art styles change with the passage of time. The changes are not necessarily cumulative: Except for the possible adoption of more complex media or tools, each style emerges from its predecessor, not seeking

any single or ultimate goal of aesthetic perfection, but instead con-
stantly changing emphases, modifying interests—making new, but
not necessarily better, art. (Indeed, Boas [1908] used related arti-
facts—prehistoric Alaskan needlecases—to show that variations in
decorative style are not controlled by any single motive, such as a
tendency from realistic representation to conventionalization, or vice
versa.)

We have returned to a point made in the first chapter of this
book, namely, that those twentieth-century societies that we term
"primitive" should not be thought of as contemporary replications of
the societies that inhabited the earth at the time of the human race's
childhood. Archeological study, whether of the American arctic or of
any other long-inhabited region, inevitably reveals a past that is
restless with change, either gradual or dramatically rapid.

Stylistic Change and "Culture Drift." As noted at the beginning of
this chapter, the study of change tends to be very difficult, and the
gradual evolutionary process that typifies autonomous change is es-
pecially elusive.

Of course, cultural anthropologists are not the only ones with
this problem: Linguists are faced with similar difficulties in studying
the gradual changes that occur in languages, and physical an-
thropologists must try to explain the genetic changes that are random
in nature rather than attempts to better adapt to the environment. In
both these situations, the notion of "drift" has shed some light on
the processes by which change occurs. The basic premise of drift is
the same in all cases: Consider an entity that has the following two
characteristics: (1) it may change, unaffected by any extraneous influ-
ences, in one or more ways; (2) at any given time, change of one sort
or another is likely to occur. With the passage of time such an entity
will change in a way that is unpredictable in direction but substan-
tial in degree. A series of changes may bring it back to its prior form,
but this is unlikely and wholly accidental.

The prehistoric winged objects from northern Alaska, whose
changes through a period of over 1,000 years were discussed in the
preceding section, illustrate the way art may change via cultural drift:
We can think of the objects as having two sets of component fea-
tures, those which are instrumental and those which are not. The
instrumental features are those that contribute to a winged object's
efficacy as a counterweight attached to the basal end of a harpoon or
dart that will be hurled with a spearthrower. Among these features
are the object's socket, the opposite pit or notch, and the fact that the
object has some weight to it. None of these features may be substan-
tially altered without rendering the object useless; hence none of

them is subject to drift. And in fact, none of these instrumental features of the winged objects did change during the 1,000-year history of their use.

The presence of wings may have been instrumental in aerodynamically stabilizing the harpoon's flight, although the effects must have been minimal since the last-made objects were totally wingless. In any case, the actual *shape* of the wings was noninstrumental, since changes in the wings' shape had no noticeable influence on the hunting effectiveness of the harpoon to which it was attached. Being noninstrumental, the shape of the wings was subject to drift: The earliest known objects had wings that were fairly wide and came out at right angles to the body of the object. From this shape, any of a number of changes could have occurred: The wings, for example, might have become more narrow but continued to stick out at right angles; or they could have become wider but shorter, causing an increase in the overall width of the object; or finally they could have—and in fact did—change by becoming more round in shape, the back edge being curved more than the front.

If we were to make prototypes of each of these three possible modifications of the wings and do systematic testing, perhaps using a wind tunnel, we might find one of the designs to be more efficient than, and hence preferable to, the other two models. But in practical usage any such differences would be so slight that the prehistoric Inuit probably would not have noticed them. Consequently, any one of the three (or more) possible alterations was equally likely.

But, for some reason that we'll probably never know, it was the third style of wing that did come into fashion. Its shape became the norm for the moment, although as the centuries passed, it too was subject to alteration in any of several ways. For one thing, it might have been changed back to the preceding shape of wing, but other possibilities presented themselves too: The wings might have become longer, shorter, or wider. In fact the change that occurred was an increased curving of the back edge of the wing, giving it the beginnings of a "swept back" appearance.

From this point again, several changes were possible; what actually happened was the lengthening and narrowing of the now rearward-slanting wings. And so the process went, with change following change, as the years and generations passed. Similarly, the decorations engraved on the winged objects changed through time, first using short unattached lines and later adopting lines woven into elegant weblike patterns. The same is true of *all* noninstrumental components of culture: Through the process of drift, noninstrumental features constantly change in inevitable, substantial, yet unpredictable ways. (As noted in the first chapter, it is virtually impossible to

know at the time whether or not some specific trait is totally non-instrumental. But since the notion of drift can only be applied to changes that have already taken place, we can say with the wisdom of hindsight that when change has occurred gradually over a long period of time with no apparent increase in efficacy, the elements must have been noninstrumental.)

The Mechanics of Stylistic Drift. The notion of drift does not explain change; it simply describes patterns of change that occur. To gain some insight into the actual causes of autonomous change we must focus on the individual artist. Chapter 5 discussed the creative process generally, but several points mentioned there have a bearing on the subject of change.

As noted in chapter 5, when an artist in a primitive society works, there is virtually never an attempt to exactly replicate a pre-existing art object. The artist works under the constraints of tradition, but dogged copying very seldom occurs. Moreover, the transmission of artistic skill from one generation to the next inevitably results in at least minor changes in style. Thus, for example, Davenport (1971:385) could see clear differences between the work of two carvers in the Eastern Solomon Islands, despite the fact that each had learned his craft from men who themselves had been apprenticed to the same master carver. These factors alone—the near universal absence of copying and the changes that occur in the process of aesthetic socialization—are enough to insure that the prerequisites of drift are fulfilled: Each piece of art differs from all others in one or more ways, and the direction of change is unaffected by considerations of practicality.

The likelihood of drift occurring is even greater in societies where there is not only an aversion to copying but an actual premium on novelty. Generally speaking, primitive societies tend to be more conservative than western societies have been in recent times, but this does not mean that new things, ideas, and styles are never sought in such societies. Cross-cultural studies of art have turned up numerous instances of societies that value a certain degree of originality in their artists. Tiwi artists, for example, carve impressive mortuary poles and although the poles inevitably conform to some traditional restraints on media and form, within these limits artists thrive on originality (Goodale and Koss 1971). Similarly the East African Pakot consider novel things to be "pretty," and thus constantly encourage native artists to shift their methods of aesthetic expression (H. Schneider 1956). In these and many other societies the pattern seems to be this: The artist and his audience like works that are a little—but not too much—different from the things that have

gone before. If the difference is too great, they—like most of us—balk at accepting the change.

Why do many people prefer a modicum of novelty in art? Several reasons may be adduced, the most mundane of which are mere practical considerations. For example, one Pueblo potter told Bunzel that she always made her pots just a little different from those of the other women so that when she took food to festivals in them she would be able to recognize hers among all the others when the festivities were over and it was time to gather together her empty pots and go home (Bunzel 1972:65).

Another possible motivation for novelty lies in the realm of politics and economics. In highly stratified societies there is always the danger for the powerful that the symbolic system publicizing their importance will be debased when commoners copy their symbols. Since the supply of art works is somewhat flexible, the less powerful can take on the trappings of the elite by imitating their art. One way for the elite to prevent this is to equate originality with quality, with the proviso that only those innovations accepted by the elite themselves are improvements—all others are simply "bad art." (The same end can be accomplished, of course, by requiring "fine" art to be made only in rare media—precious metals or stones, hard-to-find dyes and fibers, high-fired porcelain, and so on.)

Needless to say, motives such as these may also occur on the more benign level of personal interaction. In societies that value individuality, people may be prompted to create unique art works simply because they find pleasure in seeing a statement of their own identity made manifest and public.

An additional explanation for the widespread appreciation of artistic innovation might be suggested. A very important trait of the human species is its adaptability. We have come to dominate the globe (at least for the moment) by our inventiveness and our ability to adopt new cultural practices if they improve the life chances of us and our children. The tendency has been to remain largely true to traditional ways while simultaneously making small alterations here and there. This process of "cautious innovativeness" is relatively safe in the short run, but it may lead to major cultural changes as the centuries roll by. Given the pervasiveness and adaptive value of these traits, it seems reasonable to assume that a similar cautious innovativeness in art is not just accidental. If a pan-human characteristic is at the base of this trait, an explanation could go either of two ways. Perhaps, on the one hand, we have a generalized instinct that tends to make us cautiously innovative by nature. Applied to technology, this would have lead us to constantly refine early stone tools, eventually to develop agriculture, and ultimately to create the

phenomenon of industrialism that surrounds us today. Applied to art, such an instinct would motivate the continuous stylistic changes we have just been discussing.

On the other hand, the argument could be turned around—with intriguing results. If innovativeness is *not* instinctual (and there is no hard evidence that it is) but rather an ability acquired through day-to-day practice, then human innovativeness in art could be looked on as a practice area for the development of skills that pay off in the pragmatic world of subsistence and protection from life-threatening dangers. Thus, for example, we often create what Ravicz (1976) has termed "ephemeral" art, i.e., art objects that deteriorate or are destroyed soon after their creation, simply because we benefit more from the process of making art, with all the practice it provides in cautiously innovative thought and work, than we do from keeping a piece of art for passive appreciation indefinitely into the future. Art, so the argument might go, offers an area in which we can play with experimentation, to some extent "discovering how to discover" without risking life and limb.

Like most nature-nurture questions, we cannot presently determine which of these two attempts to explain innovativeness in art is more valid. And of course we cannot exclude the likely, if less satisfying, possibility that the truth lies somewhere between the two—that, perhaps, humans have an inborn predisposition for innovativeness, but that postnatal experience is necessary for its fruitful development.

Although there are good reasons why innovativeness, in moderation, is fostered in the arts of many societies, we should not lose sight of the fact that the countervailing force of conservatism is always potent. Again, there are good reasons why this is the case. For example, while some innovation may benefit the powerful in stratified societies, too rapid change would undermine the status-conveying capacity of art. Some elites have decided, as it were, not to take any chances and have attempted to prohibit innovation. In traditional Maori (New Zealand) culture, deviations from the traditional were considered to be evil omens; and Firth (1925) has claimed that Maori carvers were summarily executed if they happened to create a novel pattern, even if the innovation occurred by accident.

Another restraint upon innovation stems from the affective response that is so often felt toward art. At least part of one's emotional reaction to a work of art is based on previous aesthetic experience. Thus, a work of art that is quite unlike any other a viewer has seen will probably be difficult to appreciate, unless a strong value is placed on innovation for its own sake. For example Alvin Wolfe (1955) has described an Ngombe carver who began

making figurines, items that had not previously been included in the Ngombe artistic repertoire. Although the carver and his peers believed that the figurines made him a more successful hunter, the new art form was considered something to be curious about but not to be imitated. As of the end of Wolfe's fieldwork, no other Ngombe carvers had taken up figurine making. Bunzel, in her work with Pueblo potters, had similar findings. She took with her numerous photographs of pots from various locales in the Southwest. When she showed them to the potters of a given village, the women took seriously those pots of their neighbors that had many similarities to their own, avidly discussing what were, in their view, the pots' strong and weak points. A few potters went so far as to incorporate into their own pottery some features they had seen in the photos of their neighbors' pots. But the photographs of pieces from more distant Pueblos brought a totally different response: The potters laughed at them—and promptly lost interest in them.

Art and Culture Contact

The preceding section discussed autonomous changes in art—changes springing from within a single society. But perhaps even more common are those changes that occur in one society as a result of contact with another. If humans are skilled innovators, they are even more adept at "borrowing" the good ideas of others when they see them.

Whenever societies are in contact with each other, change is likely to occur in one or both of them. The situation we know most about is that of contact between various primitive societies and Euroamerican society, but it is also very common for two primitive societies that are in contact with one another to each adopt something from the other's artistic repertoire. A circum-global example of the diffusion of an asthetic motif has already been described in chapter 3, namely, the spread of the heraldic woman design, from its point of origin in the Middle East to such far-flung places as West Africa, Southeast Asia, Oceania, and North and South America.

A more local, but more extreme, case of artistic borrowing is exemplified by the masks of the West African Guro (cf. Himmelheber 1963:105-6). The Guro constitute a unified tribal group, but they have two distinctly different artistic styles: One style has been borrowed from the Baulé, the Guro's eastern neighbors, while the other strongly reflects the art of the Senufo to the north of the Guro.

Of necessity the best documented instances of change resulting from culture contact are those in which a primitive culture comes

under the influence of Euroamerican culture. Around the globe, western explorers, traders, missionaries, and bureaucrats have made their presence felt in the native societies they have encountered. The remainder of this chapter will deal with the repercussions this process has had on art, but before continuing a few new terms must be introduced.

When primitive societies come under the influence of nonprimitive ones, the resultant changes often quickly transform the former to such a degree that they no longer fit the category "primitive" as it was defined in chapter 1. Following current usage, I will refer to such groups as "Fourth World" societies. ("First" and "Second" World refer, respectively, to western noncommunist and western communist nations; the "Third World" is made up of the emerging nations of the nonwestern world.) Characteristically, Fourth World societies were primitive until their relatively recent contact by First (or Second or Third) World people, and they have since fallen under the political domination of one or another of these outside powers.

Every instance of artistic change due to acculturation is unique, but some order can be found in this diversity by noting two variables that are applicable to all such situations (cf. Graburn 1969, 1976a:5-9). The first question we may ask about art produced in a Fourth World society concerns its origins. Two extremes are possible: Either the art is a modern-day continuation of traditional art, with no significant changes in subject matter, medium, or style; or at the opposite extreme, the Fourth World society may have adopted an art form from the First, Second, or Third World Society that has impinged upon it, borrowing subject matter, media, or styles that were totally absent in the precontact situation. Clearly many instances will fall somewhere between these two extremes, with a Fourth World society, say, combining new tools and materials with traditional styles and subjects to produce a wholly unique art form.

A second dimension to be noted is the intended market for the art of Fourth World societies. On the one hand, art may be made for local use, valued by the native population for its aesthetic merit according to their own standards. Alternately, members of a Fourth World society may have begun to create art for sale to outsiders. The buyers may be visiting tourists or professional dealers who buy goods in large or small quantities, ship them to western commercial centers, and display them or sell them for a profit. Again, a middle position is possible: Navajo silver jewelry, for example, was for a long time made both for local consumption and for sale to outsiders.

Given these two variables, it's easy to use them to construct a table into which most Fourth World art can easily be fit. Graburn has done this and suggested names for the resulting categories (1976a:8);

with a few minor modifications, his system will be used through the remainder of this chapter. Figure 6-2 shows the table, including ethnographic examples to illustrate each of the categories. The example of "traditional" art has already been discussed; examples of the other categories of acculturative art will be dealt with in the following pages. The interested reader can find additional examples in the excellent collection of essays edited by Nelson H. H. Graburn, *Ethnic and Tourist Art of the Fourth World* (1976d).

Destination of Art Form

		Fourth World Society	Other than Fourth World Society
		Traditional Art	*Commercial Fine Art*
	Traditional Fourth World Society	Eskimo "winged objects"	New Guinean shields made for sale to outsiders
		Reintegrated Art	*Novelty Art*
Origin of Art Form	Synthesis of Native and Alien Traditions	Cuna *molas*	Contemporary Inuit soapstone carving
		Popular Art	*Assimilated Fine Art*
	Other than Fourth World Society	Navajo jewelry made for local sale	Inuit prints Navajo jewelry made for sale to outsiders

Figure 6-2 Typology of art production, with examples. (*Adapted from Graburn, 1976.*)

"Reintegrated Art:" Cuna Molas. Mari Lynn Salvador has described a definitive example of "reintegrated art," i.e., an art form that emerged from the culture contact situation as a synthesis of ideas from native and alien cultures and has now become integrated into the matrix of the Fourth World society. Salvador did fieldwork among the Cuna of the San Blas Islands, off the Atlantic coast of Panama, focusing primarily on the attractive molas that are made there primarily for local use.

Molas have become part of the everyday dress of Cuna women, being used as front or back panels of blouses. Contemporary molas are made of two or three layers of brightly colored cloth. Patterns—either geometric designs or representational figures—are cut out of the top layer or layers and the pieces are stitched together to create handsome works of reverse appliqué such as the one shown in Figure 6-3.

Before the arrival of Europeans, a major Cuna art medium was personal decoration in the form of body painting and jewelry; molas did not exist. But the contact situation brought with it two things: an

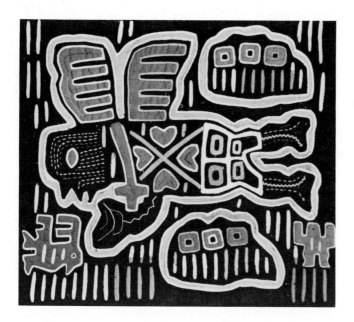

Figure 6-3 Cuna mola, San Blas Islands. Reverse appli-
que, cotton cloth; 14½ inches by 16 inches. *Collection of
the author.*

ethic of personal modesty that required the covering of most of the
body with clothing, and relatively easy access to factory-made cloth,
needles, thread, and scissors. Salvador reconstructs the development
of the molas thus:

> In 1868, Cuna women were wearing 'short sleeved chemises extending
> to the knees' (quoted in Stout 1947:67). Later, the blouses worn were
> reported as dark blue with a red border at the hem and were worn over
> the picka underskirt, which was painted with geometric designs. . . .
> By 1900, as more bright-colored cloth became available, women began
> to make simple molas, the decoration cut out of the top layer and sewn
> to the layer below, a type of decoration that is an indigenous develop-
> ment. Soon the mola work covered the bottom half of the blouse. When
> printed-blue trade cloth was introduced the women used it as a wrap-
> around skirt over the picka underskirt, which was no longer painted
> (Stout 1947:67). The blouse was then made shorter and the mola portion
> was increased until now only a small yoke and the sleeves are made of
> plain cloth. The painting on the picka has been discontinued (Salvador
> 1976a:172).

Thus the technique of mola work is a synthesis of an alien medium
with native aesthetic expression and ingenuity. The decorations that
appear on the molas are similarly eclectic: The two-layer geometric

molas resemble designs used in precontact body painting and traditional Cuna basketry. Other molas have representational figures depicting political, recreational, and religious themes—the latter itself being a syncretistic combination of native and Christian belief. Fads in mola design and subject matter come and go: In the 1960s "missionary molas" were popular—molas depicting the Bible stories of Adam and Eve, the crucifixion, and so on. Now such molas have fallen out of fashion and few women wear them. A mola with a political theme is llustrated by Salvador (1976a:177, Figure 55c): Copied from a poster for the "Movimiento Nacional Liberacion," it shows a worker breaking the chains that bind his muscular arms.

The relatively young art of mola work has become an integral part of Cuna culture. Fine molas are a source of pride for the family of the maker, and their production provides an expressive outlet for Cuna women. Not all women are equally skillful at mola work, and an elaborate set of criteria exists for judging molas. Some of the standards concern workmanship: In Salvador's words, "The sewing must be carefully done with matched thread, no stitches showing, and no raw edges. Lines have to be even, thin, and equally spaced" (1976a:172). Other standards relate to aesthetic values: Large areas around representational figures should be filled in with straight lines or geometric patterns; patterns should be balanced; the top layer of material must be all one color—usually red; all colors should be intense, not muted; and the contrast between different colors must be carefully worked out (cf. Salvador 1976b).

Molas have also taken on an economic importance for the Cuna. Since women's tastes frequently change, molas often go out of style before they are worn out. Molas have become popular purchase items for tourists, and for years Cuna men have taken molas to sell in cities on the mainland. A few women now make "tourist molas" for sale directly to outsiders, but these molas are "made quickly at the expense of the accepted quality criteria. Women who make them are often criticized and the problem of 'tourista molas' has been discussed at the Cuna congress" (Salvador 1976a:180).

But commercialization has not had a uniformly adverse effect on quality: In 1966 the *Cooperative de Mola de San Blas* was organized, partly as a means of marketing the dresses made by women in a sewing school started by Peace Corps volunteers in 1963. The Coop now has three hundred members, and the molas they produce are of the finest quality, partly, Salvador says, because the members take pride in the work they do for the Coop, and partly because the products are under the scrutiny of a strict quality-control board composed of the most skillful mola makers.

The Cuna molas illustrate one possible result of a primitive

society's encounter with the west. They represent a felicitous blend of the traditional and the alien that benefits both parties—the Cuna in now having a new art form that plays an important role in their culture, and us in our being the recipients, through one channel or another, of strikingly handsome (if often second-hand) works of art.

Commercialization of Art: A Navajo Example

The evolution of Cuna molas is relatively simple by comparison to the developments that have occurred in many other primitive societies as a result of contact with the west. The following two sections describe two of the more interesting and better documented cases—that of silversmithing by the Navajo and the commercialization of art among Canadian Eskimo groups. A subsequent section discusses in general terms the dynamics of changing art traditions, including the process of commercialization. That section will also consider the social and artistic repercussions of commercialization of, art in primitive (or transitional) societies. But whatever the final estimate of the phenomenon, I wish to state here that the subject not only deserves our study but that it is one of the most important topics to be considered in this book. Some scholars feel that art made for sale to westerners is inevitably inferior to traditional art and that, therefore, it does not merit serious consideration. This view, however, errs on three counts. First, it implies that before the time of contact with the west, art in primitive societies was immune to influence from other societies. As has already been shown, such was not the case. Second, the view suggests that all art produced under the influences of acculturation is inferior to traditional art. In terms of workmanship, this is sometimes true and sometimes false; the same is presumably true with respect to the aesthetic merit of commercialized art, although differences depend largely upon the viewer's tastes and assumptions. Third—and, I feel, most importantly—the commercialization of the arts of some small-scale societies is a force affecting thousands of people around the world. Whether we care for the art itself (and, I should admit, some of it I do like and some I don't), it is a subject that we cannot turn our backs upon as long as we claim to be interested in the lives of the other women and men with whom we share this globe.

The Development of Navajo Silversmithing. Thanks to John Adair's excellent *Navajo and Pueblo Silversmiths* (1944; reissued 1970), we know most of the pertinent details about the development of silversmithing among Native Americans of the Southwest—its origin, its spread of popularity among Navajo and Pueblo peoples, commercialization of

the craft as Anglos began buying it, and the changes in technique and style that have marked its evolution. Adair's treatment of the subject is a model of thoroughness. The spread of the craft from Navajo smiths to numerous Pueblo groups is an interesting subject in itself, but our discussion here will be largely confined to silversmithing among the Navajo themselves. And for the most part the situation we will be discussing is the one that existed at the time of Adair's fieldwork before 1944; more recent developments will be described only in the last part of the section.

Like the mola work of the San Blas Cuna, Navajo silversmithing is a relatively young art form. Before the mid-nineteenth century, none of the native groups living north of the Rio Grande did metalwork of any sort. The Mexicans to the south had a tradition of metalwork, derived both from the pre-Columbian Aztec civilization and its antecedents, and from subsequent contact with the Spanish colonizers.

Some time around 1859 a Navajo man named Atsidi Sani ("Old Smith") went to New Mexico to work, and from Mexican smiths who lived there he learned the craft of ironworking; by 1870 he had mastered silversmithing. When he returned to Navajo country his new skills came with him, and his neighbors—both Navajo and Pueblo—provided a ready market for his silver jewelry and functional pieces such as decorated horse bridles and bow guards. Atsidi Sani did not make a great amount of silver, but he did do something more important: He taught the craft to his four sons, and they all became prolific silversmiths and teachers.

From that time to the present, Navajo silversmithing has undergone constant modification. Some changes have resulted from the introduction of new tools, techniques, and media. The use of metal stamps to make small repetitive patterns on silver began around 1885. (This technique, too, came from the south in that the first stamps were obtained from Mexican leatherworkers.) The insetting of turquoise began around 1880.

As is typical of the culture contact situation, Navajo society did not indiscriminately adopt ideas and items from the alien population, but rather picked those things that fit best into the traditional system of thought and material culture. For example, the iconography of the Franciscan missionaries in the Southwest provided a whole gamut of designs that smiths could incorporate into their silverwork, but the one that became most commonly used by Zuni smiths was the double-barred cross motif. To the Spanish missionaries the design stood for Saint James, the patron saint of Spain, but its popularity among the Zuni was due to its similarity to the traditional representation of Dragon-Fly, a figure that had been popular in Zuni art long

before the arrival of the Spanish. At the time of Adair's fieldwork, four of his six informants still equated the double-barred cross with Dragon-Fly.[3]

Navajo Silver as "Popular" Art. Silver ornaments from Mexico had been prized in Southwestern societies long before the development of local silversmithing. Since Navajo smiths could easily tap—and expand—this market by being more accessible, more responsive to the tastes of their clients, and presumably by selling at lower prices, the new craft caught on quickly, making it an example of what Graburn (1976a:7-8) classified as "popular" arts, i.e., arts introduced from outside the society but which, in their adoptive form, become genuinely appreciated within the population.

Fine silverwork is held in high esteem in contemporary Navajo communities. Individuals—both men and women—wear their silver with pride; Adair recounts that a common means of one Navajo complimenting another is to remark on the quantity and quality of that person's jewelry. As with Euroamericans, Navajos view silver as a sign of prestige: The merit of a family's silver is considered (along with their sheep and goats) to be an indicator of the group's social standing in the community. Adair notes, "This display of wealth is not a personal matter as much as it is a family matter. It is not 'see how much money I have,' but 'see how much money we have in our family' " (1944: 98). And the silver is not just a means of displaying wealth; it also plays a role in the ongoing economic system, since pieces may be repeatedly pawned at the trading post when the owner is temporarily in need of money or other goods.

But the silver worn by Navajos does more than fill economic needs; it's also an art form, valued for its beauty and judged according to a set of standards that, though they have shifted through time, are commonly held throughout the Navajo population. At the time of Adair's research, silver bracelets were felt to need one or more turquoise settings to be attractive: Deep, clear, robin's egg blue stones were preferred. Tastes in design have shifted from the simple bold designs popular at the turn of the century to the more elaborate styles in the 1920s; finally, at the time of Adair's research, there was a swing back toward jewelry with more simple symmetry and elegance. Transcending these changes in fashion, however, was a constant seeking of fine workmanship: Navajos rarely wear sloppily made silver jewelry.

[3]The Dragon-Fly icon is exceptional in that most of the designs used on Southwest silver are nonrepresentational, despite the claims to the contrary by some Anglo traders who know that their white customers will pay more for a piece if told that its decorations hold some supernatural meaning in the mind of its maker (Adair 1944:104).

Navajo Silver as "Assimilated Fine Art." Silversmithing has had a dual existence in the culture of twentieth-century Navajo and Pueblo societies: It is a living art form within the societies themselves, a highly-regarded craft that produces works of local value. But in addition to that, the making of silver jewelry for sale to Anglos has been a major source of income for many of the populations. Thus, using Graburn's typology, we can say that Navajo silver is both a popular *and* an assimilated fine art.

The craft was already well established as a popular art when, in 1899, the Fred Harvey Company began ordering silver for sale to Anglos. Tourists from the east had shown interest in buying "Indian-style" silver, but the pieces made for native use were considered too heavy to carry back home and wear in society. Seeing a potential market, Herman Scheizer, head of the Fred Harvey Company's curio department, bought a supply of silver and polished turquoise sets and farmed it out to various traders, asking them to have Navajo smiths make jewelry that was lighter in weight than that made for local use. The technique was a commercial success, with the Harvey Company—and later others—selling the new-style jewelry to people touring the west on the Santa Fe Railroad, staying along the way at hotels at the Grand Canyon and Albuquerque. By the mid-1920s Navajo and Pueblo smiths were turning out large quantities of the lighter weight jewelry.

The development of an outside market for Navajo silver has influenced the craft as a whole. New tools and techniques have been introduced to hasten production; torches have commonly replaced natural fires and blowpipes as a source of heat for soldering, and mechanical rollers are used by some full-time smiths. These aids do not noticeably alter the quality of the final product and are used not only on silver made for sale but also on silver intended for local use.

The difference between the two markets is, however, kept in mind with respect to style and workmanship. Both smiths and traders typically believe—probably rightly so—that most nonnatives feel authentic silverwork should look old, with tarnish in the crevices of fine work. Tom Burnside, Adair's principal informant, artificially oxidized the pieces he made for sale to Anglos by first heating them and coating them with a tarnish-producing chemical, and then buffing them to leave only the grooves darkened. (By contrast, jewelry made for local use is not artificially tarnished since Navajos take pride in bright, shiny silver that is new in appearance, if not in fact.) Also, most smiths are quite willing to make specific types of jewelry at the request of traders, regardless of the style.

The most important difference between the jewelry produced for

export and that made for local use results from the buying methods of the traders. Usually jewelry is bought from smiths by the ounce, giving little or no premium for careful craftmanship. As one would expect, this practice encourages many smiths to turn out work as quickly as possible with only minimal regard to quality. Adair commissioned Tom Burnside to make a bracelet and the artist, wanting to do his best work, spent twelve and a half hours making it. While in Gallup, New Mexico, Adair showed the bracelet to a trader who bought the work of many Navajo smiths. Adair recounts the scene: "He admired it, and then asked me how long it took the smith to make it. I told him, and he said: 'Well it ought to be good; if a smith that worked for me spent that much time on one piece, it would be just as good as that one, but I give them too much work to do. I have to fill the orders which I get from the wholesalers, and I must have a half a dozen bracelets produced in one day, so they can't be as good as this one' " (1944:61).

Another unfortunate outcome of the commercialization of Navajo silver lies in the fact that if a certain style proves popular and can possibly be mass-produced, in all likelihood a nonnative entrepreneur somewhere will begin manufacturing jewelry that imitates the successful Navajo handmade work. As early as 1910 a Denver firm was imitating Navajo jewelry; and it is not unknown for curio dealers to manufacture "Indian-made" silverwork, drawing upon Navajo and Pueblo urban immigrants as a source of cheap labor for their factories.

Navajo Commercial Silver in Retrospect. Although silversmithing was once a very important source of money for the Navajo population (Adair estimated in 1944 that it brought in $100,000 per year), recent years have witnessed a decline in the economic viability of the craft. The vogue of "Indian-style" jewelry that swept through the United States in the early and mid-1970s gave manufacturers ample incentive to produce imitation jewelry that could be sold at prices far lower than that for which the traditional craftsman could make his wares by hand and market them. (By contrast, Zuni silver, which is somewhat less easily copied, continues to thrive, still providing what is probably the largest single source of income in Zuni [Mary Jones, personal communication].)

Navajo and Pueblo smiths still make fine silver to sell locally, and jewelry retains its important role in native culture. Commercialization of the craft is an interesting case history in the phenomenon of acculturation that has characterized so many of the world's small-scale societies in the twentieth century.

Commercialization of Art: The Canadian Arctic

The North American arctic illustrates another course which art may take as acculturation proceeds. Fortunately for us, many of the changes that have taken place throughout the area have been described accurately and in substantial detail.[4] The most interesting developments have occurred in the Canadian arctic.

Changes in Inuit Art. The evolution of art styles in prehistoric northern Alaska, as illustrated by changes in the so-called winged objects, was discussed earlier in this chapter. The changes that occurred elsewhere in the arctic were more tumultuous, in some instances apparently resulting from the wholesale replacement of one cultural tradition by another (cf. Martijn 1964).

Thule was the last in the succession of cultures that swept across the region before the appearance of Europeans. Originating probably around 1000 A.D. in northeastern Alaska, Thule culture diffused both eastward to Greenland and westward to the Bering Strait. Perhaps as a reflection of diminishing food and game supplies, Thule had a less elaborate material culture (although dog-traction sleds and iron lance blades both came into use during Thule times). In comparison to earlier periods, Thule culture produced art works that were fewer in number and more rudimentary in style than those previously produced in the arctic: Most objects that remain were carved in ivory, with only occasional work in wood, bone, and antler. Simple animals and human figures were carved, decorated with only small drilled dots.

Contact with outsiders had immediate economic repercussions: The natives soon sought to acquire trade goods such as tools, weapons, and luxury items; and the westerners for their part sought not only whales and fur pelts but also showed a keen interest in buying locally made carvings. An early traveler named Nevins described in 1847 how he

> expected to see some of the Esquimaux in sailing up the (Hudson) Strait, as they generally come from some of the islands on the north coast. For several days before we saw them, we were busy making preparations for what the sailors call the "Huskie (i.e., Eskimo) trade," and speculating upon what we were likely to get from them. They had brought a considerable quantity of ivory and whalebone, and this was the most valuable part of the trade, but what interested me most were some little models of their canoes. . . . There were two (women) in particular with whom I carried on a brisk trade. They had brought a

[4]See, especially, Ray (1961, 1967) on developments in coastal Alaska. Swinton (1972) provides an extensive bibliography.

number of little figures carved in bone and ivory, and representing the
different kind of animals and birds which are met with in the Straits
(Nevins 1847:9-12, 124; quoted in Martijn, 1964:559).

Europeans brought not only unfamiliar goods, but also new tech-
niques: The art of scrimshaw was learned from early whalers, and
the making of nontraditional items such as carved ivory cribbage
boards became popular.

The sale of Inuit carvings increased gradually from the mid-
nineteenth to the mid-twentieth century, making the craft an exam-
ple of Graburn's category of "novelty art," i.e., art originating as a
synthesis of native and nonnative media, techniques, and subject
matter, made expressly for a nonnative market. The Canadian Hand-
icrafts Guild showed interest in the carvings that came to them, and
in 1930 the McCord Museum in Montreal held an exhibition of Inuit
art. Nevertheless, distribution of the carvings was erratic, dependent
as it was upon occasional sales to visiting ships (and later, airplanes)
and to trading posts of the Hudson's Bay Company whenever post
managers thought they might be able to sell the goods to markets in
the south.

The picture changed drastically, however, in the late 1940s and
early 1950s (cf. Houston 1951, 1952; Graburn 1976b; Martijn
1964:561-65; Swinton 1972:123-26). Previously the Inuit had gotten
trade goods—guns, tobacco, flour, and other items—largely by trad-
ing pelts to the Hudson's Bay Company, but the market for pelts
took a number of downward turns, forcing increasing numbers of
Eskimos onto government welfare rolls. Simultaneously health service
costs increased as tuberculosis spread through the no longer nomadic
populations. Then in the summer of 1948 James Houston, a young
Ontario artist and lecturer, went on a painting and sketching trip to
the eastern shores of Hudson Bay. While there he bought several
native carvings and, on his return to Montreal, showed them to
members of the Canadian Handicrafts Guild.

Suspecting that a steady, viable market might exist for contem-
porary Inuit art, the Guild provided Houston with funds to return
north the following summer and buy more items. With the coopera-
tion of the Hudson's Bay Company and the Anglican Mission,
Houston purchased about 1,000 items at Port Harrison, Povungnetuk,
and Cape Smith. The Handicrafts Guild arranged a show of the work
in Montreal, and within three days of the show's opening, the entire
supply of sculptures was sold.

By the following year (1950) the Canadian government had taken
an interest in the project, seeing a possible means of both increasing
Inuit employment and decreasing government welfare payments.

Within three years Houston had taken a Civil Service post and was coordinating the production of Inuit sculpture from Baffin Land and the entire Hudson Bay region, while the Handicrafts Guild and the Hudson's Bay Company marketed the pieces and the Canadian government mounted a major promotional campaign, using movies, pamphlets, booklets, and travelling exhibits to increase the market for Inuit art in Canada, the United States, and Europe.

With the sales of sculptures increasing rapidly, two other important developments occurred. To further increase employment and income, Houston taught some Cape Dorset artists the technique of printmaking. The craft caught on and has now spread to several areas in the Canadian arctic. Also, native-run cooperatives were organized to coordinate production and marketing of art works. (The Hudson's Bay Company still found its largest profits in fur trading. To encourage the best hunters to bring in their pelts, some Company post managers bought carvings only from these men, neglecting those artists in greatest need of income supplements—women and disabled men who could not hunt. Also, if a post manager accumulated too large a surplus of sculptures, all purchase of art work might be suspended without warning to the producers [Graburn 1976b:46].)

The commercialization of art in the Canadian arctic has been quite successful. From its start in three villages, sophisticated production and marketing techniques have spread far and wide, and even some of the neighboring non-Eskimo groups have tried their hand at soapstone carving. In the mid-1970s Graburn (1976b:41) estimated that sales of Eskimo art amounted to "well over two million dollars per year," with nearly one-fourth of all adults carving at least occasionally. "Cash income per family has grown from approximately $25 per month in 1949-1950 to approximately $150 per month at the present time in most settlements and to well over $1,000 per month for a few individuals," presumably largely as a result of the sale of native art work. At the present, many major possessions such as snowmobiles, outboard motors, and even houses are paid for with money received from art production.

Inuit Art Today. How does the new "novelty" art of the Canadian Inuit compare with art created before the arrival of Europeans? That is a hotly debated question. At one extreme are James Houston and other supporters of the commercialization of Eskimo art. They have argued that contemporary sculpture is not significantly different from traditional art; if any difference exists, they maintain, it is only that modern work is of higher quality than earlier sculpture. Given that contemporary Inuit work is marketed as being "traditional" and "primitive," these partisans clearly have a strong interest in mini-

mizing any differences that might exist between old and new Inuit art, and these motives may be strengthened by desires on the part of government officials who would like to see the popularization of contemporary Inuit art as resulting from a growing respect among whites for traditional Eskimo culture.

Edmund Carpenter has taken the extreme opposite view, claiming that much post-1948 Eskimo sculpture is "Western-designed, Western-valued, and some of it Hong Kong-made" (1971:166). Arguing from an unabashedly subjective viewpoint, Carpenter has repeatedly stated (1966, 1973; Carpenter et al. 1959; Carpenter and Hyman 1973) his firm conviction that traditional Eskimo artists thought differently about art and aesthetics than do either westerners or contemporary Eskimo artists producing works for sale to outsiders.

What then are the similarities and differences between old and new Eskimo sculpture?[5] The major differences are as follows (cf. Martijn 1964):

1. Function. Prehistoric Eskimo art probably was made largely as good and bad luck charms and as toys for children to play with; much art took the form of decorations on utilitarian items. Whatever its use, precontact art was certainly not made for trade to other peoples as a means of income for the artist. By contrast, contemporary Inuit art is made *only* for sale to outsiders in an effort to obtain foreign goods. This, I feel, does not necessarily make the new sculptures better or worse as art; it does, though, mean that the constraints placed on modern art production differ from those in the past. Previously art had to conform to traditional religious belief. Commercial art, by contrast, must appeal to the aesthetic values (and sheer curiosity) of Euroamericans. Interestingly, both old and new Eskimo art served (and still serves) an important didactic function: Toy models of boats and animals were previously a means of socializing Inuit children into the ways of their elders; modern sculptures, with all the tableaux of "Man Harpooning Seal," "Woman Carrying Child," and so on, portray traditional Eskimo culture (or some semblance thereof) to foreigners—and, perhaps, to those contemporary Eskimo children who are no longer exposed to the old ways of life.

2. Media. As pointed out earlier, ivory was the most common prehistoric medium for sculpture in the arctic, with bone, antler, wood, and horn used in lesser amounts. Soapstone was carved, but only to make utilitarian items such as cooking pots and seal-oil

[5]Eskimo printmaking is so clearly an assimilated art form that it will not be discussed in the present context.

lamps. By contrast, virtually all modern Inuit sculpture is carved from stone, principally soapstone and serpentine. There may have been a few cases of soapstone sculpture before 1948, but Houston grossly misrepresented the traditional situation when he claimed (1954:7) that "Out of the lifeless rocks [pre-1948 Eskimos] wrested imaginative and lively forms, depicting not only human beings and animals but also imagined creatures seen only in their dreams. Even today . . . this primitive art persists, original, creative, and virile." Indeed, the carvers to whom Graburn spoke consistently reported that it was Houston himself who first asked them to carve figurines in the unfamiliar sculptural medium of soapstone.

3. Size. Most traditional carved figures of the Inuit were quite small—with a few exceptions, they were less than 4 inches long and often they measured less than 1 inch (Swinton 1958:44). Martijn (1964:565-66) has documented the steadily growing size of sculptures produced since 1948: 7½ inches was reported in 1953, 18 inches in 1955; by 1961 a 27-inch, 390-pound figure titled "Man Cutting Seal-line" was made.

4. Motif and Style. Contemporary Inuit sculpture inevitably portrays human and animal figures—often several figures are grouped together in a supposedly lifelike scene. Facial details are usually shown, humans are typically clothed, and incised designs (like those carved onto the winged objects) are generally absent. By contrast, much traditional art was probably nonrepresentational (as decorations on utilitarian items), and those animal and human figures that were carved were not portrayed in any particular "action" context. Clothes were seldom depicted, facial features were not always emphasized, and incised patterns of lines and circles were common. Although the promoters of commercial Inuit art minimize these differences, traders have consistently paid premium prices for those pieces they thought would sell best, thus inevitably influencing the producing artists. Gordon Robertson has remarked, "The romantics who say that Eskimos must stare at the sky and create only what the spirits tell them with no reference to commercial influences are just being unrealistic—and the Eskimo is a realist" (1960:53).

Inuit Art as Synthesis. Although there are distinct differences between contemporary and prehistoric Eskimo art, there are of course also salient similarities between the two. Indeed, the transitions that Eskimo art has undergone illustrate a theme that is central to the present chapter, namely, that art is always and everywhere in a constant state of flux, with the work produced at one particular time both building upon and going beyond earlier work. In the case of

contemporary Eskimo art, all innovations aside, there are obvious ties with the art of the prehistoric era, with its subtle and well-crafted three-dimensional portrayals of traditional subject matter. I have little doubt that if an uninformed individual were given several contemporary Eskimo sculptures and told to find their antecedents in a worldwide ethnographic art collection, the person would rightly place them with artifacts from the American arctic and not with sculpture from Africa, Oceania, or subarctic North or South America.

Rather than basing one's judgment upon the degree to which it does or does not carry on the traditions of the past, contemporary Inuit art should be judged on its own terms, seen as a genuine art form, important for its own sake. At least from the standpoint of anthropology, far more valuable than all of the diatribes about whether contemporary art from the north is "good" or "bad" is the fieldwork of Nelson Graburn (1971; 1972; 1976b, 1976c). Graburn has examined the economic impact of commercialization on traditional Inuit culture and society, the way in which sculpture is manufactured today, and, most importantly, the artists' feelings about their work, including their current aesthetic preferences. The latter is, as might be expected, a combination of the old and the new: Most carvers still show traditional admiration for pieces that are smooth, well made, and use some ivory for special effects; but unlike earlier generations they have adopted Euroamerican tastes for elaborate pieces that portray complex scenes. Indeed, if traders did not discourage such complex works on the grounds that separate pieces easily get lost or broken in transit to the south, more of them would be produced today (Graburn 1976b:51-52).

A remark made by Charles Martijn is a fitting final note. He has said that for the benefit of the artists themselves, "it is imperative to discard the sham facade of 'primitiveness' which certain outside 'experts' have tacked onto this modern art phase. The latter ought to be appraised on the strength of its true character, while those who create it should be permitted to reap the full financial reward to which their efforts entitle them" (1964:583).

The Dynamics of Art and Acculturation

Cuna molas, Navajo silver, and Inuit sculpture are just three examples of a worldwide phenomenon. Wherever primitive societies have come strongly under the influence of colonizing nations, their traditional art forms have been changed in one way or another. Simple extinction of old art forms may be the result, in which case we can only mourn their passing. But in other instances traditional

skills and aesthetics, although significantly modified, are maintained or increased in their importance. (The Central African Fang's estimate of their own traditional reliquary sculpture increased considerably when they learned that whites not only want it but are willing to trade it among themselves at prices in the tens of thousands of dollars [Fernandez 1973:218fn].) With reports of individual art works from primitive societies bringing prices of over a quarter of a million dollars (McLeod 1975:122; Anon. 1976), there is little doubt that western influence will continue to have a marked effect and that the future will only bring increased commercialization of these arts. And in many cases the native populations themselves do not seem reluctant to change. As Graburn has remarked, when two societies are in prolonged contact with each other and when the two "are at greatly different economic and technological levels, great modifications are introduced into the material culture of the less-developed societies. All people, save the most spartan, may seek easier ways to carry out their essential activities. . . . [Fourth World peoples] may *want* to change" (1976b:10-12).

What broad patterns can be discerned in this transition? The social sciences have not been very successful at making models that predict the particulars of change in specific cases, but the large number of ethnographic descriptions of cases of acculturation does allow us to discern those factors that influence change and to catalog the possible repercussions that may follow.

Factors that Influence Acculturation. Four different kinds of factors—economic, social, cultural, and artistic—have a bearing on the course taken by acculturation in a given society.

With regard to *economic factors,* a prerequisite of commercialization of art in a Fourth World society is the presence of a felt need on the part of many of the society's members for the possible material changes that may result from commercialization. Several factors can prompt such a need: In the case of the Eskimos, the arrival of Euroamericans, with their many material goods, coincided with increased difficulties in traditional means of subsistence, as the supply of whales and other fauna decreased. Or, alternatively, people may turn to commercialization of art to meet their needs as their own numbers grow or as their desires for trade goods increase. Often this process has two phases: First, westerners arrive, willing to pay or trade for those native goods they want; next, as supplies and markets change, the members of the small-scale society realize that the sale of art works is a relatively effective means of increasing income. Thus for example, the trade of pelts in the Canadian arctic first brought manufactured goods; then, when the market for pelts became erratic,

commercial art production was adopted as an alternative basis of trade.

Nancy William's excellent account (1976) of the introduction and development of the marketing of Australian aboriginal art in the village of Yirrkala is another example of how economic pressures may lead to the commercialization of art. Bark paintings, a synthesis of traditional and introduced art forms and techniques, were first made in limited quantities and traded to whites in the 1930s. For their paintings, artists received "tobacco, cloth, rice, tea, 'Golden Syrup,' and metal knives and axes" (Williams 1976:273). World War II brought two kinds of changes in the situation: Transportation was disrupted, temporarily restricting the marketing of bark paintings and other art produced by the native Australians; but more importantly, many young men from Yirrkala took jobs at a military installation located nearby. Wages from these jobs, far exceeding the income previously derived from art sales, brought the Australians even more intimately into the market economy of the west, with all of the material goods it provides to those who can buy or trade for them. When the war ended the military installation no longer provided employment, but with the arrival of a new missionary at Yirrkala, production and sales of art increased greatly, gross sales growing from less than $300 (U.S.) per year in the mid-1950s to nearly $25,000 per year at the end of the 1960s—an increase of nearly 10,000 percent (1976:276).

From an economic viewpoint, there is much to recommend the commercialization of art in societies that are in transition from being small autonomous groups to becoming parts of larger, technologically complex nations. This process of "development," as it is usually termed (although the connotations of that word are both self-centered and overly optimistic on our part), is often hampered by a shortage of capital in the developing societies. But this absence of goods and wealth is typically accompanied by a surplus of labor; and production and sale of handmade items, using locally available materials, is a possible solution to the problem since it is labor-intensive and requires little capital. It does require some means of marketing the items as well as a method for keeping artists aware of the demands of the market. These requirements have not, in most past experience, been too great a problem since entrepreneurs are usually on hand to capitalize on such trade. The real problem is insuring that the traders do not exploit the artists in such situations. In at least some cases (e.g., with the Cuna and Canadian Inuit crafts described in this chapter) this has been possible through the establishment of native-controlled cooperatives.

In addition to economic issues, *social and personal factors* also

play an important role in the process of acculturation. Some individual must introduce both the idea and the technique of commercialization. Outsiders are often responsible: Missionaries, Peace Corps volunteers, and anthropologists themselves have all been instrumental in doing this in various societies.

Often though the individual responsible for the introduction is someone considered at least marginally a member of the group. For example, Kiste (1974) has described the plight of the Bikinians, who were removed from their Pacific atoll when the United States government decided to test nuclear warheads there. While relocated on the island of Kili, they were aided by James Milne, an islander of mixed Micronesian-European descent. Drawing on his knowledge of both traditional skills and western markets (gained from living in Hawaii and going to the University of Hawaii), Milne designed a woman's purse that could be made from materials readily available on Kili. Woven by Bikinian women, the "Kili Bag" became a popular purchase for Americans who lived in or visited the Pacific. (Unfortunately, logistic problems and the departure of Milne led to a collapse of the industry.)

Cultural factors also play a part in the acculturation process. It has been suggested that some traditional societies are more predisposed to adopt new market-oriented techniques, while others show less interest in exploiting such an innovation. While this is no doubt true in the abstract, actual cases often contradict this thesis. For example, the Zuni have been characterized as an archetypically conservative society (Benedict 1934), but Zuni silverwork is currently one of the most commercially viable native crafts in the American Southwest.

Ruben Reina (1963) has recorded the details of one case in which a generalized cultural conservatism led to the abandonment of a possibly profitable new art form. On numerous field trips to the modern Mayan village of Chinautla, Reina followed the progress of a young potter named Delores. All women in Chinautla make ceramic water jars (*tinajas*), gathering the raw materials themselves, preparing the clay and coiling the jars, firing them, and selling them at a small profit in nearby Guatamala City. When she was 12, however, Delores learned from her grandmother how to make clay figurines of animals. The polished, white-slip decorated figurines were very attractive and were in great demand among Guatemala City buyers.

Delores' unique craft soon became a commercial success, but she was not so fortunate in her personal life. At 14, Delores was old enough for marriage, and negotiations began between her family and that of an industrious young man named Jesus. After much time and financial investment had gone into the negotiations, Jesus' parents

changed their minds and withdrew their offer of marriage, prompted largely by the warnings of a native diviner who advised that Delores might not fit smoothly into their household. Thereafter, two additional marriage proposals were made but failed to come to fruition. Reina relates:

> Because of the three failures, Delores' aunt became very much concerned that her niece might not find a good man, for with each case her desirability had lessened. People began to think that perhaps she was not a good prospect for marriage, and that perhaps she was not capable of controlling the general bad aspects of human nature (1963:28).

By the time she was 17, Delores had stopped making the handsome figurines, reverting to making only clay water jars like all the other women in Chinautla. Within a short time she received another marriage proposal and this one led to marriage. While other factors may well have been involved, Reina suggests that Delores' innovative art work played an important role in determining her desirability as a wife: Her innovativeness in making a novel type of ceramics was taken as a sign of unreliability. Reina observes:

> One of the dominant assumptions among Chinautlecos is that human nature is intrinsically bad and if the person does not recognize the available traditions and does not possess the will to organize his life by controlling his drives, his reputation will be severely affected. "Life here is very hard, anyway, and why should one get even deeper by not being careful in the selection of a mate" (1963:30).

Thus can a generalized cultural conservatism, as in the village of Chinautla, hamper or prevent the development of new commercial enterprises.

A final cultural pattern should be noted with respect to commercialization of traditional arts. Graburn (1969) has noted that a craft that was traditionally somewhat ephemeral to a society often has a better chance of successful commercialization than does one that played a central and fundamental role in traditional culture. Thus, for example, Canadian Eskimos did indeed carve soapstone before 1948, but in this medium they produced only utilitarian items—cooking pots and lamps—with little or no decoration. When James Houston arrived with news of possible markets for soapstone sculpture, carvers were able to explore this new art medium without too many restraints from traditional taboos and hidebound aesthetic predispositions. Similar patterns of change have been noted for Navajo textiles (Kent 1976) and silversmithing (Adair 1944), Beni woodcarvers (P. Ben-Amos 1976a), and Tzintzuntzan weaving and carpentry (Foster 1967:346).

There are, finally, several factors influencing the likelihood of successful commercialization of art that derive from the *art objects themselves*. Obviously, art works that are perishable, fragile, or difficult to transport are unlikely candidates for sale to outsiders. In addition to those traits, experience has shown that another factor that can limit the development of commercialization is the ease with which an art form can be copied by machine, produced in large numbers, and sold more cheaply than handmade items from Fourth World societies. Thus, as noted previously, Navajo silversmithing is a less profitable venture than it once was because Navajo styles can be copied and mass produced by Anglos who have a nominal amount of skill and capital. By contrast, Zuni silver, characterized by its elaborate and careful inlay and other techniques, can only be made manually by individuals with a great deal of experience. Significantly, silverwork remains a profitable enterprise for the Zuni. And, from the northern extremities of the North American continent, Dorothy Ray has noted that Alaskan Eskimo carvers "strive constantly to keep objects 'handmade' because they perceive that this is one of the intrinsic values of Eskimo-carved ivory" (1961:107).

The media used in a given society may also have a bearing on its potential commercialization. If artists happen to have access to a material valued by outsiders, use of the material may enhance the appeal of traditional arts. Kaufmann (1976:69) reports, for example, that argelite is so rare and so valued by collectors, that carvers among the Northwest Coast Haida receive about $40 an inch for their argelite carvings, regardless of other aesthetic considerations. Similarly, Bini carvers now work in the nontraditional medium of ebony, capitalizing on the high value that Europeans and Americans place on this wood.

Sociocultural Repercussions of Commercialization. Commercialization of art in a Fourth World society typically results in significant changes in the society and culture of the people involved. Artists in some primitive societies are motivated by economic gain, but art work as a full-time economic endeavor and as the sole means of survival exists only in conjunction with complex societies. A shift to art sales as a major means of subsistence may alter traditional work patterns and, perhaps more importantly, patterns of social and political influence. Margaret Wilhite (1977) has discovered an interesting instance of this in the highlands of Guatamala: Indians there make a variety of textiles, but a strict division of labor between the sexes exists, with men using floor looms to weave wool while women use backstrap looms to weave cotton. Each is responsible for trading his or her own products. As in many parts of the world the men were

being more rapidly acculturated than were the women as a result of several kinds of interaction with outsiders, most importantly through trading both craft and noncraft items and learning Spanish in schools. But now, as tourists increasingly visit markets to buy the locally produced textiles, the women are getting their chance to interact with non-Indians, selling their textiles to foreigners and buying their material from itinerant traders, thus providing the women with their own avenues of acculturation.

The development of a market for locally made art goods brings with it all of the problems of commerce. For example, Alaskan Eskimos have an ample market for their ivory carvings, but given the scarcity of ivory from walrus tusks a carver is forced to decide whether to make "quick money" by carving a cribbage board from a tusk, or instead to maximize his profits by carving several smaller items that will sell well and that will minimize the amount of wasted ivory (Ray 1961:112). In any case, the Alaskan carver cannot expect to get rich: In 1961 Ray noted that a carver "can earn, at the most, only eight or nine hundred dollars a year. With the high cost of living in Nome, this is comparable to an income of three or four hundred dollars in the rest of the United States" (p.118). Sandelowsky (1976:354, 356) discovered a similar situation among carvers along the Okavango River in South West Africa: Because a Ruanda government agency had stopped buying their sculptures, a two-foot high carved stool would bring a price of only one dollar (if a buyer could be found at all), and only two of the many carvers she interviewed were enthusiastic about the money that could be made selling carvings.

Such findings must temper any optimism we might have about art commercialization being an easy and reliable means of economic development in Fourth World societies. At best, it may only be a first step in that direction, necessarily having to be followed by other sorts of economic developments. Graburn's work in the Canadian arctic is illuminating in this context. "I interviewed," he says, "nearly all of the 90 adults in one settlement, and all but one said he disliked carving although it was necessary to earn a living" (1967:32). In a more recent paper Graburn writes, "In those settlements where carving is important, the majority of the Eskimos say they would prefer full-time wage labor as an occupation because of the security it represents and because it enables them to purchase prestigious material goods" (1976b:47). Many would even prefer hunting to their present activities if they were able to support themselves in that way. (From the point of view of an outsider, we may question whether or not cottage industries such as commercial art are more or less desirable than the types of wage labor that may be available in Fourth

World societies—for example, in South African diamond mines or on Hawaiian plantations.)

But if commercialization of art is not altogether an economic boon, it does offer a different sort of benefit to the producing society: It may serve as a focus for an emergent ethnic identity, a symbol of the makers' unique cultural heritage. Modern beadwork made by the Kiowa of the American Great Plains is novelty art, originating in the culture contact situation and now made for tourist consumption, but its importance extends beyond the realm of economics. Mary Jane Schneider notes,

> The people engaged in this tourist production regard their work as traditionally Indian. Most recall mothers or grandmothers who did similar work. . . . Because these items are made specifically by Indians for sale to nonIndians, the production serves to reinforce Indian identity. The colors, designs and techniques are aimed at presenting an Indian art to the purchaser. As one woman said, "God gave White people reading and writing, he gave us Indians beadwork to earn our living." In order to continue this tradition, there is a continuing, consistent demand to have beadwork and other skills taught in the schools. With language and history it is part of Kiowa identity (1976:7).

The Effects of Commercialization on Art Works. Can any general statements be made in evaluating the influence of commercialization on the art works themselves? This is a controversial issue, with some of the more intrepid scholars not hesitating to decry all cases of commercialization. For example the British anthropologist, William Fagg, in a general discussion of artists in Africa, excludes from his consideration *all* items made for sale to tourists, claiming that "tourist art . . . of course, is not art in any proper sense, but more or less mechanically produced Kitsch, or trashy souvenirs, for the less sophisticated traveler" (1969:45). And Abramson (1976) has labeled much of the work currently sold in New Guinea "degenerate, slapdash junk." Some pieces made for sale, he continues, "are actually extremely well done in terms of pure craftsmanship, but something vital is missing in every one" (p. 259). (Abramson does go on to concede that some New Guinea art rises above this level, regaining a measure of the "vital something" that he himself cannot define but is confident he can recognize.)

The debate, of course, concerns several different aspects of art production. There is, first, the question of whether or not art made for sale to outsiders appeals to our own western aesthetic tastes. Inasmuch as we typically consider the conditions under which a western art work was produced to be irrelevant to an evaluation of its aesthetic merit, and since in any case we applaud western artists

regardless of whether or not they derive any monetary benefit from their work, I feel we are totally unjustified in dogmatically assuming that commercialization inevitably results in the production of art that is poor by our own standards of taste. Whether or not a particular style—commercial or otherwise—appeals to us is largely a personal matter, and little more can be said about it here.

There are, however, other aspects of the effects of commercialization that can be noted. For one thing, even art made expressly for sale to outsiders is typically governed by native standards of quality. Predictably, such standards are often an amalgam of traditional and introduced values, but they are nevertheless widely held and have a significant effect on current art production. Contemporary Inuit aesthetic values were described earlier in the present chapter; and Paula Ben-Amos (1976a) has described how Beni carvers in Nigeria, working in the nontraditional medium of ebony, place a high value on workmanship as reflected in accuracy of portrayal of naturalistic subjects, shininess of finish, and carefulness of detail.

It is difficult to generalize about the effects of commercialization on quality of workmanship. First it should be noted that even traditional noncommercial art items vary widely with regard to craftsmanship: many are carefully made while others fall far short of either native or western standards of excellence. The same situation prevails for art produced for sale: Some is well made, and some reflects the maker's carelessness or lack of skill. Cordwell (1959) has gone so far as to suggest with respect to African art that "the same percentage of 'hack' artists has continued to exist with only their subject matter changed as a result of contact with Euroamerican norms" (p. 47).

Besides intrasocietal variation, however, quality of workmanship also can vary from one society to another. Several factors may lead to a lessening of skill or carefulness of production. Among the Bangwa of West Cameroon, for example, western influences were so pervasive that for nearly a generation before 1966 there had been no carving of the once well-made Night masks and ancestral figures. Then, when possibilities of sales to outsiders became apparent, the old art forms were reborn. Brain and Pollock (1971) note that "today, spurred on by recent European interest in their work, everyone, trained or not, is chip-chipping away, copying a Night mask, or an ancestral figure. Even the professional works as fast as possible since the prices given cannot compare with those paid by wealthy chiefs in the past" (p. 62). This situation results in carvings made of unseasoned wood, the extremities of which may break off with the slightest mishandling.

The Bangwa case raises a problem of interpretation, however. Brain and Pollock go on to say:

> A statue used to take several months to complete. Now a carver spends less than a week. Older men know that these rough and ready methods must detract from the perfection of the work. They say that it used to take twenty years of apprenticeship before a sculptor could or should tackle an ancestral figure, and that a Night society mask should not be attempted with any chance of success until a carver had both a daughter and a son. The total commitment of the old masters included abstinence from sex and certain foods throughout the period of work. Modern carvings, say the elders, cannot compare with the inspired work of the past (1971:62-63).

But are these changes in Bangwa carving methods signs of an inevitable lowering of actual workmanship, or do they merely indicate a *change* from past ways, one not necessarily for the worse? Did it really take Bangwa novices 20 years to acquire the technical skills needed to undertake the most elaborate sculptures, or was the long apprenticeship largely a ritualistic requirement, with no more artistic importance than the rule that artists must have had a daughter and a son before undertaking certain pieces? And of the acceleration of carving—from "several months" to "less than a week"—how much is due to the carver's working longer hours each day and using imported tools that permit carving to be done more quickly with no detrimental effect on the end product? Brain and Pollock do not answer these questions, but rather accept the view of the older generation of carvers that things aren't as well made as in "the good old days," a feeling that is by no means limited to the elders of our own society but that is found in even the most stable of primitive societies (cf., e.g., Murphy and Murphy 1974). Assuming that quality of workmanship is a cross-culturally identifiable trait, ethnographic descriptions of art in transition would be more valuable if they specified the details of the changes that have actually occurred in specific art traditions, using less subjective criteria than to describe contemporary work as "uninspired."

I am not suggesting that the quality of workmanship is never impaired by the commercialization of an art form. The use of unseasoned wood by contemporary Bangwa sculptors *is* a very unfortunate development. But what of the fact that the same carvers rub their creations with oil and soot and hang them over smokey fires to give them an aged appearance. Certainly this involves a break with tradition, and dishonesty is involved if gullible tourists are told that the works actually are quite old. But these factors, again, are not the same thing as quality of workmanship. Instead, they reflect changes

in tastes and shifts in audience. They are not necessarily more reprehensible than the fact that the beautiful black pottery that was developed by the Martinez family in the Pueblo of San Ildefonso is not practically functional since it is not water tight and the finish is dulled and streaked after exposure to water (Bunzel 1972:7). If the blackware were made for practical use, these would be serious shortcomings; they are *not* faults in pottery made only for purposes of display.

A final question with respect to the effects of commercialization of art is related to originality and copying. Again, the picture is mixed. On the one hand, there are numerous cases like that of the so-called billikins that are carved in large numbers for sale by Alaskan Eskimos. The original billikin figure was created (and patented!) in 1908 by a Miss Florence Pretz, an art teacher in Kansas City, Missouri (Ray 1961). The rather Buddha-like figure was supposed to represent Pretz' idea of "The God of Things as they Ought to Be." Billikins were soon the rage throughout the United States, and in 1909 an influential Alaskan carver named Happy Jack carved one in ivory, at the insistence of a local shopkeeper. Since then, Ray says, "thousands, if not millions, [of billikins] have been made in all sizes by the Alaskan carvers" (Ray 1961:122).

But although billikins have been copied excessively, the carvers themselves chafe at the mindless job of endless duplication of the original billikin. Given a market for other ivory carvings, they avoid making billikins when possible. And over the years, substantial changes have occurred in the billikin figure: It has been simplified in shape, details have been omitted, and various novelty features, such as movable male genitals, have sometimes been added (Ray 1961:23).

Thus, although the pressures of the market may force commercial artists to copy, there is often a countervailing desire on their own part to innovate—contrary, perhaps, to the wishes of outsiders. For example, the bark paintings of the native Australians at the post of Yirrkala were first marketed in 1935 by a missionary named William Chaseling. In recounting the events, Chaseling has said that "no innovations were allowed" (quoted in N. Williams 1976:272). Nevertheless, as years passed the artists constantly made changes in their production of bark paintings. Williams notes that "innovation in the carving of nonritual objects is positively valued at the present time. Individuals prize the claim as 'the first' to carve certain types of figures and derogate their imitators" (1976:271). Similarly, Mary Jane Schneider (1976) reports that "originality in beadwork is a Kiowa aesthetic value which is maintained even in tourist items" (p. 7).

The preceding sections have dealt with the sweeping changes that are taking place in the arts of Fourth World societies. Many objective, fieldwork-based accounts of commercialization of art are only now seeing the light of day. There is no question as to the importance of the phenomenon: It is intimately affecting the lives of an enormous number of people, and for this reason alone it should command our attention. The art itself is highly diverse. Certainly the best of it—best with regard to workmanship and our own aesthetic standards and interests—deserves a place in western collections of ethnographic art alongside the best traditional art. And, as Third World countries increasingly (and justifiably) restrict the number of older traditional art works that can be exported, contemporary Fourth World art will take on an even greater significance in western collections. We can hope that as our understanding of the processes of change increases we will be able to foster those circumstances that make the best of the inevitable situation, both for the members of societies that produce the art and for the art itself.

The Development of Fine Art Traditions in Third and Fourth World Societies

"Fine" arts, that is, art created for appreciation by, and sale to, an elite portion of the society, have long been characterized by frequent and fertile cross-pollination, both among diverse individuals and among different artistic traditions. Western artists have long been influenced by art from primitive societies: On viewing some of the booty sent back from the New World by early explorers, Dürer wrote in 1520, "All the days of my life I have seen nothing that rejoiced my heart so much as these things, for I saw amongst them wonderful works of art and I marveled at the subtle ingenuity of men in foreign lands" (quoted in Fraser 1971:25). Since that time, art works from around the world have had a powerful influence on western artists, particularly with twentieth-century innovators such as Picasso, Brancusi, Modigliani, Ernst, and Pollock (cf. Carpenter 1976:57-60; Firth 1951:156-61; Fraser 1971; Gerbrands 1957:1-9; Goldwater 1967, 1969; Muensterberger 1971; Spencer 1975:467-504; Willet 1971:27-41).

As political and economic elites have emerged in Third World nations, fine art traditions have sprung up there as well, bringing a new synthesis of indigenous and western art styles. The relative proportions of foreign and native influences differ substantially from one place to another. Thus, for example, when Sir Adesoji Aderemi

ascended the throne of the Nigerian Ife in 1930, he established the Museum of Ife Antiquities, now considered the best single collection of traditional Nigerian art (Willett 1972:215). (In doing this the King was continuing a centuries-old Nigerian tradition of royal patronage of the arts.) The popularity of traditional arts has continued to spread in contemporary Nigeria: Bascom (1973:68) reports that among formally educated Yoruba it has become popular to collect traditional works as fine art. (Mount adds a more cautious note: "It should be stressed, however, that only a small fraction of the African 'elite' society collects art. They are much more interested in politics and sports, and many of them regard the development of a new African art as a needless luxury" [1973:63-64].)

The creation of schools that provide formal instruction in art has been an important factor in the emergence of fine art traditions; at least, such has been the case in sub-Saharan Africa, where the process has occurred most widely. As early as the 1930s art departments were established in universities in Britain's African colonies. At the present there are numerous art schools in operation in West, Central, South, and East Africa (cf. Mount 1973:74-159). The schools themselves represent a wide range of approaches to art instruction. For example, the influential school in Lumumbashi (formerly Elizabethville), Zaïre, started in 1944 by Pierre Romain-Desfossés, traditionally has only provided students with materials and a congenial place to work, encouraging them to create works that are attuned to their own cultural background, making no attempt to inculcate aesthetic values from the Euroamerican tradition (Mount 1973:75). By contrast, the Académie des Beaux-Arts in Kinshasa, Zaïre, started by the Reverend Frère Marc-Sanislas in 1943, offers courses in sculpture, painting, architecture, ceramics, and graphics. At this school, traditional designs and motives are utilized in the first phases of the seven-year course of study, but during the last four years all emphasis is on emulating western techniques, learning to sketch landscapes and do figure studies in the "classic" manner. Courses in art history are given at the Académie, with a major emphasis on the history of European art (Mount 1973:83).

Contemporary fine arts in Africa run the gamut of media, and novel media have been developed as well. Maude Wahlman's *Contemporary African Arts* (1974) provides an excellent account of the work of 14 living artists (or groups of artists), conveying a feeling for the vitality and diversity that now exists. Included are artists in beadwork and calabash carving, as well as those working in sculpture, painting, and what may be called counter-repoussé (i.e., low reliefs made on metal panels by hammering the features out from the

panel's back and filling in background spaces on the front of the panel with incised designs.)

The artistic development of Bruce Onobrakpeya, a Nigerian, provides a good example of the work of a contemporary fine artist in Africa (cf. Wahlman 1974:58-63; Mount 1973:132, 136; Beier 1968:68). Born a member of the Urhobo tribe in Nigeria, Onobrakpeya graduated in 1961 from the Art Department of Ahmadu Bello University at Zaria in northern Nigeria, a school that offers training in painting, sculpture, graphics, and textile work. Although he also works in sculpture and painting, Onobrakpeya is best known for his printmaking, a skill he first learned at a workshop held in Oshogba, Nigeria, and run jointly by an African artist and a European. He works effectively in lino-cut, etching, and woodcut, also making bronzed low reliefs by spraying carved lino-cut blocks with bronze paint and then inking in the interstices. He has exhibited widely, receiving acclaim in other African nations and in Europe. Onobrakpeya reaches an even larger audience through the illustrations he produces for popular books. Most of his prints draw their subject matter from traditional African culture, particularly from Urhobo legends and mythology and from his visits to extant religious shrines. His prints, such as *Quarrel between Ahwaire the Tortoise and Erhako the Dog* (Mount 1973, Plate 68), are minimally representational, relying for their emotional impact upon semi-abstract use of mass and line.

Onobrakpeya is fully aware that his work is a synthesis of native inspiration and alien techniques: "I try," he says, "to speak to the present about the future and in the process choose what I wish from the past" (quoted in Wahlman 1974:58).

Conclusion

As time passes we can expect the art traditions of primitive societies to change drastically. As long as the societies remain economically and culturally marginal to the larger societies that are engulfing them, their art may be sold to outsiders who, for one reason or another, are interested in it. The end point of development, however, will probably be the incorporation of the traditional styles into national, and international, styles of fine or popular arts.

In one sense these changes are tragic. Alexander Alland, Jr. commented not long ago, "Most of us see anthropology as a means of documenting the richness of our species' creative capacities. Each time a way of life disappears, the repertoire of human experience is diminished" (1975:viii). Alland's point is well taken, but whether we like it or not such changes are taking place. We cannot make time

stand still any more than we can convince Fourth World peoples to forgo those alien things that they themselves desire or than we can convince all sectors of the First and Second World nations to desist from influencing other peoples.

All cultural phenomena are by their nature dynamic rather than static, and the phenomenon of art is no exception to this pattern. But the ubiquity of change in art is matched by the difficulty we have understanding its fundamental causes and processes.

Even in the absence of outside influences, art changes. The concept of "drift," developed in research in population genetics and historical linguistics, seems also to apply to art. As the case of the north Alaskan prehistoric winged objects illustrates, changes which individually are minor in importance and random in direction, add up, with the passage of time, to produce substantial changes in the overall style and appearance of art.

Whereas drift is a slow, evolutionary process, changes that result from culture contact are often abrupt and, in some cases, cataclysmic. The best documented instances of this are the changes that have resulted from the impingement of the First, Second, and Third World nations upon the societies of the Fourth World.

Every instance of culture contact is unique in some ways, but Graburn has brought some order to the rapidly growing study of changes in Fourth World art. He has proposed a typology that distinguishes the major varieties of art now being produced. The typology is based on two significant dimensions of differences, namely (1) the extent to which subject matter, medium, and style are traditional rather than alien, and (2) the intended market for the art work, be it indigenous or foreign. Using this typology as a guide, the arts of the rapidly changing Fourth World societies can be systematically catalogued and studied.

GUIDE FOR ADDITIONAL READINGS

Much writing by archeologists deals with long-term culture change. Any survey of archeology (e.g., Willey 1966) provides numerous descriptions—if not explanations—of autonomous culture change, including stylistic changes in art.

Interest in the effects of contact with the West upon art in primitive societies has gained momentum rapidly in the past decade, largely as a result of Graburn's seminal work (1967, 1969, 1976c). The recent volume edited by Graburn, *Ethnic and Tourist Arts: Cultural Expressions from the Fourth World* (1976d), contains many excellent articles, each based on ethnographic fieldwork.

The repercussions of Western contact have been more thoroughly documented in Africa than in any other culture area. Cordwell (1959) has discussed the events that occurred prior to the 1960's, while specific cultures are discussed in Reinhardt's account of West African dying (1976) and in Biebuyck's description (1970) of the effects on Lega art of the banning of the Bwami association.

In the Americas, Ray (1961) provides an excellent account of the changes that have occurred in Alaskan Eskimo art since 1850. O'Neale (1932) deals, among other things, with the influence of whites on Yorok-Karok basketry, while Tanner (1960) discusses the repercussions for Southwest art. Arima and Hunt (1976) describe the production of Kwakiutl "tourist masks."

The emergence of "fine art" traditions have been described for Australia (Tuckson 1964) and for the American Southwest (Dunn 1968).

Finally, Lip's *The Savage Hits Back* (1966, orig. 1937) presents an interesting anthology of art works from primitive societies that portray the colonizers and the colonial experience through the eyes of the colonized.

Chapter 7

Art: Cross-Cultural Perspectives

Two questions remain to be discussed, and dealing with them provides an opportunity to reiterate and summarize some of the more important points made in the preceding chapters. First, what, if any, universal patterns can be discerned in the phenomenon we call art? Second, what are the significant similarities and differences between contemporary art in the western world and art in the primitive societies that have been the topic of this book?

Universal Patterns in Art and Aesthetics

Anthropology, like all of the sciences, has a twin goal: It describes the widely diverse social and cultural systems found throughout the human species, and it also attempts to discover regularities of pattern that occur in this diversity. Generally speaking, the former goal is easier to accomplish than the second for the

obvious reason that no two societies—indeed, no two people—are ever exactly identical. Since every aspect of culture affects many others, any universal, fundamental patterns that might exist are disguised beneath the mask of the exotic.

Such is certainly the case with respect to art. Not only are the art works themselves highly diverse, but also their roles in the societies that produce them differ widely. In most societies the conceptual category "art" does not have an explicit meaning in native thought; and in those where it does, there is only an approximate correspondence between their notion of art and our own (cf. H. Schneider 1956, 1966).

These problems notwithstanding, a few cross-cultural patterns can be seen in the general phenomenon of art. First we can recall the working definition that was adopted in the first chapter: Art is that area of human activity in which virtuosity may be developed to a particularly high level by some individuals. Our definition arbitrarily includes only those human activities that produce tangible items as their end results. A survey of the world's societies seems to indicate that art, by this definition, occurs in all societies. There may be wide variation in the quantity of art produced, the media used, and so on; but the visual arts seem to be universal.

Technical virtuosity may be the basis of various widespread, if not universal, artistic values. Smoothness of finish, symmetry, and regularity of design are common criteria of aesthetic judgment, and these qualities can be attained only by the most skillful (cf. Boas 1955:21). Often a given society singles out only a few of these skill-based standards for special development, giving kudos, say, to the individual who masters smoothness without demanding an excessively high degree of symmetry.

A second cross-cultural pattern regarding art is that it often conveys meaning to the viewer. For nonnatives these meanings may be obscure, may pass totally unnoticed, or may be grossly misinterpreted. Chapter 3, on symbolism and iconography, described a wide variety of subjects that could be portrayed via art, and the techniques used in various societies to accomplish this communication are equally wide ranging. As a general rule, art works convey information which the makers feel is particularly important. Very often the subject matter is related in one way or another to one of three topics: reproduction, food, or dominance and submission to other people. The pan-human interest and importance of these subjects may indeed provide the most common basis for appraising art from other societies (cf. Leach 1974): No matter that we differ in many ways, these are three areas of basic concern to us all. (The

importance of the meaning-conveying capacity of art is confirmed by the fact that in those societies—such as dynastic Egypt, China, and pre-Columbian Mesoamerica—that developed some form of writing or protowriting, the meanings conveyed by art works were often reiterated in words or messages written on the pieces themselves.)

Perhaps the most intriguing question with respect to universal patterns in art relates to aesthetic preferences. To what extent, if any, is there a pan-human appreciation of certain formal qualities in art? If we had reliable and extensive information regarding aesthetic standards in other societies, we might be able to answer this question with some certainty. But not only have there been very few careful fieldwork-based studies of aesthetic values in other societies, but anything less than such studies is more likely to deceive than to accurately inform us. The items that have accumulated in ethnographic art museums in Europe and America may or may not reflect native standards of excellence. For example, after extensive fieldwork among the Bangwa, Brain and Pollock (1971) concluded that many of the Bangwa figures in western collections are "no more distinguished than rough-hewn carvings made by youths to pass away a few minutes" (p. 60).

Further, the items that appear in our museums are often there as a result of coincidence coupled with the tastes and interests of one or more westerners. For instance, much of the traditional art of the Egbado Yoruba was destroyed in 1951 when a nativistic cult called Atinga raged through the Nigerian countryside. Much of the pre-1951 art that remains is that rescued by Kenneth Murray, who hastily travelled through the area, saving such "superior" pieces as he could find (cf. R. Thompson 1969:125-26). Although we are better off having western-selected collections than none at all, there is ample evidence that the items *we* like best are not always the ones *they* prefer. Native artists themselves may compound the problem by regularly keeping for themselves or their patrons those works they like best, while selling to outsiders those pieces that don't quite measure up to native standards (cf. Bohannon 1971:78; Murray 1961:98; R. Thompson 1971:376).

Irvin L. Child and his associates have attempted to determine the possible universality of aesthetic values in an objective manner. The technique used by Child and Siroto (1971[orig. 1965]), which was repeated with minor variations for other sample populations (cf. Iwao and Child 1966; Ford et al. 1966; Iwao et al. 1969), may be briefly described here.

Two previous attempts to discover cross-cultural regularities in aesthetics (Lawlor 1955; McElroy 1955) had used nonartists as subjects

and had produced negative results. Child and Siroto, by contrast, surveyed the opinions of two groups of individuals who had special interest in the arts: One group was composed of 13 "art experts (advanced art students and others able to make such judgments) in New Haven, Connecticut" (1971:276); the second group was made up of 16 elderly BaKwele men, all with a history of art-related activity, from numerous hamlets in their native central Africa. Individuals in each group were shown 39 photographs of masks that had been made either by the BaKwele or their neighbors and were asked to rank the masks in order of aesthetic merit.

The results of the surveys of the two groups were compared using a relatively straightforward statistical procedure. Child and Siroto found there was a surprisingly high degree of accord between the two groups: Although their evaluations were not in perfect agreement with each other, the two groups agreed to an extent that could be attributed to accident in fewer than one out of a hundred chances. (In subsequent studies Child and his associates arrived at similar results in comparing the aesthetic preferences of art experts from America, Japanese potters, and craftsmen in a remote Fijian village; a test of craftsmen from the Cycladic Islands of Greece failed to produce statistically significant results.)

One interpretation of these experiments—and the one preferred by Child and his associates—is that art specialists everywhere, regardless of their specific cultural background, share broad principles of aesthetic judgment such that young artists in New Haven, Connecticut, in total innocence of BaKwele art and aesthetics, make roughly the same judgments of BaKwele masks as do native BaKwele art users.

Is this a safe conclusion to draw from the data presented by Child and his associates? Candidly, the writers concede that other factors could contribute to the cross-cultural agreement they found. For example, the photographs of the BaKwele masks varied in quality, and the masks themselves varied in craftsmanship. Perhaps both sets of subjects ranked certain masks low because they were hard to see or were poorly made, rather than because they were inferior with respect to abstract aesthetic principles. Determining the importance of such factors is difficult, but improvements in the experimental design of future studies could probably solve such technical problems.

A second type of problem is harder to contend with. The BaKwele have been in contact with Europeans since the late 1800s, and masks have not been used ritually since the 1920s; acculturation has been rapid. Although Child and Siroto say that among contemporary BaKwele "there is little sign of interest in European art" (1971:276), it

is very difficult to rule out the effects of possible influence by Euroamerican art standards. As noted in chapter 6, the influence of western values, including aesthetic tastes, is insidious, often having substantial effects without our being aware of it.

The BaKwele experiment illustrates this point. Siroto questioned his BaKwele subjects by speaking in French to an interpreter who in turn put the questions to the informants in their own language. Child and Siroto describe their procedure thus:

> The interpreter was requested to ask the subject to choose the masks that he found "les plus beaux" or "qu'il aime plus que les autres." The terms used by the interpreter in carrying out this instruction referred to goodness in general or to beauty as it applies to persons. The BaKwele constructions for "well-made" or "well-carved" were not used in posing questions but were sometimes used by the interviewees in their comments on the masks (1971:277).

The difficulty with this approach is obvious: The experimenters assumed from the outset that questions such as "Choose the masks you find most beautiful" or ". . . the ones you like more than the others" can be translated into the BaKwele language with no change in meaning. But this assumption *cannot be made* when the purpose of the experiment is to test this very hypothesis, to discover whether or not there is indeed a BaKwele standard that means the same to them as "beauty" does for us. The influence of acculturation is again pertinent: Child and Siroto note that the younger generation of BaKwele individuals speak French "as a second language and are commonly literate in it" (1971:276). Learning another language inevitably entails learning new distinctions and new standards, so that when a BaKwele learns the meaning of "les plus beaux," he or she presumably learns what French speakers—and Euroamericans generally—believe to be beautiful. (Significantly, the younger BaKwele subjects tended to be in even greater agreement with the American responses than did the older men.)

If the experiments by Child and his associates have serious methodological problems, it nevertheless seems unwise to dogmatically assert that aesthetic values are entirely culture-specific. As previously noted, standards of quality of workmanship have cross-cultural applicability, and they in turn may lead to an appreciation of such formal qualities as symmetry and balance. And, in portrayals of humans and human-like animals we can well expect that standards of healthiness of body should be widely, if not universally, admired.

But speculations such as these are no substitute for careful fieldwork. As more cross-cultural information becomes available, our ability to discover global patterns in art should improve.

Western Art in Perspective

The motives prompting the anthropological endeavor differ from person to person, but one widespread feeling is that if we learn enough about the ways of other peoples we might begin to see our own society in a new light. Insofar as this feeling is justified, an appropriate final question is to ask just how our own art, artists, and aesthetics appear by comparison to those of other societies. Of course any answer to this question must be highly tentative, given both the limited nature of our current understanding of art in primitive societies and the diversity that seems to characterize all aspects of our own culture. Despite these qualifications, some broad patterns do emerge in a general comparison of Euroamerican art and art in primitive societies.

Chapter 1 posited a rough continuum ranging from primitive to nonprimitive. Primitive societies were defined as being relatively small in size, comparatively homogeneous socially and culturally, and relying for subsistence upon a relatively simple technology based on hunting and gathering or hoe agriculture. Given the weblike nature of sociocultural systems, with each factor influencing all the others in a given group, it is altogether reasonable to expect that the demographic, social, and economic differences distinguishing primitive from nonprimitive societies will have a bearing upon the nature of art in the two kinds of groups. (Of course a rigorous comparison between art in primitive and nonprimitive societies would contrast the art of primitive societies not just with Euroamerican art but also with art in all nonprimitive societies—Chinese civilization and its congeners, the traditions that developed in the Indus Valley, and the prehistoric civilizations of the Near East, Mesoamerica, and the Andes.)

Chapter 2 showed how art in a given society can serve any of a number of functions—religious, psychological, educational, and so on. What, we may ask, is the function (or functions) of art in our own society? We can easily list those things that are *not* art's function in the west: In contemporary America and Europe, the fine arts are largely bereft of religious and educational significance, and they are typically devoid of utilitarian purpose. (Certainly there are exceptions to this and to all of the generalizations made here; only broad patterns are being noted.) The fine arts do have a psychological function in that they please the viewer, but significantly only a relatively small segment of the total population indulges in these pleasures. One repercussion of the social stratification present in our society is that, for better or worse, accurately or not, most people

believe they do not "understand" contemporary fine arts, even if they have taken a course in "art appreciation."

Certainly, too, our arts perform additional functions. They have an economic aspect in that many artists are full-time specialists; art provides an income to artists and to members of a whole array of other professions—art dealers, museum staffs, art educators, and producers and sellers of art materials. (The practices of forging and of theft of fine art are evidence that art is "big business" in our society. Cf. Meyer 1973.)

Further, contemporary western fine arts resemble the art of many primitive societies in that they serve as a means of displaying social status. Like the "totem poles" and other art of the Northwest Coast, our art is sponsored primarily by the socioeconomic elite of our society, and the ownership of an impressive collection of paintings or sculpture is as much a display of one's importance as was art for the aristocratic families among Northwest Coast tribes. Many segments of our population are well beyond the point where the acquisition of life-sustaining goods such as nutritious food or protection from the elements is needed; like the Ashanti kings, members of our elite find it convenient to display and reinforce their status by symbolic means. And, as in the Ashanti case, our art serves this purpose perfectly. In the instance of Northwest Coast art it was noted that the mythical creatures and stories portrayed in their traditional art often could not be accurately identified by people other than the family that owned the art, but that this was not too important since *any* native knew that the ownership of numerous and large pieces of art, whatever their mythic meaning, also meant the owners were people of importance. Similarly, one could argue with regard to western fine art that it matters little that the majority of the people in our society do not "understand" modern art. They certainly are aware that possession of a large collection of such art is commonly taken to be evidence of the wealth and cultivation of the owner (cf. T. Wolfe 1975).

Leaving aside the function of fine arts in Euroamerican society, another interesting area of comparison with art in primitive society concerns the psychology of art. First we may note that acculturation into the arts occurs less often via kinship lines than it typically does in primitive societies. Griff (1968) has discovered that recruitment into the visual arts in our society very often occurs via art teachers in public schools and through art classes sponsored by art museums.

In regard to art instruction itself, however, the methods of our society are not unique. Here, as in most primitive societies, at any given time the neophyte artist usually gets most of his or her artistic

instruction from a single accomplished artist. Teaching is confined largely to instruction in practical areas of media use, being exposed to the teacher as he or she makes art, and having one's own creations criticized by the teacher. Although didactic teaching of fundamental principles characterizes most other areas of formal education in the west, it is relatively absent from art instruction. This practice may place western art students in something of a dilemma: Overt copying of another's art style is frowned on, but guidelines for creating a unique style are seldom explicitly taught.

Another difference between western art and that of primitive societies lies in the way symbolism is used. Firth (1973:37-47) has characterized the difference as being between using "public" versus "private" symbols: The artist in primitive societies may—and typically does—call upon a whole repertoire of symbols (and icons) that are readily recognized by large sectors of the audience. By contrast, western artists have come to rely in greater or lesser degrees upon images from their own vision of the world, making art that is highly personal and idiosyncratic.[1] Perhaps more important than the change from a reliance on public symbols to an increased use of private ones is the shift in ideology that has accompanied this change: Western artists are not necessarily obliged to make their works understandable to non-artists; if others fail to understand an artist's works it can be argued that the problem is not the artist's but, if anyone's, the viewer's.

Another point of comparison between western art and art from primitive societies concerns the artist's role in society. By definition, primitive societies are typified by their smallness and intimacy, and by the fact that no individuals are full-time specialists in any one activity. Western artists, by contrast, are typically full-time specialists. Reducing the economic picture to its basics, western artists produce works which they trade to others in return for life necessities—food, clothing, and so on. Since other individuals—shopkeepers and traders—specialize in mediating this exchange, western artists are not obliged to interact with the diverse congeries of their contemporaries. If they so desire they can limit their social sphere to other artists, art dealers, and a few other entrepreneurs.

One implication of the full-time specialization of western artists is that they typically produce a greater quantity of art than do their counterparts in primitive societies. Also, as full-time specialists, they may master a wide range of skills, such as numerous painting and

[1]A painting by Henri Matisse was accidentally displayed upside down during most of a seven-week show at New York's Museum of Modern Art (Anon 1961). That only one of some 116,000 viewers complained that something was amiss indicates just how "private" an art work may be.

drawing media, printmaking, and various kinds of sculpture. Full-time specialization also allows the use of media based on an increasingly complex technology.

With respect to the role of artists in western society we might also remember that since the Romantic Rebellion artists have been variously stereotyped as "neurotic" individuals and "rebels" (cf. Zucker 1969; Trilling 1945). Regardless of the accuracy of such generalizations, we can recall from chapter 4 that artists endure similar stereotypes in some, but not all, other societies. For example, Herskovits and Herskovits (1934) describe the Dahomean view of the "typical" wood carver in these terms:

> He is, they say, always eager to go off into the bush in search of fine wood, and once gone, he may not return for weeks. Upon his return, he will busy himself making a figure from some piece of rare wood, working long and contentedly, and neglect to make a mortar or a stool for which a buyer is waiting. That is why, say the Dahomeans, wood carvers are poor providers for their wives and children. In the days of the kings they were no less dilatory, so that when a monarch wished one of these famous carvers to make certain objects for him, he would send out a detachment of soldiers to bring him to the palace, where he was kept under guard until he finished his task. "The king could have had him killed for not obeying him, but that wouldn't have got him the carvings. . . . And they were all like that, these carvers" (p. 128).

Even more striking cross-cultural similarities are found if we consider the Gola of West Africa. Warren L. d'Azevedo, who did fieldwork in Liberia, notes that the Gola believe the creative person, artist or otherwise, has a special sort of relationship with an intangible "friend" in the spirit world. This results in the individual's having a personality that parallels the contemporary Western stereotype of artists. Thus, those Gola "who are considered to be of the genius type arouse both admiration and suspicion. Their extraordinary abilities are usually limited to some narrow range of expression. . . . In both cultures there is the idea that the consequences of genius vacillate precariously between the social and the anti-social" (1966:19).

A final area of comparison between western art and that of primitive societies concerns the values held to be important in judging art. As in some other societies, we put a very high value on innovativeness on the part of the artist. Objectively measuring novelty is difficult, but it does seem certain that the changes in style which have occurred in western art since the Renaissance, and especially since 1900, have come more rapidly one after the other than we generally find in primitive societies. Perhaps this results only from our putting a high value on innovativeness in any endeavor: It

is interesting that Pierre Romain-Despossés, the French founder of one of the formal art schools in Africa mentioned in chapter 6, allowed his students total freedom in their art work with one significant exception, namely, that each thing they made had to be new, never a repetition of anything they had done before (Mount 1973:75). Then too, the rapid changes in our art only mirror other changes in our society—increased industrialism and wealth, urbanization, secularization, and so on. Perhaps also the western penchant for novelty in art is a reaction to the mass production industrialism depends on: A one-of-a-kind art work is a welcome addition to an environment otherwise constructed of, and furnished with, items that are manufactured by the hundreds with boring repetitiveness.

The foregoing comparison of western art with that from primitive societies is necessarily generalized and highly tentative. Among other problems, we are limited by our minimal understanding of western art itself.

But, more important, we are limited by the general state of ignorance of primitive societies generally, and of their arts in particular. In every chapter of this book it has been necessary to admit "We don't have the answer to that—yet." The study of art in primitive societies is especially exciting today because of the intriguing information gained to date, and also because of the work that remains to be done. As stated at the outset, the intent of this book has been to report on the state of the anthropological study of art in primitive societies, and my goal has been merely to bring together what I feel to be the fruits of our efforts so far. Quite literally, the book is a work in progress, since it reflects a field that is growing, expanding, and, in a most exciting way, is a field that is itself "in progress".

GUIDE TO ADDITIONAL READINGS

Attempts to discern and empirically study possible universal patterns in art and aesthetics are few in number, and those that do exist tend to be very limited in scope. Farley and Ahn (1973), for example, used fairly rigorous methods to show that individuals from five different societies do not significantly differ in their preferences when asked to choose among regular polygons with varying numbers of sides.

It is common for writers on art from non-Western societies to implicitly note the similarities and differences between Western and non-Western traditions. d'Azevedo (1966) is one of the few to make such a comparison explicit.

Bibliography

ABRAMSON, J. A. 1976 "Style Change in an Upper Sepik Contact Situation," in *Ethnic and Tourist Arts* ed. Nelson H. H. Graburn, pp. 249-265. Berkeley: University of California Press.

ADAIR, JOHN 1944 [reprinted 1970] *Navajo and Pueblo Silversmiths.* Norman: University of Oklahoma Press.

ADAMS, MARIE JEANNE 1973 "Structural Aspects of Village Art." *American Anthropologist* 75:265-279.

ALLAND, ALEXANDER, Jr. 1975 *When the Spider Danced.* Garden City, N.Y.: Anchor Press.

——— 1977 *The Artistic Animal.* Garden City, N.Y.: Doubleday.

ANONYMOUS 1961 "Modern Museum is Startled by Matisse Picture." *New York Times,* December 5, 1961, p. 45.

ANONYMOUS 1976 "F.O.B. Detroit." *Newsweek,* October 25, 1976, p. 25.

ARIETI, SILVANO 1976 *Creativity: The Magic Synthesis.* New York: Basic Books.

ARIMA, EUGENE Y. and E. C. HUNT 1976 "Notes on Kwakiutl 'Tourist Mask' Carving," in *Contributions to Canadian Ethnology, 1975*, ed. David Brez Carlisle. National Museum of Man, Mercury Series, Canadian Ethnology Service, Paper 31.

BALIKCI, ASEN 1970 *The Netsilik Eskimo.* Garden City, N.Y.: Natural History Press.

BARNETT, H. G. 1953 *Innovation: The Basis of Cultural Change.* New York: McGraw-Hill.

BARRY, HERBERT, III 1957 "Relationships between Child Training and the Pictorial Arts." *Journal of Abnormal and Social Psychology* 54:380-383.

BASCOM, WILLIAM RUSSELL 1969 *The Yoruba of Southwestern Nigeria.* New York: Holt, Rinehart and Winston.

——— 1973 "A Yoruba Master Carver: Duga of Mẹkọ," in *The Traditional Artist in African Societies*, Warren L. d'Azevedo, pp. 62-78. Bloomington: Indiana University Press.

BATESON, GREGORY 1958 [orig. 1936] *Naven.* Second edition. Stanford, Calif.: Stanford University Press.

——— 1972a "Metalogue: What is an Instinct?" in Bateson, *Steps to an Ecology of the Mind*, pp. 38-58. New York: Ballantine.

——— 1972b "Style, Grace, and Information in Primitive Art," in Bateson, *Steps to an Ecology of the Mind*, pp. 128-152. New York: Ballantine.

——— 1972c "Metalogue: Why a Swan?" in Bateson, *Steps to an Ecology of the Mind*, pp. 33-37. New York: Ballantine.

BEIER, ULLI 1960 *Art in Nigeria, 1960.* Cambridge, England: Cambridge University Press.

——— 1968 *Contemporary Art in Africa.* New York: Praeger.

BELLAH, ROBERT N., ed. 1965 *Religion and Progress in Modern Asia.* New York: Free Press.

BEN-AMOS, DANIEL 1975 *Sweet Words: Storytelling Events in Benin.* Philadelphia: Institute for the Study of Human Issues.

BEN-AMOS, PAULA 1976a " 'A la Recherche du Temps Perdu': On Being an Ebony-Carver in Benin," in *Ethnic and Tourist Arts*, ed. Nelson H. H. Graburn, pp. 320-333. Berkeley: University of California Press.

——— 1976b "Men and Animals in Benin Art." *Man* 11 (2):243-252.

BENEDICT, RUTH 1934 *Patterns of Culture.* Boston: Houghton Mifflin.

BENSON, ELIZABETH P., ed. 1972 *The Cult of the Feline.* Washington, D.C.: Dumbarton Oaks Research Library.

BERLYNE, D. E. 1971 *Aesthetics and Psychobiology.* New York: Appleton-Century-Crofts.

BERNDT, RONALD M. 1958 "A Comment on Dr. Leach's 'Trobriand Medusa.' " *Man* 58(65):65-66.

BIEBUYCK, DANIEL P. 1968 "Art as a Didactic Device in African Initiation Systems." *African Art Forum* 3(4)/4(1):35-43.

———— 1969 "Introduction," in *Tradition and Creativity in Tribal Art*, ed. Daniel P. Biebuyck, pp. 1-23. Berkeley: University of California Press.

———— 1970 "Effects on Lega Art of the Outlawing of the Bwami Association," in *New African Literature and the Arts*, Vol. 1, ed. Joseph Okpaku, pp. 340-352. New York: Crowell.

———— 1972 "The *Kindi* Aristocrats and Their Art among the Lega," in *African Art and Leadership*, ed. Douglas Fraser and Herbert M. Cole, pp. 7-20. Madison: University of Wisconsin Press.

———— 1973 *Lega Culture*. Berkeley: University of California Press.

BLACKWOOD, BEATRICE 1961 "Comment on Herta Haselberger's 'Method of Studying Ethnological Art.'" *Current Anthropology* 2:360.

BOAS, FRANZ 1897 "The Decorative Art of the Indians of the North Pacific Coast." *Bulletin of the American Museum of Natural History* 9(9):123-176.

———— 1908 "Decorative Designs of Alaskan Needlecases." *Preceedings of the U.S. National Museum* 34:321-344. (Reprinted in Boas, 1940, *Race, Language and Culture*, pp. 564-592. New York: Free Press.

———— 1940 "Representative Art of Primitive People," in Boas, *Race, Language and Culture*, pp. 535-540. New York: Free Press.

———— 1955 [orig. 1927] *Primitive Art*. New York: Dover.

BOHANNAN, PAUL 1971 "Artist and Critic in an African Society," in *Anthropology and Art*, ed. Charlotte M. Otten, pp. 172-181. [Orig. in *The Artist in Tribal Society*, ed. Marian W. Smith, 1961:85-94. London: Routledge and Kegan Paul.]

BRAIN, ROBERT and ADAM POLLOCK 1971 *Bangwa Funerary Sculpture*. Toronto: University of Toronto Press.

BROWN, ROGER and A. GILMAN 1960 "The Pronouns of Power and Solidarity," in *Style in Language*, ed. Thomas A. Sebeok, pp. 253-276. Cambridge, Mass.: MIT Press.

BRUNER, JEROME 1963 "The Conditions of Creativity," in *Contemporary Approaches to Creative Thinking*, ed. H. E. Gruber, G. Terrell and M. Wertheimer, pp. 1-30. New York: Atherton Press.

BUNZEL, RUTH 1971 [Orig. 1929] *The Pueblo Potter: A Study of Creative Imagination in Primitive Art*. New York: Dover.

BURTON, MICHAEL L., LILYAN A. BRUDNER and DOUGLAS R. WHITE 1977 "A Model of the Sexual Division of Labor." *American Ethnologist* 4(2):227-272.

BYERS, PAUL 1964 "Still Photography in the Systematic Recording and Analysis of Behavior." *Human Organization* 23(1):78-84.

CARPENTER, EDMUND 1966 "Image Making in Arctic Art," in *Sign, Image, Symbol*, ed. Gyorgy Kepes, pp. 206-225. New York: George Braziller.

———— 1973 "Some Notes on the Separate Realities of Eskimo and Indian

Art," in *The Far North: 2000 Years of American Eskimo and Indian Art,* pp. 281-289. Washington, D.C.: United States National Gallery of Art.

———— 1971 [orig. 1961] "The Eskimo Artist," in *Anthropology and Art,* ed. Charlotte M. Otten. Garden City, N.Y.: Natural History Press. [Orig. in *Current Anthropology* 2(4):361-63.]

———— 1976 "Collectors and Collecting." *Natural History* 85(3): 56-67.

———— and KEN HYMAN 1973 *They Became What They Beheld.* New York: Ballantine.

————, FREDRICK VARLEY, and ROBERT FLAHERTY 1959 *Eskimo.* Toronto: University of Toronto Press.

CARROLL, KEVIN 1967 *Yoruba Religious Carving.* Dublin: Geoffrey Chapman.

CHAPPEL, T. J. H. 1972 "Critical Carvers: A Case Study." *Man,* n.s. 7(2):296-307.

CHILD, IIRVIN L. and LEON SIROTO 1971 "BaKwele and American Aesthetic Evaluations Compared," in *Art and Aesthetics in Primitive Societies,* ed. Carol F. Jopling, pp. 271-289. [Orig. in *Ethnology* 4(4):349-360, 1965.]

COLE, HERBERT M. 1972 "Ibo Art and Authority," in *African Art and Leadership,* ed. Douglas Fraser and Herbert M. Cole, pp. 79-97. Madison: University of Wisconsin Press.

COLE, MICHAEL and SYLVIA SCRIBNER 1974 *Culture and Thought.* New York: John Wiley.

COLLINS, HENRY B. 1962 "Eskimo Culture," in *The Encyclopedia of World Art,* Vol. 5 pp. 4-28. New York: McGraw-Hill.

———— 1964 "The Arctic and Subarctic," in *Prehistoric Man in the New World,* ed. Jesse D. Jennings and Edward Norbeck, pp. 85-114. Chicago: Chicago University Press, for William Marsh Rice University.

CORDWELL, JUSTINE M. 1959 "African Art," in *Continuity and Change in African Cultures,* ed. William R. Bascom and Melville J. Herskovits, pp. 28-48. Chicago: University of Chicago Press.

CROWLEY, DANIEL J. 1968 "Crafts," in *International Encyclopedia of the Social Sciences,* ed. Edward L. Sils, Vol. 3, pp. 430-434. New York: Macmillan.

———— 1971 "An African Aesthetic," in *Art and Aesthetics in Primitive Societies,* ed. Carol F. Jopling, pp. 315-327. New York: Dutton. [Orig. in *The Journal of Aesthetics and Art Criticism* 24(4):519-524, 1966.]

———— 1972 "Chokwe: Political Art in a Plebian Society," in *African Art and Leadership,* ed. Douglas Fraser and Herbert M. Cole, pp. 21-39. Madison: University of Wisconsin Press.

———— 1973 "Aesthetic Value and Professionalism in African Art: Three Cases from the Katanga Chokwe," in *The Traditional Artist in African Societies,* ed. Warren L. d'Azevedo, pp. 221-249. Bloomington: Indiana University Press.

D'ANDRADE, ROY G. 1961 "Anthropological Studies of Dreams," in *Psychological Anthropology*, ed. Francis L. K. Hsu, pp. 296-332. Homewood, Ill.: Dorsey Press.

DAVENPORT, WILLIAM H. 1971 "Sculpture of the Eastern Solomans," in *Art and Aesthetics in Primitive Societies*, ed. Carol F. Jopling, pp. 382-423. New York: Dutton. [Orig. in *Expedition* 10(2):4-25, 1968.]

D'AZEVEDO WARREN L. 1958 "A Structural Approach to Esthetics: Toward a Definition of Art in Anthropology." *American Anthropologist* 60(4):702-14.

——— 1966 *The Artist Archetype in Gola Culture*. Desert Research Institute Preprint No. 14, University of Nevada. (Revised and reissued, 1970.)

———, ed., 1973a *The Traditional Artist in African Societies*. Bloomington: Indiana University Press.

——— 1973b "Sources of Gola Artistry," in *The Traditional Artist in African Societies*, ed. Warren L. d'Azevedo, pp. 282-340. Bloomington: Indiana University Press.

DEJAGER, E. J. 1973 *Contemporary African Art in South Africa*. Cape Town, South Africa: C. Strunk (PTY) Ltd.

DIAMOND, STANLEY 1974 *In Search of the Primitive: A Critique of Civilization*. New Brunswick, N.J.: Trans-Action Books.

DODDS, E. R. 1951 *The Greeks and the Irrational*. Berkeley: University of California Press.

DOUGLAS, FREDERIC H., and RENE D'HARNONCOURT 1941 *Indian Art of the United States*. New York: Museum of Modern Art.

DOUGLAS, MARY 1970 *Natural Symbols*. London: Cresset.

DRESSLER, WILLIAM W. and MICHAEL C. ROBBINS 1975 "Art Styles, Social Stratification, and Cognition: An Analysis of Greek Vase Painting." *American Ethnologist* 2:427-434.

DRUCKER, PHILIP 1955 *Indians of the Northwest Coast*. New York: McGraw-Hill.

DUNN, DOROTHY 1968 *American Indian Painting of the Southwest and Plains Areas*. Albuquerque: University of New Mexico.

DURKHEIM, EMILE 1938 [orig. 1895] *The Rules of the Sociological Method*, John H. Mueller, trans. Chicago: University of Chicago Press.

EHRESMANN, DONALD L. 1975 *Fine Arts: A Bibliographic Guide to Basic Reference Works, Histories, and Handbooks*. Littleton, Colo.: Libraries Unlimited.

FAGG, BERNARD 1961 "Comment on Herta Haselberger's 'Method of Studying Ethnological Art.' " *Current Anthropology* 2:364-365.

FAGG, WILLIAM 1961 "Comment on Herta Haselberger's 'Method of Studying Ethnological Art.' " *Current Anthropology* 2:365-367.

―――― 1969 "The African Artist," in *Tradition and Creativity in Tribal Art,'* ed. Daniel Biebuyck, pp. 42-57. Berkeley: University of California Press.

FARIS, JAMES C. 1972 *Nuba Personal Art.* Toronto: University of Toronto Press.

FARLEY, FRANK H. and SUN-HYE AHN 1973 "Experimental Aesthetics: Visual Aesthetic Preferences in Five Cultures." *Studies in Art Education* 15(1):44-48.

FAW, T. T. and J. C. NUNNALLY 1967 "The Effects on Eye Movements of Complexity, Novelty, and Affective Tone." *Perception and Psychophysics* 2:263-267.

FERNANDEZ, JAMES W. 1971 "Principles of Opposition and Vitality in Fang Aesthetics," in *Art and Aesthetics in Primitive Societies,* ed. Carol F. Jopling, pp. 356-373. New York: Dutton. [Orig. *Journal of Aesthetics and Art Criticism* 25(1):53-64, 1966.]

―――― 1973 "The Exposition and Imposition of Order: Artistic Expression in Fang Culture," in *The Traditional Artist in African Societies,* ed. Warren L. d'Azevedo, pp. 194-220. Bloomington: Indiana University Press.

FIRTH, RAYMOND 1925 "The Maori Carver." *Journal of the Polynesian Society* 34:277-291.

―――― 1951 *The Elements of Social Organization.* London: Watts and Company.

―――― 1973 *Symbols: Public and Private.* Ithaca, N.Y.: Cornell University Press.

―――― 1974 "Tikopia Art and Society," in *Primitive Art and Society,* ed. Anthony Forge, pp.25-48. New York: Oxford University Press.

FISCHER, JOHN L. 1971 "Art Styles as Cultural Cognitive Maps," in *Anthropology and Art,* ed. Charlotte M. Otten, pp. 141-161. Garden City, N.Y.: Natural History Press. [Orig. *American Anthropologist* 63(1):79-93, 1961.]

FLAM, J. D. 1970 "Some Aspects of Style Symbolism in Sudanese Sculpture." *Journal de la Société des Africanistes* 40(2):137-150.

FORD, C. S., E. TERRY PROTHRO, and IRVIN L. CHILD 1966 "Some Transcultural Comparisons of Esthetic Judgment." *Journal of Social Psychology* 68:19-26.

FORDE, CYRIL DARYLL 1951 *The Yoruba-Speaking Peoples of Southwestern Nigeria.* London: International African Institute.

FORGE, J. ANTHONY 1967 "The Abelam Artist," in *Social Organization: Essays Presented to Raymond Firth,* ed. Maurice Freedman, pp. 65-84. London: Cass.

―――― 1970 "Learning to See in New Guinea," in *Socialization: The Approach from Social Anthropology, ASA 8,* ed. Philip Mayer, pp. 269-291. London: Tavistock.

—— 1971 "Art and Environment in the Sepik," in *Art and Aesthetics in Primitive Societies*, ed. Carol F. Jopling, pp. 290-314. New York: Dutton. [Orig. *Proceedings of the Royal Anthropological Institute of Great Britain and Ireland* 1965, pp. 23-31.]

——, ed. 1974 *Primitive Art and Society*. N.Y.: Oxford University Press.

FOSTER, GEORGE M. 1967 *Tzintzuntzan*. Boston: Little, Brown.

FRASER, DOUGLAS 1955 "Mundugamor Sculpture: Comments on the Art of a New Guinea Tribe." *Man* 55:17-20.

—— 1966 "The Heraldic Woman: A Study in Diffusion," in *The Many Faces of Primitive Art*, ed. Douglas Fraser, pp. 36-99. Englewood Cliffs, N.J.: Prentice-Hall.

—— 1971 "The Discovery of Primitive Art," in *Anthropology and Art*, ed. Charlotte M. Otten, pp. 20-36. Garden City, N.Y.: Natural History Press. [Orig. in *Arts Yearbook I: The Turn of the Century*, ed. Hilton Kramer, pp. 119-133, 1957.]

—— 1972a "The Symbols of Ashanti Kingship," in *African Art and Leadership*, ed. Douglas Fraser and Herbert M. Cole, pp. 137-152. Madison: University of Wisconsin Press.

—— 1972b "The Fish-legged Figure in Benin and Yoruba Art," in *African Art and Leadership*, ed. Douglas Fraser and Herbert M. Cole, pp. 261-293. Madison: University of Wisconsin Press.

—— and HERBERT M. COLE, eds. 1972a *African Art and Leadership*. Madison: University of Wisconsin Press.

—— 1972b "Art and Leadership: an Overview," in *African Art and Leadership*, ed. Douglas Fraser and Herbert M. Cole, pp. 295-328. Madison: University of Wisconsin Press.

FRIED, MORTON H. 1975 *The Notion of Tribe*. Addison-Wesley Module in Anthropology. Menlo Park, Calif.: Cummins.

GARDNER, HOWARD 1973 *The Arts and Human Development*. New York: Wiley.

—— et al. 1972 *Art, Perception and Reality*. Baltimore: Johns Hopkins Press.

GEERTZ, CLIFFORD 1973 *The Interpretation of Cultures*. New York: Basic Books.

GERBRANDS, ADRIAN A. 1957 *Art as an Element of Culture, Especially in Negro-Africa*. Mededlingen van het Rijksmuseum voor Volkenkunde, Leiden, Number 12. Leiden, Holland: E. E. Brill.

—— 1967 *Wow-Ipits: Eight Asmat Woodcarvers in New Guinea*, trans. Inez Seeger. The Hague: Mouton.

GETZELS, JACOB W. and MIHALY CSIKSZENTMIHALYI 1976 *The Creative Vision: A Longitudinal Study of Problem Finding in Art*. Somerset, N.J.: John Wiley and Sons, Inc.

GOLDWATER, ROBERT 1967 *Primitivism in Modern Art*. New York: Vintage Books.

—— 1969 "Judgments of Primitive Art, 1905-1965," in *Tradition and Creativity in Tribal Art*, ed. Daniel Biebuyck, pp. 24-41. Berkeley: University of California Press.

GOMBRICH, ERNST H. 1972a "The Visual Image," in *Communication*, the editors of *Scientific American*, pp. 46-60. San Francisco: W. H. Freeman.

—— 1972b *Art and Illusion*. Fourth edition. London: Phaidon Press.

GOODALE, JANE C. and JOAN D. KOSS 1971 "The Cultural Context of Creativity among Tiwi," in *Anthropology and Art*, ed. Charlotte M. Otten, pp. 182-200. Garden City, N.Y.: Natural History Press. [Orig. in *Essays on the Verbal and Visual Arts*, ed. June Helm McNeish, pp. 175-191. Seattle: University of Washington Press, 1967.]

GRABURN, NELSON H. H. 1967 "The Eskimo and 'Airport Art.' " *Trans-Action* 4(10):28-33.

—— 1969 "Art and Acculturative Processes." *International Social Sciences Journal* 21(3):457-468.

—— 1971 "Traditional Economic Institutions and the Acculturation of the Canadian Eskimos," in *Studies in Economic Anthropology*, ed. George Dalton, pp. 107-121. Washington, D.C.: American Anthropological Association.

—— 1972 "A Preliminary Analysis of Symbolism in Eskimo Art and Culture," in *Proceedings of the XL International Congress of Americanists*, Rome, 2:165-170. Genoa: Tilgher, December.

—— 1976a "Introduction: Arts of the Fourth World," in *Ethnic and Tourist Arts*, ed. Nelson H. H. Graburn, pp. 1-32. Berkeley: University of California Press.

—— 1976b "Eskimo Art: The Eastern Canadian Arctic," in *Ethnic and Tourist Arts*, ed. Nelson H. H. Graburn, pp. 39-55. Berkeley: University of California Press.

—— 1976c "I Like Things to Look More Different Than That Stuff Did: An Experiment in Cross-Cultural Art Appreciation." in *Art, Artisans and Society*, ed. V. Megaw. London: Duckworth.

—— ed. 1976d *Ethnic and Tourist Arts*. Berkeley: University of California Press.

GRIFF, MASON 1968 "The Recruitment and Socialization of Artists," in *International Encyclopedia of the Social Sciences*, ed. David L. Sils, Vol. 5 pp. 447-455.

GUMPERZ, JOHN J. 1971 *Language in Social Groups: Essays by John J. Gumperz*, selected and introduced by Anwar S. Dil. Stanford, Calif.: Stanford University Press.

GUNTHER, ERNA 1962 *Northwest Coast Indian Art*. Seattle: University of Washington Press.

HARLEY, GEORGE W. 1950 *Masks as Agents of Social Control in Northeast Liberia*. (*Papers of the Peabody Museum of Archaeology and Ethnography,*

Harvard University, Vol. 32, no. 2.) Cambridge, Mass.: Peabody Museum.

HARNER, MICHAEL J. 1972 *The Jívaro.* Garden City, N. Y.: Anchor Press-Doubleday Books.

HARRIS, MARVIN 1975 *Culture, People, Nature.* Second edition. New York: Thomas Y. Crowell.

HASELBERGER, HERTA 1961 "Method of Studying Ethnological Art." *Current Anthropology* 2:341-355.

HATCHER, EVELYN PAYNE 1974 *Visual Metaphors: A Formal Analysis of Navajo Art.* American Ethnological Society, Monograph No. 58. St. Paul, Minn.: West Publishing Company.

HATTERER, LAWRENCE J. 1965 *The Artist in Society: Problems and Treatment of the Creative Individual.* New York: Grove Press.

HAWTHORN, HARRY B. 1961 "The Artist in Tribal Society: The Northwest Coast," in *The Artist in Tribal Society,* ed. Marian W. Smith, pp. 58-70. New York: Free Press.

HEMPEL, CARL 1959 "The Logic of Functionalist Analysis," in *Symposium on Sociological Theory,* ed. L. Gross, pp. 271-307.Evanston, Ill.: Row Peterson.

HERSKOVITS, MELVILLE J. 1959 "Art and Value," in *Aspects of Primitive Art,* by Robert Redfield, Melville J. Herskovits, and George F. Ekholn, pp. 43-60. New York: Museum of Modern Art.

—— and F. S. HERSKOVITS 1934 "The Art of Dahomey II: Wood Carving." *American Magazine of Art* 27:124-131.

HESS, ECKHARD H. 1975 "The Role of Pupil Size in Communication." *Scientific American* 233(5):110-119.

HIMMELHEBER, HANS 1960 *Negerkunst und Negerkünstler.* Braunschweig: Klinkgardt and Bierman.

—— 1963 "Personality and Technique of African Sculptors," in *Technique and Personality,* by Margaret Mead, et al., pp. 80-110. New York: Museum of Modern Art.

HOGBIN, H. I. 1971 *Social Change.* Melbourne, Australia: Melbourne University Press.

HOLM, OSCAR WILLIAM (BILL) 1965 *Northwest Coast Indian Art: An Analysis of Form.* Seattle: University of Washington Press.

—— 1972 *Crooked Beak of Heaven: Masks and Other Ceremonial Art of the Northwest Coast.* Seattle: University of Washington Press.

—— and WILLIAM REID 1975 *Form and Freedom.* Houston: Rice University, Insitute of the Arts.

HOULIHAN, PATRICK THOMAS 1972 *Art and Social Structure on the Northwest Coast.* Unpublished Ph.D. dissertation, University of Wisconsin, Milwaukee.

HOUSTON, JAMES 1951 "Eskimo Sculptors." *The Beaver*, June issue, pp. 34-39.

—— 1952 "In Search of Contemporary Eskimo Art." *Canadian Art* 9(3):99-104.

—— 1954 *Canadian Eskimo Art.* Ottowa: Queen's Printer, Department of Northern Affairs.

IWAO, SUMIKO and IRVIN L. CHILD 1966 "Comparisons of Esthetic Judgments by American Experts and Japanese Potters." *Journal of Social Psychology* 68:27-34.

—— and MIGUEL GARCÍA 1969 "Further Evidence of Agreement between Japanese and American Esthetic Evaluations." *Journal of Social Psychology* 75(1):11-15.

JAFFÉ, ANIELA 1964 "Symbolism in the Visual Arts," in *Man and His Symbols*, ed. Carl G. Jung, pp. 230-271. Garden City, N.Y.: Doubleday.

JONES, W. T. 1974 "Talking about Art and Primitive Society," in *Primitive Art and Society*, ed. Anthony Forge, pp. 256-277. New York: Oxford University Press.

JOPLING, CAROL F., ed. 1971 *Art and Aesthetics in Primitive Societies: A Critical Anthology.* New York: Dutton.

JUNG, CARL G. 1964 "Approaching the Unconscious," in *Man and His Symbols*, ed. Carl G. Jung, pp. 18-103. Garden City, N.Y.: Doubleday.

KAEPPLER, ADRIENNE L., JUDY VANZILE, and CARL WOLZ, eds. 1977 "Asian and Pacific Dance: Selected Papers from the 1974 CORD-SEM Conference. Committee on Dance Research." *Dance Research Annual*, Vol. 8.

KAPLAN, FLORA S. 1977 "Structuralism and the Analysis of Folk Art." Paper read at the 76th Annual Meeting of the American Anthropological Association, Houston, Texas.

KAUFMANN, CAROLE N. 1976 "Functional Aspects of Haida Argilite Carvings," in *Ethnic and Tourist Arts*, ed. Nelson H. H. Graburn, pp. 56-69. Berkeley: University of California Press.

KAVOLIS, V. M. 1972 *History on Art's Side: Social Dynamics of Artistic Efflorescences.* Ithaca, N. Y.: Cornell University Press.

KENT, KATE PECK 1976 "Pueblo and Navajo Weaving Traditions and the Western World," in *Ethnic and Tourist Arts*, ed. Nelson H. H. Graburn, pp. 85-101. Berkeley: University of California Press.

KIELL, NORMAN 1965 *Psychiatry and Psychology in the Visual Arts: A Bibliography.* Madison: University of Wisconsin Press.

KISTE, ROBERT C. 1974 *The Bikinians: A Study in Forced Migration.* The Kiste-Ogan Social Change Series in Anthropology. Menlo Park, Calif.: Cummins.

KURATH, GERTRUDE P. 1960 "Panorama of Dance Ethnology." *Current Anthropology* 1:233-254.

LANGER, SUSANNE K. 1951 *Philosophy in a New Key.* Third edition. Cambridge, Mass.: Harvard University Press.

LAWLOR, M. 1955 "Cultural Influences on Preferences for Designs," *Journal of Abnormal and Social Psychology* 61:690-692.

LEACH, EDMUND R. 1961 "Aesthetics," in *The Institutions of Primitive Society,* by E. E. Evans-Pritchard et al., pp. 25-38. N.Y.: Free Press.

———— 1971 "A Trobriand Medusa?" in *Art and Aesthetics in Primitive Societies,* ed. Carol F. Jopling, pp. 45-63. New York: Dutton. [Orig. in *Man* 54(158):103-105, 1954.]

———— 1974 "Levels of Communication and Problems of Taboo in the Appreciation of Primitive Art," in *Primitive Art and Society,* ed. Anthony Forge. New York: Oxford University Press, pp. 221-34.

LÉVI-STRAUSS, CLAUDE 1963 *Structural Anthropology,* trans. C. Jacobson and B. G. Schoepf. New York: Doubleday.

———— 1966 *The Savage Mind,* trans. George Weidenfeld. Chicago: Chicago University Press.

———— 1970 *Triste Tropiques,* trans. John Russell. New York: Atheneum.

LEWIS, PHILIP H. 1961 "The Artist in New Ireland Society," in *The Artist in Tribal Society,* ed. Marian W. Smith, pp. 71-79. New York: The Free Press.

LINTON, RALPH 1941 "Primitive Art." *Kenyon Review* 3(1):34-51.

LIPS, JULIUS E. 1966 [orig. 1937] *The Savage Hits Back,* trans. V. Benson. New York: Yale University Press.

LLOYD, PETER C. 1966 "The Yoruba of Nigeria," in *Peoples of Africa,* ed. James L. Gibbs, Jr., pp. 549-582. New York: Holt, Rinehart and Winston.

LONGACRE, WILLIAM A. 1968 "Some Aspects of Prehistoric Society in East-Central Arizona," in *New Perspectives in Archeology,* ed. Sally R. Binford and Lewis R. Binford, pp. 89-102. Chicago: Aldine-Atherton.

LUSTIG-ARECCO, VERA 1975 *Technology: Strategies for Survival.* New York: Holt, Rinehart and Winston.

MCALLESTER, DAVID P. 1971 *Readings in Ethnomusicology.* New York: Johnson Reprint Corp.

MCELROY, W. A. 1955 "Abstract: Aesthetic Ranking Tests with Arnheim Land Aborigines." *British Psychological Society, Bulletin* 25:44.

MCGHEE, ROBERT 1976 "Differential Artistic Productivity in the Eskimo Cultural Tradition." *Current Anthropology* 17:203-212.

MACKINNON, DONALD W. 1968 "Creativity: Psychological Aspects," in *International Encyclopedia of the Social Sciences,* ed. David Sils, Vol. 3 pp. 434-442.

McLEOD, M. D. 1975 "Traders and Fakers in African Art." *New Society* 31(641):122-125.

McLEOD, NORMA 1974 "Ethnomusicological Research and Anthropology," in *Annual Reviews of Anthropology,* Vol. 3, pp. 99-115, ed. Bernard J. Siegel, et al. Palo Alto, Calif.: Annual Reviews, Inc.

MacNEISH, JUNE HELM, ed. 1968 *Essays on the Problem of Tribe: Proceedings of the 1967 Annual Spring Meeting of the American Ethnological Society.* Seattle: University of Washington Press.

MALINOWSKI, BRONISLAW 1922 *Argonauts of the Western Pacific.* London: Routledge and Kegan Paul.

MAQUET, JACQUES 1971 *Introduction to Aesthetic Anthropology.* Addison-Wesley Module in Anthropology. Reading, Mass.: Addison-Wesley.

MARTIJN, CHARLES A. 1964 "Canadian Eskimo Carving in Historical Perspective," *Anthropos* 59:546-596.

MARTINDALE, COLON and DWIGHT HINES 1975 "Creativity and Cortical Activation During Creative, Intellectual, and EEG Feedback Tasks." *Biological Psychology* 3(2):91-100.

MAUSS, MARCEL 1967 [orig. 1925] *The Gift: Forms of Exchange in Archaic Societies.* New York: Norton.

MEAD, MARGARET 1971 [orig. 1960] "Work, Leisure, and Creativity," in *Art and Aesthetics in Primitive Societies,* ed. Carol F. Jopling. New York: Dutton, pp. 132-145. [Orig. in *Daedalus,* Winter 1960, pp. 12-23.]

MEMEL-FOTÊ, HARRIS 1968 "The Perception of Beauty in Negro-African Culture," in *UNESCO: Colloquium on Negro Art, Dakar 1966,* pp. 45-65. Editions Présence Africaine.

MERRIAM, ALAN P. 1964 *Anthropology of Music.* Evanston, Ill.: Northwestern University Press.

MESSENGER, JOHN C. 1958 "Reflections on Aesthetic Talent." *Basic College Quarterly* 4:20-24.

——— 1962 "Anang Art, Drama, and Social Control." *African Studies Bulletin* 5(2):29-35.

——— 1973 "The Role of the Carver in Anang Society," in *The Traditional Artist in African Societies,* ed. Warren L. d'Azevedo, pp. 101-127. Bloomington: Indiana University Press.

MEYER, KARL E. 1973 *The Plundered Past.* New York: Atheneum.

MILLS, GEORGE 1971 [orig. 1957] "Art: An Introduction to Qualitative Anthropology," in *Art and Aesthetics in Primitive Societies,* ed. Carol F. Jopling, pp. 66-92. New York: Dutton. [Orig. in *Journal of Aesthetics and Art Criticism* 1957 16(1):1-17.]

MOORE, HENRY 1952 "Notes on Sculpture," in *The Creative Process,* ed. Brewster Ghiselin, pp. 73-78. New York: New American Library.

MOORE, WILBERT E. 1974 *Social Change.* Second edition. Englewood Cliffs, N.J.: Prentice-Hall.

MORRIS, DESMOND 1962 *The Biology of Art.* New York: Knopf.

MOUNT, MARSHALL W. 1973 *African Art: The Years Since 1920.* Bloomington: Indiana University Press.

MOUNTFORD, CHARLES P. 1960 "Phallic Objects of the Australian Aborigines." *Man* 60(118):81.

—— 1961 "The Artist and His Art in an Australian Aboriginal Society," in *The Artist in Tribal Society,* ed. Marian W. Smith, pp. 1-13. New York: Free Press.

MUENSTERBERGER, WARNER 1971 "Roots of Primitive Art," in *Anthropology and Art,* ed. Charlotte M. Otten, pp. 106-128. Garden City, New York: Natural History Press. [Orig. in *Psychoanalysis and Culture,* ed. G. B. Wilbert and Warner Muensterberger, pp. 371-389, 1951.]

MUNDKUR, BALAJI 1976 "The Cult of the Serpent in the Americas: Its Asian Background." *Current Anthropology* 17(3):429-455.

MUNN, NANCY 1962 "Walbiri Graphic Signs: An Analysis." *American Anthropologist* 64:972-984.

—— 1964 "Totemic Designs and Group Continuity in Walbiri Cosmology," in *Aborigines Now,* ed. M. Ready. Sydney, Australia: Angus and Robertson.

—— 1970 "The Transformation of Subjects into Objects in Walbiri and Pitjantjatjara Myth," in *Australian Aboriginal Anthropology,* ed. Ronald Berndt, pp. 141-163. Nedlands: University of Western Australia Press.

—— 1971 "Visual Categories: An Approach to the Study of Representational Systems," in *Art and Aesthetics in Primitive Societies,* ed. Carol F. Jopling, pp. 335-355. New York: Dutton. [Orig. in *American Anthropologist* 68(4):936-950.]

—— 1973 *Walbiri Iconography: Graphic Representation and Cultural Symbolism in a Central Australian Society.* Ithaca, N.Y.: Cornell University Press.

—— 1974 "The Spatial Presentation of Cosmic Order in Walbiri Iconography," in *Primitive Art and Society,* ed. Anthony Forge, pp. 193-220. New York: Oxford University Press.

MURDOCK, GEORGE PETER 1957 "World Ethnographic Sample." *American Anthropologist* 59:664-687.

MURPHY, YOLANDA and ROBERT F. MURPHY 1974 *Women of the Forest.* New York: Columbia University Press.

MURRAY, K. C. 1961 "The Artist in Nigerian Tribal Society: A Comment," in *The Artist in Tribal Society,* ed. Marian W. Smith, pp. 95-101. New York: Free Press.

NETTL, BRUNO 1956 *Music in Primitive Culture.* Cambridge, Mass.: Harvard University Press.

NOTON, DAVID and LAWRENCE STARK 1971 "Eye Movements and Visual Perception." *Scientific American* 224(6):34-43.

NUNNALLY, JUM C. 1977 "Meaning-Processing and Rated Pleasantness." *Scientific Aesthetics* 1(3):161:181.

———, T. T. Faw and M. B. BASHFORD 1969 "Effects of Degrees of Incongruity on Visual Fixations in Children and Adults." *Journal of Experimental Psychology* 81:360-64.

O'NEALE, LILA M. 1932 "Yorok-Karok Basket Weavers," *University of California Publications in American Archaeology and Ethnology* 32(1):1-184.

OSBORNE, HAROLD, ed. 1972 *Aesthetics.* New York: Oxford University Press.

OSWALT, WENDELL H. 1973 *Habitat and Technology: The Evolution of Hunting.* New York: Holt, Rinehart and Winston.

OTTEN, CHARLOTTE M., ed. 1971 *Anthropology and Art: Readings in Cross-Cultural Aesthetics.* Garden City, N.Y.: Natural History Press.

OTTENBERG, SIMON 1975 *Masked Rituals of Afikpo: The Context of an African Art.* Seattle: University of Washington Press.

PARSONS, TALCOTT 1951 *The Social System.* New York: Free Press.

PAUL, ROBERT A. 1976 "The Sherpa Temple as a Model of the Psyche." *American Ethnologist* 3(1):131-146.

PIDDOCKE, STUART 1965 "The Potlatch System of the Southern Kwakiutl: A New Perspective." *Southwestern Journal of Anthropology* 21:244-264.

POWDERMAKER, HORTENSE 1933 *Life in Lesu: The Study of a Melanesian Society in New Ireland.* New York: Norton.

PRICE-WILLIAMS, D. R., W. GORDON, and M. RAMIREZ 1969 "Skill and Conservation: A Study of Pottery-making Children." *Developmental Psychology* 1(6):769.

RADCLIFFE-BROWN, A. R. 1935 "On the Concept of Function in Social Science." *American Anthropologist* 37:394-402.

——— 1964 [orig. 1922] *The Andaman Islanders.* New York: Free Press.

RAINEY, FROELICH 1971 "The Vanishing Art of the Arctic," in *Anthropology and Art,* ed. Charlotte M. Otten, pp. 341-353. [Orig. in *Expedition* 1(2):3-13, 1959.]

RANK, OTTO 1943 *Art and Artist, Creative Urge and Personality Development,* trans. Charles F. Atkinson. New York: Knopf.

——— 1959 *Otto Rank: The Myth of the Birth of the Hero, and Other Writings,* ed. Philip Fred. New York: Knopf.

RAPPAPORT, ROY A. 1968 *Pigs for the Ancestors.* New Haven: Yale University Press.

RAVICZ, MARILYN EKDAHL 1976 "Ephemeral Art: A Case for the Functions of Aesthetic Stimuli." Unpublished paper, read at the Annual Meetings of the American Anthropological Association, November 19, 1976, New York, N.Y.

RAWSON, PHILIP S., ed. 1973 *Primitive Erotic Art.* New York: G. P. Putnam.

RAY, DOROTHY JEAN 1961 *Artists of Tundra and Sea.* Seattle: University of Washington Press.

——— 1967 *Eskimo Masks: Art and Ceremony.* Seattle: University of Washington Press.

REDFIELD, ROBERT 1971 [orig. 1959] "Art and Icon," in *Anthropology and Art,* ed. Charlotte M. Otten, pp. 39-65. Garden City, N.Y.: Natural History Press. [Orig. in *Aspects of Primitive Art,* pp. 12-40. New York: Museum of Primitive Art.]

REICHEL-DOLMATOFF, GERARDO 1972 "The Cultural Context of an Aboriginal Hallucinogen: Banisteriopsis Caapi," in *Flesh of the Gods: The Ritual Use of Hallucinogens,* ed. Peter T. Furst, pp. 84-113. New York: Praeger.

——— 1975 *The Shaman and the Jaguar: A Study of Narcotic Drugs among the Indians of Colombia.* Philadelphia: Temple University Press.

REINA, R. A. 1963 "The Potter and the Farmer: The Fate of Two Innovators in a Maya Village." *Expedition* 5(4):18-30.

REINHARDT, LORETTA 1976 "Mrs. Kadiato Kamara: An Expert Dyer in Sierra Leone." *Fieldiana: Anthropology* 66(2):11-33.

ROBBINS, MICHAEL C. 1966 "Material Culture and Cognition." *American Anthropologist* 68:745-748.

ROBERTSON, R. GORDON 1960 "The Carving Industry of Arctic Canada." *The Commerce Journal, University of Toronto,* spring issue.

ROHEIM, GÉZA 1945 *Eternal Ones of the Dream.* New York: International Universities Press.

ROHNER, RONALD P. and EVELYN C. ROHNER 1970 *The Kwakiutl: Indians of British Columbia.* New York: Holt, Rinehart and Winston.

ROYCE, ANYA P. 1977 *The Anthropology of Dance.* Bloomington: University of Indiana Press.

SACHS, CURT 1937 *World History of the Dance.* New York: W. W. Norton.

SALISBURY, RICHARD P. 1959 "A Trobriand Medusa?" *Man* 59(67):50-51.

SALVADOR, MARI LYNN 1976a "The Clothing Arts of the Cuna of San Blas, Panama," in *Ethnic and Tourist Arts,* ed. Nelson H. H. Graburn, pp. 165-182. Berkeley: University of California Press.

——— 1976b *Molas of the Cuna Indians: A Case Study of Artistic Criticism and Ethno-aesthetics.* Unpublished Ph.D. dissertation, University of California, Berkeley.

SANDELOWSKY, B. H. 1976 "Functional and Tourist Art Along the Okavango River," in *Ethnic and Tourist Arts,* ed. Nelson H. H. Graburn, pp. 350-365. Berkeley: University of California Press.

SARLES, HARVEY B. 1972 "The Dynamics of Facial Expression." Paper read at the Annual Meeting, International Association of Dental Research, March 1972, Las Vegas, Nevada.

SCHILLER, PAUL H. 1971 "Figural Preferences in the Drawings of a Chimpanzee," in *Anthropology and Art,* ed. Charlotte M. Otten, pp. 3-19. Garden City, N.Y.: Natural History Press. [Orig. in *The Journal of Comparative and Physiological Psychology* 44(2):101-111, 1959.]

SCHMITZ, CARL 1962 *Ozeanische Kunst: Sculpture aus Melanesien.* München: F. Bruckmann.

SCHNEIDER, HAROLD K. 1956 "The Interpretation of Pakot Visual Art." *Man* 56:103-106.

——— 1966 "Turu Esthetic Concepts." *American Anthropologist* 68:156-160.

SCHNEIDER, MARY JANE 1976 "But, Is it Art?: A Critical Look at nthropological Studies of Non-European Art." Paper read at the annual meetings of the Central States Anthropological Association, March, 1976, St. Louis, Missouri.

SIEBER, ROY A. 1962 "Masks as Agents of Social Control." *African Studies Bulletin* 5(11):8-13.

——— 1976 "Art in Traditional Socities," unpublished lecture, Walker Art Center, Minneapolis, Minnesota, June 30, 1976.

SIEBERT, ERNA 1967 *North American Indian Art.* London: Paul Hamlyn.

SMITH, D. A. 1973 "Systematic Study of Chimpanzee Drawing." *Journal of Comparative and Physiological Psychology* 82:406-414.

SMITH, MARION W., ed. 1961 *The Artist in Primitive Society.* New York: Free Press.

SONTAG, SUSAN 1977 "Photography in Search of Itself." *New York Review of Books* 23(21-22):53-59.

SPECTOR, JACK J. 1972 *The Aesthetics of Freud.* New York: McGraw-Hill.

SPENCER, HAROLD 1975 *The Image Makers: Man and His Art.* New York: Scribner's Sons.

STEWARD, JULIAN H., ed. 1967 *Contemporary Change in Traditional Societies.* Urbana: University of Illinois Press.

STOUT, DAVID B. 1947 *San Blas Cuna Acculturation: An Introduction.* New York: Viking Fund.

STOUT, DAVID B. 1971 [orig. 1960] "Aesthetics in 'Primitive Societies,' " in *Art and Aesthetics in Primitive Societies,* ed. Carol F. Jopling, pp. 30-34. New York: Dutton. [Orig. in *Men and Cultures: Selected Papers of the Fifth International Congress of Anthropological and Ethnological Sciences, Philadelphia, September 1-9, 1956.*]

STURTEVANT, WILLIAM C. 1967 "Seminole Men's Clothing," in *Essays on the Verbal and Visual Arts*, ed. June Helm MacNeish pp. 160-174. Seattle: University of Washington Press.

SWINTON, GEORGE 1958 "Eskimo Carving Today." *Beaver*, spring issue, pp. 40-44.

—— 1972 *Sculpture of the Eskimo*. Greenwich, Conn.: New York Graphic Society.

TANNER, CLARA LEE 1960 "The Influence of the White Man on Southwest Indian Art." *Ethnohistory* 7:137-150.

THOMPSON, LAURA 1945 "The Logico-Aesthetic Integration in Hopi Culture." *American Anthropologist* 47:540-553.

THOMPSON, ROBERT FARRIS 1969 "Àbátàn: A Master Potter of the Ègbádò Yorùbá," in *Tradition and Creativity in Tribal Arts*, ed. Daniel Biebuyck, pp. 120-181. Berkeley: University of California Press.

—— 1971 [orig. 1968] "Aesthetics in Traditional Africa," in *Art and Aesthetics in Primitive Societies*, Carol F. Jopling, ed., pp. 374-381. New York: Dutton. [Orig. in *Art News* 66(9): 44-45, 63-66, 1968.]

—— 1973 "Yoruba Artistic Criticism," in *The Traditional Artist in African Societies*, ed. Warren L. d'Azevedo, pp. 19-61. Bloomington: Indiana University Press.

TRILLING, LIONEL 1945 "Art and Neurosis," in Trilling, *The Liberal Imagination*, by Lionel Trilling, pp. 160-180. New York: Viking Press.

TUCKSON, J. A. 1964 "Aboriginal Art and the Western World." In *Australian Aboriginal Art*, ed. Ronald M. Berndt, pp. 60-68. New York: The Macmillan Company.

TURNER, VICTOR 1967 *The Forest of Symbols*. Ithaca, N.Y.: Cornell University Press.

—— 1969 *The Ritual Process: Structure and Anti-Structure*. Chicago: Aldine.

UCKO, PETER J. and ANDRÉE ROSENFELD 1967 *Paleolithic Cave Art*. New York: McGraw-Hill.

VAUGHAN, JAMES H., Jr. 1973 "əŋkyangu as Artists in Margi Society," in *The Traditional Artist in African Societies*, ed. Warren L. d'Azevedo, pp. 162-193. Bloomington: Indiana University Press.

WAHLMAN MAUDE 1974 *Contemporary African Arts*. Chicago: Field Museum of Natural History.

WAITE, DEBORAH 1966 "Kwakiutl Transformation Masks," in *The Many Faces of Primitive Art*," ed. Douglas Fraser, pp. 265-299. Englewood Cliffs, N.J.: Prentice-Hall, Inc.

WARREN, D. M. and J. KWEKU ANDREWS 1977 *An Ethnoscientific Approach to Akan Arts and Aesthetics; Working Papers in the Traditional Arts Number 3*. Philadelphia: Institute for the Study of Human Issues.

Webster's New Collegiate Dictionary 1959 Second edition. Springfield, Mass.: G. & C. Merriam.

WHITE, LESLIE A. 1959 *The Evolution of Culture.* New York: McGraw-Hill.

WILHITE, MARGARET 1977 "Marketing and Bilingualism: Patterns of Accommodation in Highland Guatemala." Paper presented at the 76th Annual Meeting, American Anthropological Association, Houston, Texas, November 29–Dec. 3, 1977.

WILLETT, FRANK 1971 *African Art.* New York: Praeger.

―――― 1972 "The Art of an Ancient Nigerian Aristocracy," in *African Art and Leadership,* ed. Douglas Fraser and Herbert M. Cole, pp. 209-225. Madison: University of Wisconsin Press.

WILLEY, GORDON R. 1966 *An Introduction to American Archaeology, Volume One: North and Middle America.* Prentice-Hall Anthropology Series. Englewood Cliffs, N.J.: Prentice-Hall.

WILLIAMS, NANCY 1976 "Australian Aboriginal Art at Yirrakala: Introduction and Development of Marketing," in *Ethnic and Tourist Arts,* ed. Nelson H. H. Graburn, pp. 266-284. Berkeley: University of California Press.

WILLIAMS, RAYMOND 1958 *Culture and Society, 1780-1950.* New York: Columbia University Press.

WINGERT, PAUL 1951 "Tsimshian Sculpture." *Publications of the American Ethnological Society,* ed. Marian W. Smith. 13:73-96.

―――― 1962 *Primitive Art: Its Traditions and Styles.* New York: New American Library.

WITHERSPOON, GARY 1977 *Language and Art in the Navajo Universe.* Ann Arbor: University of Michigan Press.

WOLFE, ALVIN W. 1955 "Art and The Supernatural in the Ubangi District." *Man* 55(article 76):65-67.

―――― 1969 "Social Structural Bases of Art." *Current Anthropology* 10:3-28.

―――― 1976 "Comment on Robert McGhee's 'Differential Artistic Productivity in the Eskimo Cultural Tradition.'" *Current Anthropology* 17:217-218.

WOLFE, TOM 1975 "The Painted Word." *Harpers Magazine,* April issue, pp. 57-92.

ZUCKER, WOLFGANG M. 1969 "The Artist as a Rebel." *Journal of Aesthetics* 23:389-397.

Index

A

Abelam art and society, 86, 91,
103-06, 105 (illus.), 129, 152
stylization of designs, 140-42
Abramson, J., 186
Adair, J., 169-73, 183
Adams, Marie Jeanne, 46
Aesthetic socialization, 116-21
Aesthetic values:
noses as a focus of beauty in
New Guinea highlands, 136
universal aesthetic values,
195-99, 204
Yoruba aesthetics, 18-21

Affective response to art, 13-18,
28-32, 51
Afikpo art and society, 24, 83,
93, 94, 95-97, 96 (illus.),
99-102, 121, 129
Africa, native arts of (*see entries*
under names of specific tribal
groups and locations, viz.,
Afikpo, Akan, Anang, Ash-
anti, BaKwele, Bangwa,
Baulé, Beni, Bété, Chokwe,
Dahomey, Fang, Gio, Gola,
Guro, Lega, Madagascar,
Mano, Marghi, Ngombe,
Okavango River, Pakot,